The Underwater Photographer

To my wife Sylvia, whose patience, support and unselfish love have made my work under water possible. My children Katie and Jamie, whose love of the sea and its wonders is a great inspiration.

To my old buddy, model and best friend Bob Wrobel. His patience and understanding have contributed so much to so many of my images.

The Underwater Photographer

Second Edition

Martin Edge

Edited by Ian Turner

Focal Press

OXFORD AUCKLAND BOSTON
JOHANNESBURG MELBOURNE NEW DELHI

Focal Press
An imprint of Butterworth-Heinemann
Linacre House, Jordan Hill, Oxford OX2 8DP
225 Wildwood Avenue, Woburn, MA 01801-2041
A division of Reed Educational and Professional Publishing Ltd

A member of the Reed Elsevier plc group

First published 1996
Second Edition 1999

British Library Cataloguing in Publication Data
A catalogue record for this book is available from the British Library

Library of Congress Cataloguing in Publication Data
A catalogue record for this book is available from the Library of Congress

ISBN 0 240 51581 1

Composition by Scribe Design, Gillingham, Kent
Printed and bound in Great Britain

Contents

Preface

The numerous articles which I have written on underwater photography were borne out of the desire to communicate certain attitudes, opinions and techniques that I would have given my right arm to read about during my early days in underwater photography, in the early 1980s.

All too often, in the majority of books and magazines, the reader was told everything it was necessary to know about underwater photographic equipment, the basics of *f*-stops, shutter speeds and ASA ratings. However, the topics not easily explained were often avoided and I, and others like me, were left to fumble on and discover the techniques for ourselves. I very quickly realised that there were other skills I needed to acquire, but I did not necessarily know what those skills were.

I have convinced myself (and on reflection believe I was correct), that choosing the particular type of film, balancing the exposures, selecting a shutter speed and determining the placement and distance of my flash gun were purely mechanical techniques that, given time, virtually anyone could master. I was forever searching for the 'essence' which separated the good technician from the great underwater photographers.

So, over the years, I questioned, pestered and badgered many of the masters of the underwater photo art. I wanted answers to the questions: Just how that person had captured such a stunning image on film? How had their vision perceived and recognised such a successful shot? How many shots had failed before they got the one that worked? What were the conditions, the depth, the time limit that they had been working within?' I listened to everyone, discarding everything I consid-

ered not pertinent and moulded together an approach and attitude that I considered to be the most successful and enjoyable. It has developed into a style which I believe in and am committed to, and it is one I have chosen to write about and to teach – the TC (think and consider) system.

Introduction

Less than half of one per cent of Planet Earth's population have explored beneath the oceans. Images of the sea are brought to them in the form of photographs, some moving, others still. Trying to describe a sea anemone to a non-diving friend is well-nigh impossible. Underwater photography is the tool we use to capture all the amazing things we see while diving.

By capturing images on film, divers are able to share the excitement of the underwater world with non-divers, family and friends. We are able to remember the excitement and beauty of a particular dive, long after it is over, through the photos we have taken.

Divers soon look for a purpose in their diving after their initial training. Some choose marine biology and related subjects; certainly many will go for wreck diving. But there is little doubt that nearly all divers who remain active will, at some time in their life, pick up an underwater camera.

The importance of the role that underwater photography plays in diving cannot be overstated. Underwater photography offers huge potential for personal satisfaction. It is an activity which requires the understanding of a few basic rules and the understanding of how those rules can be most effectively applied to obtain the desired result. Within these criteria you will be able to take good photographs right from the start.

If you are diver who just likes to take a camera along to record a dive, by applying the basic rules you will be able to approach

your chosen subject and get more than just a snapshot. Indeed, you might become completely absorbed in underwater photography and dive purely for the purpose of taking pictures. This marks the beginning of a lifelong process that continually searches for new ways of improving your skills.

No matter how good a photographer is, there is always room for improvement. Creative expression is limitless. I, for one, believe that this quest for improvement is responsible for the incredible dedication a number of underwater photographers have.

The divers who take cameras merely to take snaps will appreciate the odds that are stacked against them to take a really good photograph. Occasionally excellent underwater photographs have been taken while diving with this approach. But it must be stressed that the vast majority of underwater photographs, seen in magazines and brochures, which give so many people the inspiration to dive and to take up underwater photography, were taken in much more controlled conditions. And by people with the right attitude and approach, not just good equipment.

The person not the camera

Whether on land or under water it is still the person, not the camera, that ultimately takes the photographs. Yet often you hear comments on prize-winning underwater photographs – sometimes from quite experienced underwater photographers – of the nature of 'I could have taken one like that if only I had the right equipment'. Not true!

Thoughts about the approach and lighting, consideration of the subject matter and concentration on the task in hand are far more likely to achieve good, maybe award-winning, results than expensive photographic gear.

Thought, consideration, concentration are words readers will come across time and again in this book. They, too, are tools at the disposal of the good photographer, albeit in the mind, as well as the cameras, flashes and accessories. And they are the very essence of this book, the whole reason behind the title 'The Underwater Photographer'.

Acknowledgements

My pursuit of underwater photography has depended upon the help, support, advice and friendship of a number of people, and I would like to thank them all for helping to make *The Underwater Photographer* so successful.

Ian Parry of Portland Sub Aquatics and the late Lionel Blandford of Blandford Sub Aqua for their help in providing my models with diving equipment which has been both reliable and attractive. In recent times I have taken advantage of the excellent 'Diamond' lycra wet suits. My thanks to Ocean Leisure for this.

Hilary Lee of Divequest UK. Her enthusiasm, social skills and attention to detail have revolutionised my photo trips to exotic places. Long may our relationship continue!

To Sarah and David Hillel of the MV *Sea Surveyor* and all the staff at Sipadan Dive Centre for their tireless support of my photo expeditions. Numerous friends and members of the British Society of Underwater Photographers (BSOUP). To Steve Warren, Colin Doeg and all the staff at Ocean Optics, thank you for your continuing support. Ex-student Alan James whose enthusiasm to get wet should be an inspiration to every underwater photographer. David Chandler and all the staff at Sea & Sea UK for their support. Jaci Moores of Nikon UK for trusting me with the precious Nikonos RS some years ago. I am also grateful to Peter Rowlands whose wisdom in matters concerning underwater photography has been so very valuable in my own work.

To Sara Cummings at Kodak. Simon Rogerson of Dive International who has helped with the editing of this re-edition.

Student and graphic designer Ian Ratcliffe for his ideas and innovative creations. To Brian and Sam Wells, Pat Dooley and all the staff at the Wintergardens Hotel, Bournemouth. Jim Eldridge whose talents with multi-projection audio visuals during the 1980s gave me a platform to show my work. I have some wonderful memories of those early days Jim, Thank you.

To Ken Fisher for the time he has spent in the darkroom teaching me to print. To Stuart Jones of Hewlett Packard for showing me the dawning of the digital age with slide scanners, HP photo-printers and Photoshop V.

To Michael Harris for permitting me to use his book *Professional Architectural Photography,* (also published by Focal Press) as a source for my chapter 'The Underwater Photographer and Digital Imaging'.

I also extend my thanks to all those who have attended my underwater photographic courses: Their thirst for knowledge and experience has provided me with the most precious moments of all! I would like to thank my editor, Ian Turner. You came to my assistance and maintained a tremendous enthusiasm throughout the time the first edition came to fruition back in 1996. I will always be indebted to you for that.

In more recent times my association with Ken Sullivan has developed into a strong friendship. His unselfish support, enthusiasm and love of underwater photography have kept me going on many occasions. His expertise in design and engineering have allowed us to experiment with facets of underwater photography which I hope soon will benefit others and perhaps be acknowledged in years to come as '***Pushing the Boundaries***'. Thank you for all that you have done.

Photographic Information

Since the first edition was published in 1996, I have up-dated my camera to a Nikon F90x. I continue to favour the Subal housing but I am very much alive to the progression of technology. If I felt the need to modernise my equipment I would have no hesitation.

The lenses which I use are all Nikon auto focus prime lenses with the exception of my 16 mm fisheye which is manual focus. They are the 105 mm macro, the 60 mm macro, 28 mm lens, 20 mm wide-angle lens and the 16 mm fisheye. I use different ports and domes which have been specially designed for me by Ken Sullivan from Photo Ocean Products in the UK. I also use a port and several bendy arms designed and constructed by Andrew Hirst. These new and lightweight designs have improved the logistics of travelling abroad. The flexible bendy flash arm system for macro and close-up has seen a cult following in the UK since the first edition was published. For wide angle and fisheye work I use arms from Subal, TLC and more recently Ultra lite. I also have a specially designed system made up from tripod arms which although cumbersome I favour for fisheye work where fill in flash is required.

The most radical change to my equipment which I have made in recent years is flash guns. Although excellent for land use, I have found that housing land flash guns is a disadvantage for my approach and style of underwater photography. With so many connectors, hot shoes and leads I have occasionally been frustrated when the flash gun and camera have difficulty in 'communicating' with each other. As a result I have reverted to using Sea & Sea YS flash guns. Over the years of teaching I

have found them to be the most reliable accurately calibrated flash gun that money can buy!

My Subal housings are each fitted with two Nikonos type bulk head connectors for flash application. This has eliminated the need to use a slave flash.

As you will read later in the book, the ring flash which I now use with great enthusiasm is made by Photo Ocean Products from UK.

My choice film stock continues to be the Elite range from Kodak. I use 100 ASA for wide angle, fisheye and some close-up work. I use 50 ASA for conventional macro.

To the reader

When I began to select photographs intended for colour reproduction in this book I took the view that I could illustrate one particular aspect or technique of underwater photography with each colour photograph. I soon realised that to attempt this was futile by virtue of the number of decisions I consciously or subconsciously made with each photograph. I found that it was impossible to discuss lighting without mentioning subject selection, composition without referring to peak of the action, visualisation and negative space.

When choosing the photographs for colour reproduction I was often torn between many aspects, all of equal importance and none relevant without the other. For these reasons I have included a detailed summary of how and why each colour photograph was made. They do not belong in one chapter but in all of them. So, I would encourage you to view them in their entirety.

Basic Techniques

This part of the book covers the more straightforward techniques and methods of taking different types of underwater photographs, favoured by beginners and experienced photographers alike.

1

The Basics

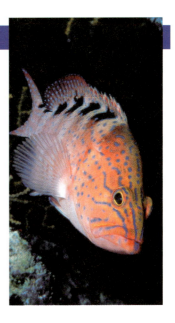

Throughout this book I have assumed that the reader has a degree of knowledge on aspects of photography and how it differs under water. The basics of shutter speeds, apertures and depth of field are core knowledge that you must have if you have any intention of applying the fundamental concepts outlined throughout this book.

Shutter speeds

Shutter speed controls the length of time that the film in your camera is exposed to the light. The faster the shutter speed the less time the light coming into the camera has to strike the film. The slower the shutter speed the longer the light coming into the camera can strike the film.

Shutter speeds are expressed in fractions of a second: 1/30, 1/60, 1/125, 1/250, 1/500 and so on. The fraction doubles between one speed and the next – this indicates that the shutter is remaining open for twice as long.

Manipulation of the shutter speed actually does two things.

Stops action. The faster the shutter speed, the more quickly the action of the situation can be 'frozen in time'. 1/125 s will freeze in time the movement of most fish and other marine life; however, dolphins and seals, for example, will possibly require a speed of 1/250 s to freeze their movement on film.

For still life images a shutter speed of 1/60 is usually adequate for most situations.

Controls the ambient light source. As you manipulate the shutter speed you increase or decrease the amount of ambient/natural light that is allowed to enter the camera and strike the film.

> Remember that shutter speeds do not affect artificial light or flash exposure; neither do they have any control over depth of field.

Synchronisation speed

When a flash gun is used in conjunction with a camera there is a shutter speed that must not be exceeded so that the flash and camera can synchronise with each other. For many years that speed was 1/60 s with the Nikonos and many other systems (1/90 s for the Nikonos V).

The recent advances in camera technology have considerably extended the boundaries of synchronisation. The Nikon F801s/8008F90X Series, for instance, will synchronise with any flash gun at speeds of up to 1/250 s.

Aperture

The aperture is the opening which is built into the camera lens. It is known as the iris or the *f*-stop. While the shutter controls the speed at which light enters the camera the aperture regulates the quantity of that light.

The values of *f*-stops are normally shown as follows:

*f*22; *f*16; *f*11; *f*8; *f*5.6; *f*4; *f*2.8

The higher numbers allow half as much light into the camera as the lower numbers immediately before them. So an aperture of *f*22 will let in half as much light as an aperture set on *f*16. So *f*16 allows in twice as much light as *f*22 but only half as much as *f*11, and so on.

Remember the higher the *f*-number the smaller the aperture. On most cameras the highest *f*-stop (i.e. smallest amount of light) is *f*22 while the lowest (most light) is *f*2.8. (Those new to photographic terms are often confused by references to 'stopping down'. This does, in fact, mean reducing the aperture of the lens by going up – not down! – to higher *f*-stop numbers to allow in less light.)

Changing a camera's aperture does three things:

* determines depth of field
* controls the ambient light source
* regulates flash-to-subject distances.

Figure 1.1
Each consecutive *f*-stop lets in half as much light as the preceding *f*-stop.

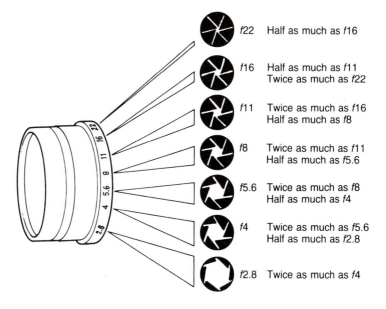

*f*22	Half as much as *f*16
*f*16	Half as much as *f*11 Twice as much as *f*22
*f*11	Twice as much as *f*16 Half as much as *f*8
*f*8	Twice as much as *f*11 Half as much as *f*5.6
*f*5.6	Twice as much as *f*8 Half as much as *f*4
*f*4	Twice as much as *f*5.6 Half as much as *f*2.8
*f*2.8	Twice as much as *f*4

Depth of field

This is defined as the area in front of the camera from the minimum to the maximum distance in which the resulting photographic image will be in focus and acceptably sharp.

The following affect depth of field:

The lens aperture setting.
The smallest *f*-stop – *f*22 – provides the greatest depth of field. By contrast the widest aperture – *f*2.8 – will give the narrowest depth of field.

The focal length of the lens itself.
Lenses with short focal lengths offer greater depth of field than those with longer focal lengths. So a 20 mm lens will give a much greater range of depth of field than a 100 mm lens will.

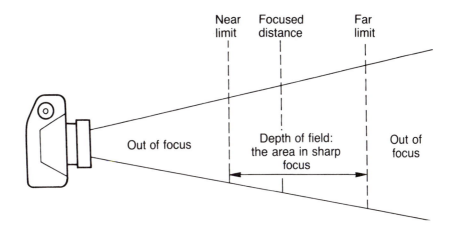

Figure 1.2
Depth of field.

The lens-to-subject distance.
The shorter the distance between the lens and the subject, the smaller the depth of field becomes. On the other hand, the greater the distance, the greater the depth of field becomes.

When you focus your lens on a subject, that is said to be the 'point of sharpest focus'. The depth of field is always greater behind that point than it is in front of it. So objects which are closer to you may be out of focus – particularly if you are using a lens with a long focal length or a standard lens with a low *f*-stop number/wide aperture – while those further away may be sharper.

Relative *f*-stops

In my early years of photography I could never understand why I needed to hold my flash 10 cm away from the framer of my 1:1 extension tube on the Nikonos on *f*22 as opposed to 30 cm away with the same aperture when using a wide-angle lens.

The reason is the relative *f*-stop. When you use an extension tube between the Nikonos body and a 35 mm lens the distance between the film in the camera and the lens increases. It's exactly the same for users of the 60 mm and 105 mm Nikon Autofocus lenses and also the 50 mm lens on the Nikonos RS.

When using the lenses in the 1:1 and 1:2 range the optics within the lens casing move further from the film. The consequence of this is a relative *f*-stop, a higher number than indicated on the barrel of the lens. Many novice photographers panic when they first use the Nikon range of Autofocus Macro lenses because apertures of *f*45 and *f*64 are displayed in the viewfinder when working extremely close.

Macro – the Easiest Way to Start

It is estimated that over 70 per cent of underwater cameras in use today are Nikonos. By simply inserting an extension tube between the lens and the Nikonos camera body you are able to extend the distance between the film in your camera and the camera lens. This decreases the focus distance of the lens to a matter of centimetres. A small wire framer or probes are attached to the extension tube and positioned in front of the lens, for framing and focus. The camera's viewfinder is not used except as a check for the Nikonos TTL (through the lens) flash.

Extension tube sizes

Extension tubes for the Nikonos 35 mm standard lens are available in four sizes: 1:3, 1:2, 1:1 and 2:1. The ratio indicates the size of the subject. The first number relates to the size of the image on the film, the second number relates to the actual size of the subject. For example, a small fish taken with a 1:3 extension tube will be a third life-size on film. On the other hand a 2:1 extension tube will create an image which is twice the subject's actual life size.

Camera settings

Since flash is used to light extension tube shots, the shutter speed is set to synchronise with your flash gun. Whether you set 'A' for Auto or 1/90 s will depend upon your model of Nikonos, and whether you intend to use TTL or manual flash.

Focusing and depth of field

Focus setting is preset at minimum or infinity (depending on the make of tubes) and the aperture is usually preset to *f*22. This provides you with the greatest depth of field – an element which is critical to macro and close-up photography. In macro an extension tube reduces your depth of field. The point of sharpest focus with a tube is towards the outside edge of the framer. To give you an idea, the depth of field at *f*22 with your extension tubes is as follows:

1:3 tube – 25 mm
1:2 tube – 12.5 mm
1:1 tube – 6 mm
2:1 tube – 3 mm

Figure 2.1
Three sizes of extension tubes. Left: 2:1 twice life size on 35 mm film. Middle: 1:1 life size on 35 mm film. Right: 1:2 half life size on film.

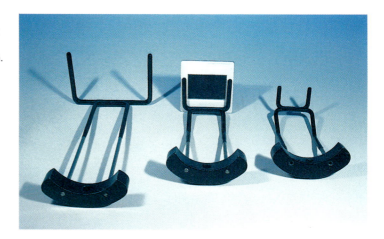

Lighting

In macro photography the flashgun is your only source of light because, in the majority of cases, natural light has no influence. Exposures are determined by how close your flash is positioned to your framer.

With TTL flash metering, all your exposures should be perfect, but with a manual flash set-up a typical flash-to-subject distance for 1:3 extension tubes would be about 20 cm, with an average power flash gun and 50 ASA film.

Why is macro described as easy?

Why, you might ask, is macro described as the easiest way to start? The answer is simple – all the adjustments and calculations are virtually fixed. But whatever type of photography

you choose, it is the column of water between the camera and the subject that is responsible for many of the problems that are encountered. With macro that water column is reduced to a minimum. Even after their first session beginners in underwater photography, using macro, will notice how sharp their pictures are, and a much higher proportion of photographs will be produced. For a small investment, extension tubes open up a whole new world which allows you to capture on film tiny subjects that many divers have never even seen.

A practical example

Take a typical approach adopted by an underwater photographer using macro techniques in blue water.

You've chosen to dive a reef lying in 18 m of water and you are told that the visibility is a maximum of 15 m. You have dived the reef many times before and recognise that one of its strongest features is the soft coral, in various colours, which grow off its face. You choose a 1:3 extension tube for your Nikonos, and a small manual flashgun, then check the camera and flash are not missing any vital accessories which might cause a flood.

Once on the bottom lay your equipment down. Ensure your shutter speed synchronises with your flash gun, that your focus is set correctly and your aperture is set at *f*22. Together with your buddy you seek out the corals you intend to photograph, taking care not to cause any damage, of course. There are thousands to choose from, of various sizes and colours, but, of all these, make sure the specimen you pick is intact, undamaged and the correct size for your framer.

Some guidelines to the right selection

Don't choose the first one you see. Think about the picture you want from the subject. A black background will make the soft coral stand out, especially if it's colourful, so choose one that is growing in the position you want and one that will give you a variety of composition and lighting options.

Make sure that you can photograph it without including a cluttered distracting background. Shoot against open water and your aperture of *f*22 or *f*16 will render this chosen background black or dark blue, to give maximum contrast to the colours.

Watch for backscatter

Having chosen your subject consider backscatter. This is so often caused by the photographer or another diver stirring up sand and silt from the bottom. Incorrect buoyancy, and bounc-

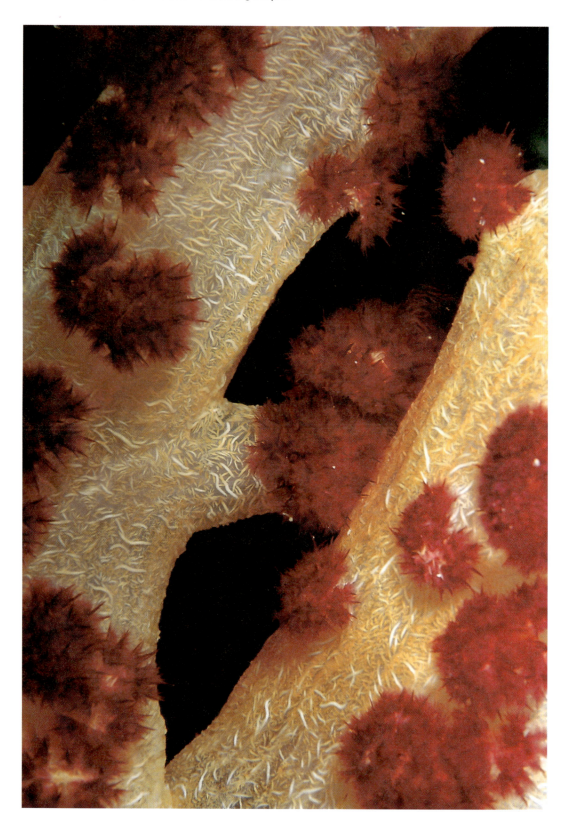

ing along or finning too close to the sea bed can, of course, cause the same effect. In macro photography, stirring up the area around the subject by striking it with the framer can also be a problem.

The importance of correct positioning

Position your flash at an angle of 40 degrees over the top and slightly to the left of the subject. This way you reduce the possibility of backscatter. Make your approach slowly and methodically. Move your framer into position. The soft coral is quite small and occupies about 50 per cent of your framer. As it grows vertically consider turning the camera on its side and matching its shape to the framer. You want a low camera angle which will allow the coral to stand out from the surface to which it's attached. Place the coral very carefully inside the framer, taking care to avoid disturbing it. (Extension tube framers are slightly oversize and allow space around all four sides.) Line up the subject between the posts to ensure it's in sharp focus.

Compose the picture

Figure 2.2 (opposite page)
Taken with a Nikonos V 1:3 extension tube with a Sea & Sea YS 50 TTL flash gun at TTL placed 20 cm from the subject. *f*22 at 1/90 s using Elite 50 ASA. It is a simple study of colourful soft corals. I selected this particular specimen because I found it easy to get near to it without fear of damaging its surroundings. The black background is in reality the bright blue water column of a tropical sea. I looked along its branches for an interesting and balanced composition. Notice the diagonal orientation across the frame. You will learn more about composition later in the book. I took about six shots of this coral, changing the composition slightly with each one but retaining the idea of the two balanced stems. The lighting is from above the camera pointing down onto the coral.

Before you press the shutter, look down the sides of the camera and place your eye just over the top of the viewfinder. This will give you a more accurate idea of perspective and composition, rather than looking high over the top of the camera as you would normally do. Now, gently squeeze the shutter. Remove the framer and recompose the picture. Try removing the flash from the camera and holding it at a variety of angles to the subject. Alter the flash-to-subject distance, bracketing your shots with 15 cm, 20 cm and 25 cm. Try side lighting and extreme top lighting. Change composition from vertical to horizontal format. Use as much film as you wish providing it's a good specimen, correct size and in the right location with potential for a really good shot.

This subject perhaps takes up to 15–20 minutes of your dive. You have taken 12 exposures, so look around for a few more subjects to complete your film. A photographer who is not prepared to use this much film and time on just one subject, but who would rather swim around taking pictures of a variety of creatures, can still adopt the same methodical approach.

Be fair to yourself and evaluate your results objectively when you wonder how your buddy got an absolutely stunning shot of the soft coral. He or she probably used the whole film and the entire dive doing it!

Twelve macro tips

1. Work the strongest feature of the site you intend to dive (providing you are familiar with it). Select the framer to match your subject. If there are large but tame schools of fish, don't go down with a 1:1 macro in mind.
2. Know your purpose. If you are going down for snapshots, then that's fine, but if you want to take good underwater photographs then formulate a plan of your intentions and make sure your buddy is aware and approves!
3. Control your buoyancy. If you are either too heavy or too light you will have difficulty composing your shot. This mistake almost certainly manifests itself in the form of backscatter in the pictures.
4. Don't choose the first subject you see. Look around and search for the very best specimen.
5. Look down the sides of the camera. This will give you a better idea of composition and perspective.
6. Be aware that the smaller 2:1 extension tube can limit subject choice and be extremely difficult to use. Depth of field is almost non-existent. The most popular and versatile is the 1:3.
7. Some underwater photographers choose to cut the left upright framer off their tube to avoid the flash casting a shadow when it is angled from the left-hand side. Some manufacturers do, in fact, provide framers which can be unscrewed to overcome this problem. Part 4, on equipment, includes details of these.
8. Learn to develop your sense of 'vision'. With practice you can quite accurately visualise the subject inside the framer and know whether the picture will work or not.
9. Give yourself a chance to eliminate any pre-occupations or distractions that may prevent you thinking and concentrating on your objective.
10. To determine the flash-to-subject distance with a manual flash and extension tubes carry out a simple exposure test as follows:

 - load with film no faster than 100 ASA
 - take a series of test exposures of a colourful subject in a swimming pool (a colourful towel is ideal). Vary flash-to-subject distance from 10 cm to 40 cm with the aperture set to f22.

11. Develop and project your slides to see which distance gives the best exposure, then finally, commit the result to masking tape and fix it to your flash.
12. Always consider the environment and the potential damage that can be caused by poor diving techniques.

Close-up Photography

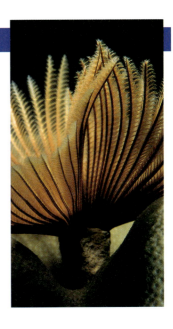

Reduce the column of water

In macro photography it is easily apparent how clear and well-focused even early attempts appear. One of the reasons for this is that the amount of water between lens and subject is kept to a minimum. This avoids many of the potential problems underwater photographers may encounter.

But just beyond the scope of your macro extension, in and around the 30–40 cm range, there will be many other interesting and varied subjects you will want to photograph. This is where close-up photography comes into its own, applying many of the criteria learned in macro photography and, in particular, the all-important rule of 'reduce the column of water'.

A personal experience

Reducing the column of water was something I learned very early on in my first two years of underwater photography. I was becoming increasingly frustrated with my attempts to take competent photographs of one of my favourite subjects – fish.

I was in the process of mastering my Nikonos III with only the 35 mm standard lens. I had recognised the disadvantages – small depth of field, narrow angle of view and an inability to focus down to less than 85 cm. However, I considered that I could cope with this and still get some good shots. All too often they were either out of focus or just bland with washed out colours and little impact at all. I needed advice! I needed to know whether my approach and attitude were compatible with my limited equipment and techniques. At an exhibition many years ago I cornered a very highly regarded British underwater photographer,

Mike Valentine, and presented my problems to him. 'Reduce the column of water' was his immediate reply. 'Whatever your subject, whatever your lens or camera or depth, reduce the column of water between your camera and your subject.' He was so emphatic that I took away this piece of advice that since then, has always been uppermost in my mind. It's advice that I will stress again and again, and I make no apology. During the five minute conversation with Mike he introduced me to close-up photography. I went away filled with expectation and enthusiasm.

Broaden your scope

Close-up offers many benefits that are simply not possible with the standard Nikonos lens. You can add a whole new group of subjects to your portfolio, subjects that would otherwise be just a little too large for an extension tube. Close-up offers the same richness of colour and sharpness as macro, but you obtain a different and more realistic perspective.

Close-up equipment

The Nikonos close-up outfit is the most widely used and, in my opinion, surpasses the optical quality of any of its rivals. It consists of a single auxiliary lens (which clamps over the primary lens) and a selection of 3 wire framers. These match up with the 3 Nikonos 28 mm, 35 mm and the little-used 80 mm lenses. The preset distance is uniform with all three at around 20 cm. Only the framers change in accordance with the lens used.

The 28 mm covers a picture area which allows photography of larger subjects and has a greater depth of field than the 35 mm. The 28 mm has a magnification ratio of 1:6.

Figure 3.1
The Nikonos close-up kit fitted to the trusty Nikonos 111. Photo by Bob Wrobel.

The 35 mm has reduced depth of field, but this does not present any great problem. It comes into its own when photographing subjects that are slightly too large for the 1:3 extension tube. The 35 mm has a magnification range of 1:4.5. Like macro the controls are preset to *f*22, and a fixed shutter speed, but with this outfit the focus is set to infinity. Flash-to-subject distance is down to trial and error with manual flash guns, and requires the same exposure tests as with macro TTL flash will cope adequately and ensure consistent exposures.

Using close-up

At its most basic, close-up photography is a simple point-and-shoot technique which allows divers to capture the many subjects seen on a dive. But with a realistic perspective, images will be sharp, in crisp detail and will show even the tiniest pattern. Colours, too, are rich.

The potential of this system, even when visibility is limited, is enormous and, for the underwater photographer who is prepared to spend time and film using close-up, the sky's the limit.

The approach you adopt with your system is very much a matter of your attitude to diving and underwater photography. Ask yourself: are you taking your camera diving with you or are you entering the water with the sole intention of taking underwater photographs?

Wherever you stand between the two, consider the following techniques, but remember the standard of your results will almost certainly be reflected in your attitude.

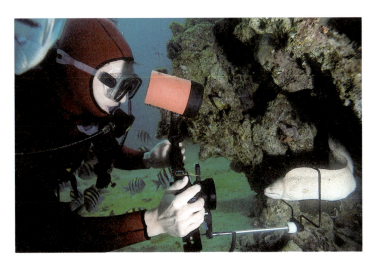

Figure 3.2
With patience and perseverance, fish and other creatures can be persuaded to occupy the picture area within the Nikonos close-up lens.

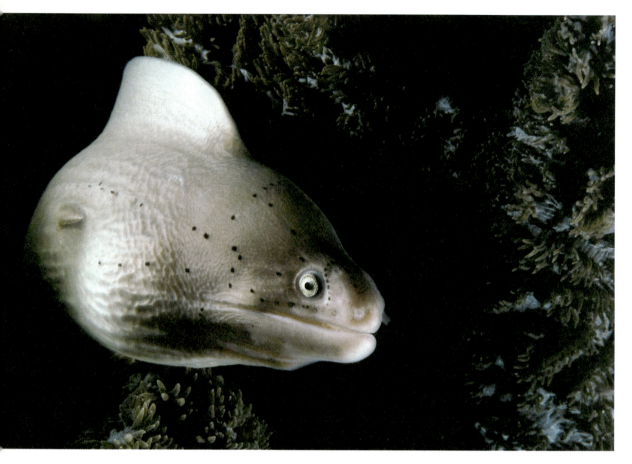

Figure 3.3
It is possible to entice moving subjects into the Nikonos close-up framer. This white snowflake moray eel kept coming out of a hole surrounded by very dark coloured corals. I knew that the potential of light skin on dark coral would achieve excellent negative space. The potential increased when the moray continued its curious inspection of my framer. On at least 25 occasions it entered the framer. I pressed the shutter between 15 and 20 times and eventually achieved a result that pleased me. I experienced this encounter back in 1989. I have taken many shots of this species of moray since but I have never equalled the result. It is significant that the quality of the opportunity has also never been surpassed. Nikonos V 35 mm lens. Nikonos Close-Up Framer f22 at 1/60 s shutter speed. Sea & Sea YS 50 TTL flash gun. Ektachrome 64 ASA. Aquaba, Jordan.

Techniques

Begin by removing any piece of photographic gear that is not essential for the type of close-up photography that you intend to do. Extra-large strobe arms, exposure meter mounts and any other accessories will all reduce the ease of handling. You can hold your flash at almost any angle, easily and accurately, by hand. Spend time searching out the correctly sized subject for your close-up lens. Choose one situated in a location which will give you the maximum potential. Shooting your subject against a mid-water background will make that subject stand out in negative space, as opposed to a subject captured against a

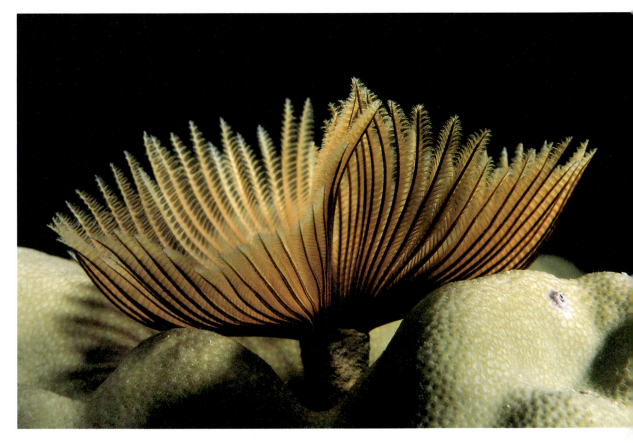

Figure 3.4
This is perhaps the only occasion I have ever been successful in shooting a tube worm in full bloom using a 35 mm Nikonos lens and close-up framer. I had attempted this shot on numerous occasions only to be frustrated when the worm 'took off for cover'. I only had chance to press the shutter once and luckily I was rewarded with sharp detail and good depth of field. Nikonos V Sea & Sea YS 50 TTL on the TTL setting. Ektachrome 50 ASA. *f*22 at 1/90 s. The following day I repeated the shot of the very same specimen with a Nikon F801s and 60 mm auto focus lens. It was much easier!

cluttered distracting background. (**Negative space** is a much-used word in underwater photography and is defined as 'everything in the photograph that is not the subject'.) An upward camera angle also helps here. When composing, look down the sides of the camera to give yourself a more realistic perspective than being 0.6 m or more above it.

With the framers or prongs still attached learn to develop an eye for the picture area. Look at the visual references, for instance the size of the camera back. If the framer is getting in the way, remove it before you start. Aim the camera by placing the end of the support rod just under the subject. This is an excellent way of getting fish into the picture area. Experiment by hand holding the flash at a variety of angles.

In shallow water and bright sunlight, with an acute upward camera angle towards the surface, ambient light levels may well be suitable for the small aperture of *f*22 or *f*16 on your camera and provide green or blue detail of the surrounding water. If your subject is moving, entice it to the surface and then attempt to capture its reflection. Combinations of a diver's face and creature or with artifacts such as those found on wrecks also offer tremendous potential.

A wide range of opportunities

Like macro, close-up offers the opportunity to photograph a wide variety of subjects and situations. It is difficult to compare the two because they both have their own separate places in underwater photography. Macro is good for high image magnification of tiny creatures, while close-up is ideal for small fish and provides more realistic perspective. Whichever you choose, remember – patience, approach and the rest of the TC system, which should form the basis of every photograph you take once you have read this book!

4

Wide-angle Photography

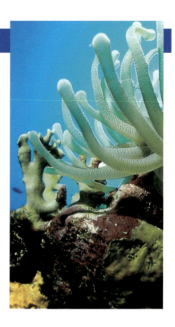

Macro and close-up photography allow divers and non-divers alike a glimpse of the multifarious and often magnificently coloured life forms we see in the waters of the world. But the memories of being there in the midst of it all can be brought to life even more through wide-angle photography. That may be the reason why wide-angle photography is without doubt the most popular form of underwater photography today. Images of divers interacting with marine life or entering a huge, intact shipwreck are the stuff dreams are made of.

A personal experience

Several years ago, while running an underwater photography course, I was approached by a student who stated his intentions to use a normal 35 mm lens, and only that, to record the underwater world. 'Wide-angle and close-up give an unrealistic perspective which I want to avoid', he believed.

That afternoon we set to work photographing underwater divers using wide-angle lenses and wide-angle adapters. The student chose his preference of the standard lens and 35 mm optical viewfinder. I watched him back away from his partner, to the limit of the 3 m visibility, in order to get his buddy's full length into the picture area. He took the picture and I then indicated for the pair to change places and his partner to take a similar picture, but using the equipment he had chosen – a Sea & Sea wide-angle adapter on a Nikonos V.

That evening we processed the 2 rolls of film and compared the results. The student was amazed at the difference between the two shots. His normal lens had forced him to back off so far that the subject (his buddy) was hardly visible in the distant gloom. When the

roles had been reversed, the wide-angle lens allowed his partner to move closer to within 1 m of his subject. The resulting image was a colourful, vibrant and pin-sharp picture.

Again it cannot be stressed enough that to take good underwater pictures, you must eliminate the column of water which separates the subject from the lens. Wide-angle photography does this to maximum effect. By reducing the distance you reduce the amount of suspended particles, and other unwanted problems, in the water.

Distortion

In topside photography the use of wide-angle lenses is associated with a distortion effect known as 'pin cushion'. Under water these lines, both vertical and horizontal, are absent and this type of distortion goes unnoticed.

Figure 4.1
A personal experience.

Perspective distortion

Figure 4.2
The same technique works for SLR cameras in housings with wide-angle lenses. This anemone was taken in Bonaire. It was growing so proud of the reef that I could get my eye behind the viewfinder to compose. The lens was set to minimum focus and I took about four shots using a Nikon F90x with 16 mm full-frame fisheye and a Sea & Sea YS 120 TTL set on TTL. Exposure was *f*22 at 1/60 s. This small aperture was as a result of shooting up directly into the sun in shallow water. Film stock was Elite 100 ASA.

However, when you use wide-angle lenses the relative size of subjects near and far is distorted. Nearer subjects appear to be larger and closer than they really are, and more distant subjects appear to be smaller and much further away. Wide-angle lenses do, in effect, increase the appearance and scale of underwater visibility because the background appears to be more distant. This can be used effectively to create huge fissures in areas where they don't exist. For instance, using a small gap as a surround for a distant diver or seascape gives the impression of a huge hole which frames the distant reef. Or when photographing divers interacting with marine life, by composing the fish closer to the lens than the diver you can achieve a dramatic impression of a subject greatly oversized in proportion to the diver in the background.

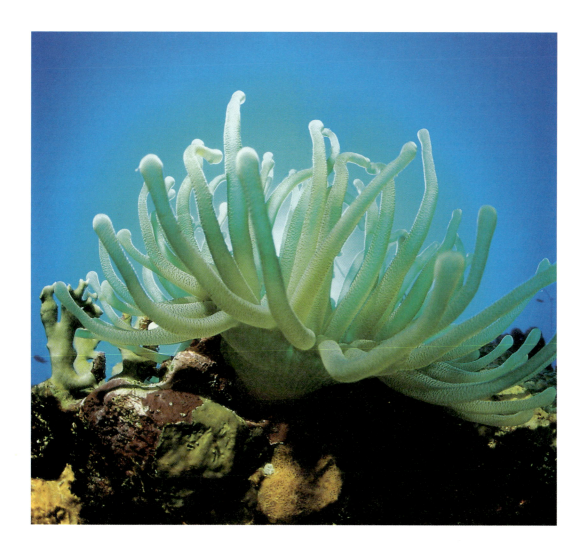

Depth of field

Apart from the ability to use the above technique to dramatic effect there is another element of wide-angle underwater photography which offers a tremendous advantage over land photography, particularly to Nikonos users. This is all to do with depth of field.

The wider the angle of the lens, the greater the depth of field. This increase is so marked that a Nikonos 15 mm lens focused at 1 m, for instance, will be in focus from 0.5 m to infinity at f8. The same applies to wide-angle adapters. When you shoot up towards the surface, with 100 ASA film, apertures of f11 and f16 can often be indicated which almost eliminate any need to focus.

Wide-angle lighting

Wide-angle lenses can produce dramatic silhouettes when used with natural light. By reducing the column of water and getting close to your subject, you can achieve a stark black image against the bright surface of the sea. Ensure that you always shoot up towards the surface and consider including the popular sunburst technique. Shooting down on a subject will almost certainly produce a flat result with little contrast and, unless it is really what you want, should always be avoided. Wide-beam flashes are often advertised as being an absolute necessity to illuminate the frame from corner to corner. But many photographers simply use a flash with a medium to high guide number, and with a diffuser attachment to spread the light evenly over a wider area, to equally good effect.

Keep the flash away

In order to minimise backscatter, it is essential to have some means of getting the flash as far away from the camera as possible. I hand-hold my flash at arm's length on a 1 m ball-joint arm. This places the flash more than 1.5 m away and for a horizontal format lights the picture area evenly all over when aimed from above. Aiming the flash inwards and downwards at an angle of 45 degrees from the photographer's left side is a common lighting angle with standard lenses, but with a wide-angle lens the upper left of the picture area may be over-exposed and lower right-hand side may be under-exposed by positioning your flash in this way. The commonest fault with hand-held flash photography is pointing the flash in the wrong direction. Hand and eye co-ordination is not learned overnight and wide-angle lighting should be practised and practised time and time again until the technique is perfected.

Ten wide-angle tips

1. Know your purpose. Make sure your buddy realises your commitment to a particular type of photography on a particular dive.
2. Check your camera settings and check them again frequently during the dive. Everyone at some time forgets to adjust aperture and focus after changing from close-up or macro system.
3. Shoot upwards. This technique will separate your subject and place it against a mid-water background.
4. Think big! A common mistake underwater is to use a wide-angle lens to photograph small fish. Think in terms of the entire scene, not just isolated subjects within that scene.
5. Use the entire picture area of the viewfinder. At distances of 1 m and more it's an accurate device and should not be treated as a gunsight.
6. Fill the frame and get close. The common fault with wide-angle underwater photography is to shoot from too far away. Remember, the closer you get the sharper the image and the better the colour.
7. Use perspective distortion to your advantage. Portholes on shipwrecks, etc., provide dramatic frames for the distant diver.
8. Learn to co-ordinate the aim of your flash when you can't actually see the hand that's holding it.
9. Dive repeatedly on the same sites. If good underwater photos are your prime objective, then by repeating a familiar site you begin to realise the quality of its potential.
10. Repeat, re-read and remember rule 6 – get close and fill the frame.

5

Balanced Light

Figure 5.1 (opposite page)
Using a Nikonos V and a 28 mm lens with a Sea & Sea YS50 TTL flash gun, I chose one particular specimen of soft coral that grew proud from the reef. The water background was the most vibrant blue. A light meter reading indicated f11 at 1/60 s. There were numerous specimens of soft corals on this particular reef but the excellent condition of this one together with the blue water negative space made it my first choice. I took three shots, maintaining the combination of aperture and shutter speed but bracketing the flash angle by hand-holding it. The other two shots had out-of-focus fish in the foreground completely ruining the image. Film stock was Ektachrome Elite 50 ASA. Egyptian Red Sea.

A great deal of good underwater photography, of course, stems from an ability to be able to 'see' things under water as they are and judge how they can best be revealed by light. With experience and practice the photographer learns to be able to visualise various ways in which light can be used. For instance, 10 m below the surface with the sun high in the sky and visibility of 15–20 m on a Red Sea, Mediterranean or Caribbean reef the human eye sees the seascape at the equivalent of $f5.6$ to $f8$ with 100 ASA film at 1/60 s. A light reading with either a built-in meter or an underwater light meter would confirm this.

However, the parameters of film chemistry in association with the conscious choice available only to the human brain, allow a tremendous amount of leeway in film exposure compared to what the eyes perceive. For example, by closing the aperture to $f22$ the colour of blue oceanic water darkens to black or very dark blue. To look directly into the sunburst at a shallow depth would cause most photographers to screw up and squint their eyes, and that natural exposure of $f5.6$ shooting into the sun would almost certainly overexpose a large portion of the finished photograph.

Using aperture control you can stop down to $f16$ or perhaps $f22$ to 'expose for the sun'. In this way you can obtain a small sunburst which adds to a picture instead of overpowering it.

Once correct exposure, flash techniques and sharp focusing methods have been mastered there are a host of decisions to be made about the aesthetic values of a photograph. These concepts cannot always be readily explained and are often

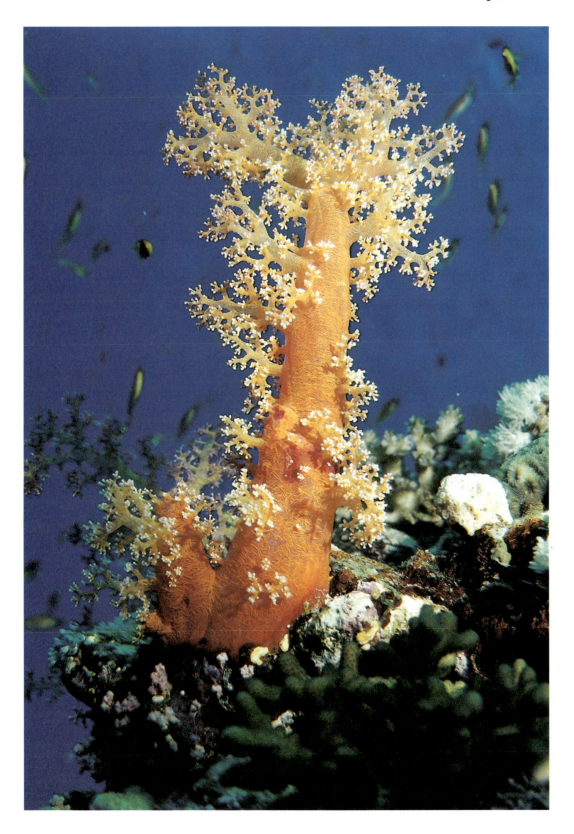

Figure 5.2

Manual flash exposure depends entirely on the output of your flash, the aperture selected and the flash-to-subject distance. The chart accompanying most flash guns indicates the baseline of exposure, and these distances should be used with TTL. This will give your flash the best possible chance of being accurate.

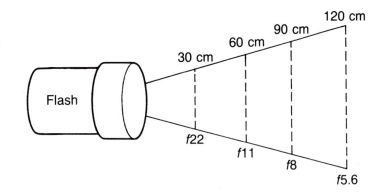

avoided. They include flare, impact, design, shape and form, texture and most importantly the quality of light and the effects which light creates. The human eye has to be trained to see under water and the mind to visualise, perceive and consider what elements are available. This is the difference between merely 'looking' and truly 'seeing'.

Painting with flash

One very effective technique is to balance the light source of your flash output and the natural light falling on a reef. You record the background in much the same way that your eye sees it, which gives the picture a tremendous sense of depth in an almost three-dimensional way. Using your flash gun you simply paint in the foreground colour. Land photographers refer to this technique as 'fill-in flash', but I much prefer Jacques Cousteau's quote of 'painting with light using a kiss of flash'.

A closer look at technique

Figure 5.3 (opposite page)

The essence of balancing the artificial light and the ambient light is making the viewer question 'Has flash been used or not?' This simple shallow reef scene taken off the beach in Aquaba, Jordan has sold many times as the 'cliche coral reef shot'. Flash has been used to paint in the shadows and replace some of the lost colour but for some it is difficult to tell. Nikonos 111 Nikonos 15 mm wide-angle lens. f5.6 at 1/60 s. Oceanic 2003 flash gun. Ektachrome 100.

This technique is worthy of closer examination. On a reef during daylight hours, using a Nikonos system with 50 ASA film, you take a light reading by pointing the camera meter or light meter at a horizontal angle towards the open water background. Your shutter speed is already synchronised with your flash. Suppose the light meter indicates f5.6. Next consider the flash exposure on the foreground subject, a branch of red soft coral. With your aperture set to f5.6 estimate the distance you require to hold your flash from the subject to give you a correct exposure. With your flash too close, the subject will be overexposed; too far away it will be too dark. The background exposure, however, will not alter since this is being taken care of by the natural light. The specific distance the flash is held depends entirely on the

output of your individual flash gun. My own Oceanic 2003 on half power gives reliable exposures at: 0.3 m at $f22$; 0.6 m at $f11$; 1 m at $f8$; 1.3 m at $f5.6$; 1.6 m at $f4$. Modern-day TTL flash is very consistent but if it is too close to the subject it cannot quench the light effectively. If the flash is too far away from the subject it can only provide full power, which may not be enough to achieve correct exposure.

This is consistent with the Nikonos 35 mm, 28 mm, 15 mm lenses and all wide-angle adapters. From the scenario illustrated here, I know that by holding my manual-powered flash 1.3 m away it will give me the correct exposure using $f5.6$ which will simply paint in the colour of soft coral. With a TTL flash gun try to hold it at the same distance. But don't worry if you're not that accurate on judging distances – it will work it out for you!

Avoid confusion

Be careful not to confuse flash-to-subject distance with camera-to-subject distance. Camera-to-subject distance is irrelevant: it's flash-to-subject distance which is all important. Adjustable power flash guns can be an advantage because you adjust your flash power in relation to your chosen distance. However, ascertaining your gun's full capabilities and limitations by various tests is by far the most satisfactory method.

Making the lighting choice (see also Chapter 11)

Problems can arise when you become ambitious and choose to include a sunburst in the background. To expose for the seabed and lower mid-water background at $f5.6$ for instance, may overexpose a large part of the shot if you include a very bright sun, which may only require a stop of $f22$. A conscious choice is required here. You must either exclude the sunburst and expose at $f5.6$ or include it but reduce your f-stop accordingly and move your flash closer to the required distance. For example, at $f22$ flash-to-subject distance will be around 0.3 m. Now both sun and subject will be correctly exposed, but the background water is reduced to dark blue or black. However, this is no longer balanced natural light as the flash is the primary source of illumination. As with countless aspects of photography it is a conscious choice you must make yourself. Give yourself time for these balanced light techniques to sink in. Experiment with them and amend the rules. Once you understand and have mastered the basic concept it will provide your photographs with much more impact and appeal.

Close Focus Wide Angles

There are various other techniques to take on board and, in particular, specific problems that users of the Nikonos system will most certainly need to overcome.

Mastering the techniques of viewfinding with the Nikonos camera and wide-angle lens or adapters are of paramount importance. Here problems manifest themselves in a variety of ways and, all too often, when viewing the results, the user will look to blame either the quality and effectiveness of the lens/adapter or the make and speed of the film. He or she may also fault themselves for lack of concentration or perhaps an inability to remain still while pressing the shutter. One thing which tends to be overlooked is the wide-angle viewfinder itself.

Wide-angle viewfinding

Learning to use the wide viewfinder to compose wide-angle underwater photographs requires new habits and techniques. The eye, screened by a diving mask, sees approximately the same angle of view as the 35 mm standard lens.

For instance, while diving a reef or wreck, you swim around the site with both your eyes and mind open. You see an impressive formation of wreckage with shoals of fish hanging above it against a bright green mid-water background. A diver with a torch comes towards you. In order not to miss the opportunity, you put your viewfinder to your eye, compose the picture and press the shutter.

Figure 6.1

All Nikonos and Sea & Sea users must be particularly aware of parallax. In this figure the photographer has composed the perfect jellyfish, arranging the image by looking through the viewfinder. At short camera-to-subject distances the image seen in the viewfinder is different from what your lens is seeing.

The above scenario describes a common error made by newcomers to underwater wide-angle photography – that of composing with mind and eye. The decision to capture the scene from your underwater location is made when you see the splendour before you! However, the lens and viewfinder see a much wider perspective. Your decision to take the picture must be made in combination with the view of the seascape through your viewfinder. This common fault is evident where the finished pictures appear to have been taken from much too far away: the subject appears to be far too small in the frame. Remember, compose through your viewfinder if you wish to photograph what you see.

With experience, you will learn to recognise a good wide-angle opportunity and not confuse it with the beauty of the seascape before you.

Parallax

Parallax is the difference between the image as viewed through the viewfinder of a non-SLR camera (i.e. Nikonos) and the actual image recorded by the lens when you focus on a closer subject.

When used in conjunction with a supplementary viewfinder the difference is even more acute and parallax correction is required at distances of 1 m and less. At mid-distance ranges the differences due to parallax are virtually nil since the picture area of the lens and the viewfinder see the same image. A tremendous advantage of wide angle is the ability to focus closely; for example, a Nikonos 15 mm lens will focus down to less than 25 cm. This advantage allows you to select subjects in

the immediate foreground with the diver or seascape in the background. The price you pay is parallax. Underwater Nikonos and Sea & Sea users the world over are constantly reminded of its necessity. It can be overcome in various ways but its importance and the consequences of forgetting cannot be overemphasised.

Adjustable viewfinders

Certain viewfinders are adjustable and calibrated with specific distances. When focused on a formation of coral 0.6 m away, you simply preset the adjustment on the viewfinder to that distance and compose. However, you must remember to correct the adjustment when shooting at greater distances. Other viewfinders are inscribed with parallax correction lines which only apply under 1 m (distance not depth). The lines of the 15 mm Nikonos viewfinder are quite accurate and this viewfinder is also a delight to use, because the image is bright and very sharp.

Other ways of correcting for parallax

The method of correcting for parallax which I myself have adopted, after trying various methods, is one which many may initially consider clumsy. It works for me and is very accurate. Compose through the viewfinder and move your eye from corner to corner, being aware of the entire picture area, and also the view of the area in the far distance. Moments before pressing the shutter raise the camera so the lens instead of the viewfinder is at eye level and fire. In this way, the lens is seeing the subject at the same angle that your eye composed it with the viewfinder. You don't see your subject when you shoot since the camera back blocks your view. But, since the subject has enabled you to approach that closely in the first place it's unlikely to move at the critical moment. Find a method which suits you and your style. Just considering parallax is half the problem solved, but never underestimate its importance!

Consider masking the edge of the viewfinder with black tape so that only the picture area is seen. Many photographers (myself included), believe that seeing more of the area than will be photographed is a hindrance to good composition and total concentration. However, there is also an opposing school of thought that you should be able to see what is approaching the picture area outlined in the viewfinder. Whichever method you chose there is no right or wrong. It's a question of personal choice.

Close focus wide angle

Close focus wide angle was a technique first brought to my attention in the excellent book by Howard Hall, *Guide to Successful Underwater Photography*. Images created in this way are perhaps some of the most dramatic, creative and popular which can be taken under water. I had seen this type of shot in the past but could never quite work out how it had been taken and, more to the point, why it was so dramatic and beautiful. The techniques related here are to the credit of Howard Hall and are outlined in his book.

The secret, as the name suggests, is to select and focus on the foreground subject with perhaps a diver hanging out in the blue water with sunshafts piercing the surface behind. By taking advantage of the extreme depth of field you are able to capture all the elements in focus at the same time. What is essential is to balance the exposures of the natural light and the light from the flash, then select an aperture of $f11$, $f16$ or $f22$ in order to retain the required depth of field.

In order to achieve this small aperture, you simply shoot up toward the lighter regions, i.e. the surface and sunburst. Select the foreground subject, such as a large starfish or Gorgonia which you can photograph at such an angle.

To achieve the correct exposure with your flash set on manual, you simply hold it at the distance which is applicable to the *f*-stop selected and the power of your particular flash gun.

With my Sea & Sea YS50 TTL flash gun set on 'full' (i.e. manual as opposed to TTL) I would hold about 0.5 m away for $f22$ and $f16$. For $f11$ with 100 ASA film at the flash sync speed of 1/90 s the distance would be 0.6 m.

The critical exposure is the one on the foreground subject. Considerable latitude can be allowed for the distant blue water and the surface.

Figure 6.2 (opposite page)
The superb coral reef of 'Hanging Gardens', Sipadan, provides wonderful opportunities for close-focus wide-angle photography. I selected a specimen of gorgonia for its size, its condition, location and accessibility on the reef wall and its vibrant colour which I had visualised with the aid of a small torch. I drifted past in the slight current. My buddy Paul Monaghan followed. I indicated the pose I wanted him to adopt and the direction of his hand light. I composed both the gorgonia and Paul accordingly. I took 8 shots, bracketing the angle of my hand-held flash for each. For CFWA I needed small apertures to provide good depth of field. Note the hint of sunburst in the top left of the frame. See how the colour of blue water graduates from light to dark as your eyes move from top to bottom. If your model is to be captured as a silhouette it is essential that they are composed in the lighter regions of the blue water background, otherwise they will be virtually invisible. Nikonos V with 15 mm lens. Sea & Sea flash gun on a flexible arm hand-held at top left.

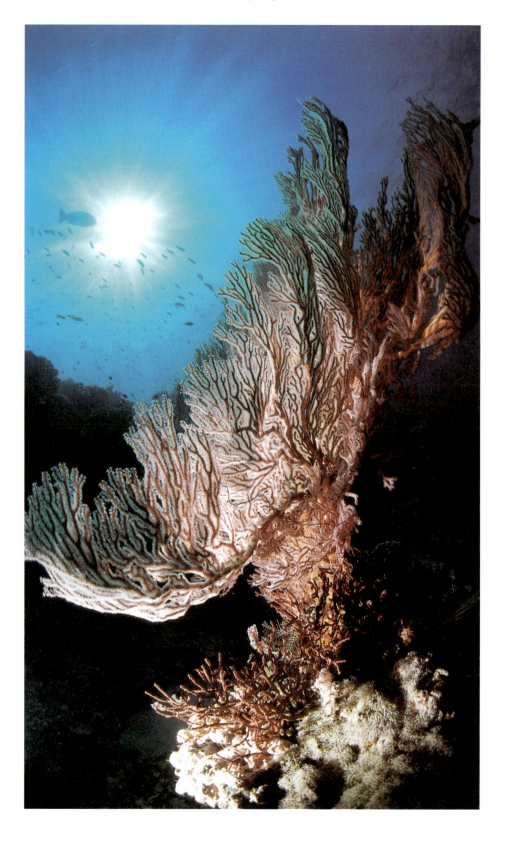

Figure 6.3 (opposite page)
The corals of Sipadan Island, Borneo, are so unique and different from those in the Red Sea. I shot them at a variety of angles and compositions using various lenses. When using a sunburst in a shot, my first priority is not allowing it to dominate. For my own style of underwater photography it is there to enhance a photograph. I always consider its placement and more often than not I compose the sun just out of the frame but use the rays to give the shot a little more of a sparkle. I took the photograph at a depth of 25 m. The sunburst appeared quite small in the frame so I selected the aperture that the camera indicated, *f*11. Top lighting with a wide-beamed flash produced a 'halo' effect and balanced the intensity of the gorgonia with that of the sunburst situated on the top left thirds intersection (see Chapter 12 on composition). My wife Sylvia has named this shot the 'mermaid's armchair'. Nikonos RS 20–35 mm zoom on the 20 mm end. SB 104 flash gun on a long flexible arm. Ektachrome Elite 100 ASA.

A practical approach

You are diving a reef with outcrops of soft coral in various shapes, sizes and colours. You have a Nikonos V with 15 mm lens, viewfinder, Sea & Sea YS50 TTL flash set on TTL and light meter.

Your most convenient asset is your diving buddy who has indicated a willingness to pose. He (or she) is aware of your intentions of shooting close focus wide angles using him or her as a distant diver, hanging in the blue with the sunburst behind. The soft corals will make an excellent foreground subject and, if equipped with a small torch, you will be able to ascertain their true colour before taking any shots.

If possible, swim into the sun looking for a good specimen in such a location that you can compose accurately and comfortably. You find what you are after, growing vertically from a coral head. Signal your buddy and allow them to view the scene through the viewfinder to give them an indication of what you are trying to capture. Take a light-reading pointing up to the surface, not directly into the sun but to one side as it may give an unreliable reading. *f*11 at 1/90 s is shown. Set your aperture to *f*11; check the shutter speed is at 'A' and set your focus so that the depth of field indicators take in the close distance of the foreground subject. Signal to your diver to fin out below the sun shafts and into the blue water. The soft coral is no more than 0.3 m in front of the lens so parallax correction is paramount. Compose and consider a vertical format which lends itself to this type of image and so many others.

Your diver swims through the scene and, holding your flash no more than 0.6 m away from the foreground subject at 45 degrees to minimise any backscatter, get below the subject. Compose your subject, correct for parallax and shoot.

If the scene looks good then bracket your aperture between *f*11 and *f*22 and also bracket your flash to subject distances and flash angles. Indicate to your buddy to swim through the scene again at whatever depth and position you wish.

The result should be a sharp, colourful, vibrant soft coral with a diver silhouetted and suspended in blue space. Remember, the lens you choose for this type of shot must be capable of very close focusing. A 35 mm or 28 mm Nikonos lens will not work in this way.

Ten tips on viewfinding

1. Compose and shoot only when a scene looks good through the viewfinder. Avoid trusting just your eyes – it's the reason your pictures will look so distant!
2. Always consider parallax problems at distances closer than 1 m. Adopt a method of correction which suits your style of photography.
3. Consider masking the area of the viewfinder which may hinder your composition and concentration.

4. With experience, you can learn to accurately 'shoot from the hip', guessing the angle of coverage of a wide-angle lens and shooting without looking through the viewfinder. This technique is invaluable should an opportunity arise where cameras and diver cannot fit into the same space, i.e. a small cave.

5. Evaluate your wide-angle results. Always consider that your viewfinder technique may be to blame for mistakes you have made.

Close focus wide angle

6. Know the capability and accuracy of your equipment, i.e. light meter, flash, etc.

7. Ensure the lens is capable of doing the job. A 28 mm lens is not wide enough.

8. Shoot upwards towards the surface using small apertures for the greatest depth of field.

9. Bracket both apertures and flash-to-subject distances.

10. Remember the potential problems of parallax.

The TC System

Just what do competent, successful underwater photographers think about when they take pictures? Exactly how do they approach their subject and how do they translate and co-ordinate what's in their mind's eye onto film? What considerations do they give to their work at the time? These and other questions prompted me into a piece of research that has lasted since 1985 and will continue indefinitely. The result, and a way to explain my opinion, is the TC system.

The TC system, for want of a better name, is a system or structure to be considered in sequence when taking a photograph under water. It is a system documented by myself after countless hours and numerous questions about how I approach my own underwater photography and how other respected underwater photographers do the same.

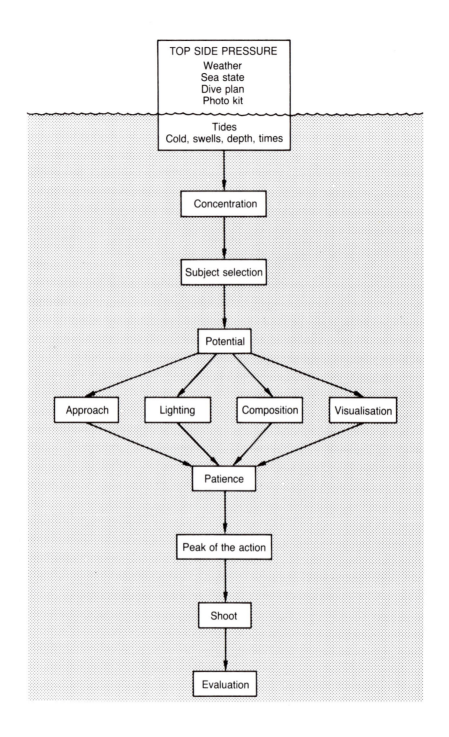

How to Use the TC System

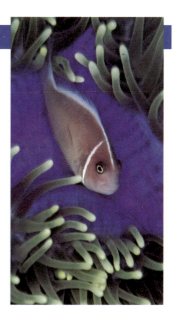

Study each feature until you are conversant with it. They are all important. Memorise them and, when taking pictures under water, apply the features you feel appropriate to that particular shot. Consider them before you press the shutter!

At first you will have little experience to draw on, but as you get a few rolls of film under your belt, your knowledge and perception will increase. Composition will be easier to understand, lighting errors will be rectified and your work, without doubt, will improve.

The really vital maxim that I cannot emphasise enough is:

Think and consider before you shoot.

Now let's take a look at the features in detail.

Pressures or distractions and their effects on concentration

I received a letter from an underwater photographer whose problems were directly related to the subject of concentration, or in his particular case, a complete lack of it.

'My technical ability is very sound. I'm keen and enthusiastic and I have an imagination full of ideas that I wish to try. When I get into the water however my mind seems to cease functioning in a photographic sense. All my ideas disappear and I have great difficulty in concentrating.

My question to you is – Is this normal or am I doing something fundamentally wrong? Have you any tips that will help my powers of concentration whilst under water? Your advice would be helpful'.

Everyone can certainly relate to the problem. Every diver who has ever taken a camera under water has experienced this inability to concentrate. You enter the water with a mind full of ideas which seem to float away as soon as the water is above you. Simple technical information is forgotten and the last thought in your head is taking photographs. Indeed, many experienced divers and underwater photographers also have this inability to concentrate on their photography whilst under water.

The generally held opinion is that it is caused by the transition from the comfort and security of dry land to the often cold and hostile environment of the underwater world.

A whole range of pressures

Everyone has experienced the pressures that relate to the sport of diving. For the novice-diver it is a nervousness, coloured with an excited but apprehensive desire to 'go below'.

On land the sea-state, the cold, the thought of a bumpy boat ride out to the site, will all occupy your thoughts. This regularly accounts for the reasons why cameras are often left behind before the boat has even left the harbour.

During journeys to dive-sites in a hard boat or inflatable, sea-sickness, rough seas or perhaps the prospect of diving with an unfamiliar dive buddy will also occupy your mind. Then during the dive itself you constantly have to consider overall safety, the safety of your buddy, your depth, your no-stop time, your air consumption. You may be holding an SMB (surface marker buoy). Perhaps it's a drift dive in a 1–2 K current. Your buddy may be a novice. Are you cold? Is your diving equipment comfortable? Masks that leak or mist up, fins that are too tight, weightbelts that have slipped round, all manner of things are on your mind. Of course there will be other diving occasions and situations where everything is going well and you can relax into enjoying the dive.

So how much concentration can you give to the task of taking a camera and flash under water, manipulating the controls and actually taking a picture?

Quite rightly in some situations photography will come low in the order of our physiological needs and priorities. Very few could abandon these priorities for the sake of taking good underwater photographs.

So minimising the pressures in every way – by diving with a familiar buddy, by being fully familiar with your equipment, for instance – are all keys to successful concentration before you even enter the water.

8

Concentration

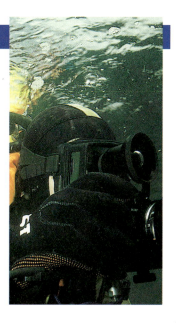

Some people's powers of concentration are better than others, and for some people, distractions can make the simple, every-day tasks of reading a newspaper, watching TV or listening to a conversation, difficult.

Wherever you may be, certain elements of your surroundings are 'distractions'. On land it might be noise from a motor car, a baby crying, or a telephone ringing. All these distractions hinder the ability to concentrate.

Lessen the distractors

As soon as you make the transition under water, numerous other things become 'distractions' – cold, currents, equipment reliability, fatigue, depth, decompression, orientation, the reliability of your newly purchased underwater camera equipment.

On your next sea dive consider things that are your distractions or that may be preoccupying your thoughts. Scale them from 1–10 on how seriously they are affecting your ability to think of non-diving-related matters.

In order to increase your ability to concentrate first identify your own personal distractions on particular dives. Personally, my depth in relation to my no-stop and my air consumption dominates my thoughts.

Once this has been achieved, you should consider how you can minimise the particular distractions.

Safe and shallow – less distraction

A personal viewpoint

I often take my best pictures while diving in a safe and shallow environment, less than 15 m deep. I try to dive at such times when tides, currents and swells are reduced to an absolute minimum. My regular buddy shares my attitudes. We are able to dive together, but in such a way that allows us to place less emphasis on each other's immediate well being and more on our photographic aims.

Other ways to avoid distraction

When boat diving I try to descend via a shot or anchor line and to make sure I know the location of the line when I'm ready to come up – particularly in situations where visibility is poor. Finning is kept to a minimum as camera equipment can create a drag effect. I very rarely take a camera while holding an SMB. I never ever take a camera when diving with a novice. In warm, clear tropical water the first 15 m are the most productive in every respect. The dive boat can often be seen suspended on the surface above. On shore dives secure a safe entry/exit point and make yourself familiar with the site. In any diving situation rely on an accurate compass to make certain of your orientation.

Try to take account of as many of these conditions as possible. Then when taking pictures you can feel much safer and more contented with the knowledge that the numerous distractions and preoccupations that would normally inhibit concentration have been reduced to a minimum.

If you find yourself with a camera diving deep with little time in which to concentrate, then take photographs by all means. But subjectively evaluate your results and appreciate the odds that might have been stacked against you if you do not obtain the quality of images you want.

The ability to concentrate is key to each and every feature of the TC system. It should be the foundation on which every other skill is developed!

Subject Selection and Potential

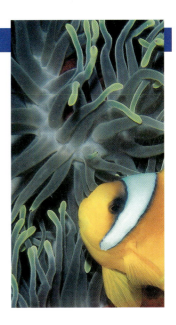

Selecting the right subject is one of the most important aspects of good underwater photography, but it is also one of the most neglected because it is seen to be a difficult concept to explain. This is perhaps the reason that it has so often been avoided in the past.

This part of the TC system is best described as *vision* – an individual's perception of the underwater world.

Basking sharks, manta rays and dolphins are an inspiration to everyone, especially when they appear in front of the camera. There is never any hesitation in taking advantage of the opportunity to photograph them. However, consider the more mundane, ordinary, everyday type of subject, depicted in many of the photographs you see and admire in magazines, books and journals. How does the photographer make those subjects so special?

The answer lies in how the particular subject is selected and singled out as having the potential to make a good photograph.

The subject must be one that will photograph well and be situated in such a way that it can be approached by the photographer with relative ease. Boulders, parts of wreckage and so on can all, on occasions, stop you from settling down comfortably to photograph a subject. You might make the most of the situation but it is far from ideal.

At other times, the location is adequate but the subject is hidden in a crevice of a reef or rock formation and there is no position to place the flash gun. The compromise is to place the

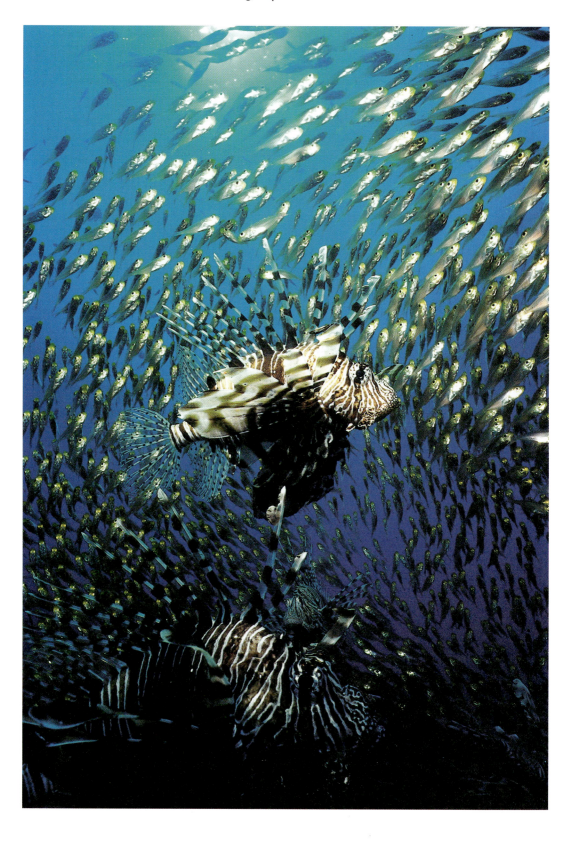

Figure 9.1 (opposite page)
Lion fish are one of the most photogenic subjects to be found. They can strike the most wonderful pose and I never pass up the opportunity to photograph them. The 'Pinnacle' reef in Eilat, Israel, is home to about 25 to 30 lion fish. They feed on a reasonable-sized shoal of glassy sweepers. Many times during the day they can be found swimming in blue water as far as 2 m out from the wall. This shot is one of many that depicts the relationship between the predator and its prey. I shot at least 4 rolls of film looking for that magic moment when everything came together! Nikon F801s. Nikon 20 mm lens. Sea & Sea YS 50 TTL flash gun $f8$ at 1/250 s to stop the movement of the glassy sweepers. Ektachrome Elite 100 ASA. In situations such as this I often find that autofocus is unreliable. I switched to manual and used the depth of field of the lens to achieve sharp focus from front to back.

light in the only space available. Sometimes it works, but at other times you might not be so lucky. Then there is the familiar scenario of having a gap just big enough to place a camera, but composition is thrown to the wind because you cannot move the camera in any way.

So do not leave your choice of subject to chance.

Select a particular subject that is situated in such a position that it allows numerous options in which to *light* and *compose* it.

Choose a subject that has good negative space, perhaps growing proud of a rock or reef, so that you can use an upward camera angle to separate it from an otherwise cluttered background. Pick a subject that you can contrast against a different coloured background. A green-coloured football on green grass would almost certainly lack impact and interest. However, replace it with a red football, and you can visualise how the subject (the football) begins to stand out.

Look around and train your eye to select subjects that fit the criteria you require – ease of access, growing proud, for instance – in other words in such a position that you can make even a mundane subject special! Don't pick the first specimen you see. Give yourself time to examine the dive site and choose the strongest feature. On one dive it may be sea urchins, another it may be anemones. Select a specimen that is the correct size for the extension tube or close-up framer – don't settle for second-best or the 'that will do' syndrome.

Consider your subject potential

Once you have found your subject you must consider its potential. How many shots will you take – one, ten, thirty-six? Just how good is it? Has it got the potential for making an outstanding image? Or is the subject worth no more than two shots, in which case, is it worth taking at all? Only the photographer can make the decision of how many to take and when to move on.

There are no hard and fast rules to subject selection. With experience and practice you increase your ability to 'see' underwater. In time you develop an awareness of a photogenic subject and instinct tells you that it is worth spending time and film on. Remember, a particular photo in a book or magazine is perhaps the product of several rolls of film and a fair degree of time and effort on the part of the underwater photographer.

Using this feature in the TC system

In summary, every time you intend to take underwater photographs consciously consider the subject you select and

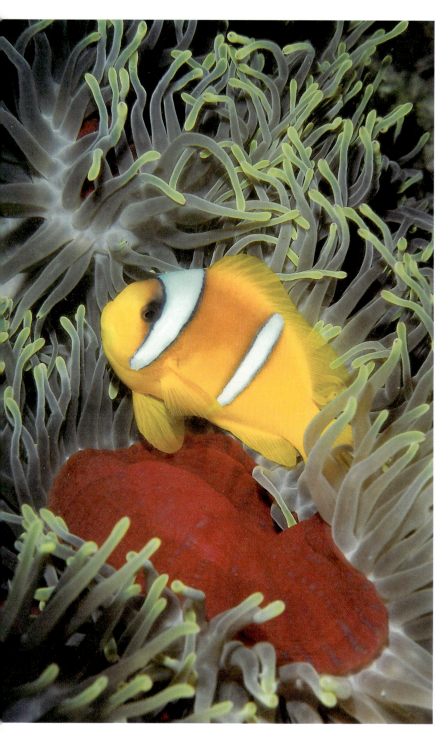

Figure 9.2

This image was taken at Anemone City, Ras Mohammed in the Red Sea. The water was a pea green colour and visibility was no more than 5 metres. The great potential of this site was the number of anemones that have a vivid crimson skirt. If the picture does not contain the bright red colour then the result will most likely be a mediocre shot of clown fish and anemone which could have been taken on any dive at any time in the Red Sea. I cannot emphasise enough the potential of the anemone! I selected a large anemone that was located on the edge of the reef in about 17 metres. A gentle current was fanning the tentacles to reveal its skirt. I intended to compose an area of good negative space 'the crimson skirt' and wait for a clown fish to swim into it. I took twenty shots on this one idea. At least fifteen shots were flawed due to uninvited domino fish appearing in the frame or tentacles obscuring the view of the fish. Four shots worked well and the finished image was very encouraging. It all looks so easy and peaceful, full of colour, well lit, eye catching, however, I needed every one of those twenty frames to realise the potential.

Nikon F801s in a Subal housing, 60 mm AF Nikon lens, twin lighting, Nikon SB 24 in a Cullimore housing and an Ikelite MS slave. Film stock was Elite 50 ASA.

Figure 9.3

During 1987 I spent many hours beneath the shallow waters of Swanage Pier near my home in Dorset. I was photographing a small fish called the tompot blenny. They had made their homes in pieces of pipe in no more than 3 metres of water. The pipe had excellent negative space around it. It was accessible, the diving was safe, shallow and virtually unlimited. I took many rolls of film by virtue of the excellent potential which I considered would produce images which would last for a lifetime. Many of those images were published and won critical acclaim. However my philosophy of capturing eye contact between the subject and the viewer was criticised by an eminent natural history photographer who commented that strong eye contact could often be confused with the fish appearing 'stressed-out' by the underwater photographer's actions. I set myself a challenge to capture the same species but in a different way. I returned to the very same spot one year later and exploited the excellent potential by portraying the tompot in a strong vertical profile. I sought the very same piece of pipe and located the resident tompot. Over a two day-eight roll period I captured this image. The moral of the story is simply the definitive potential which this site offered in relation to this particular subject. Never before, or since, have I observed the tompot in a better location for obtaining a quality image.

Nikon F2, 55 mm Micro Nikkor lens in a Oceanic Hydra housing. Two manual Ikelite MS flash guns with EO connectors. Kodachrome 64 ASA. Most probably set at f16 at 1/60 s. A magical combination for macro subjects!

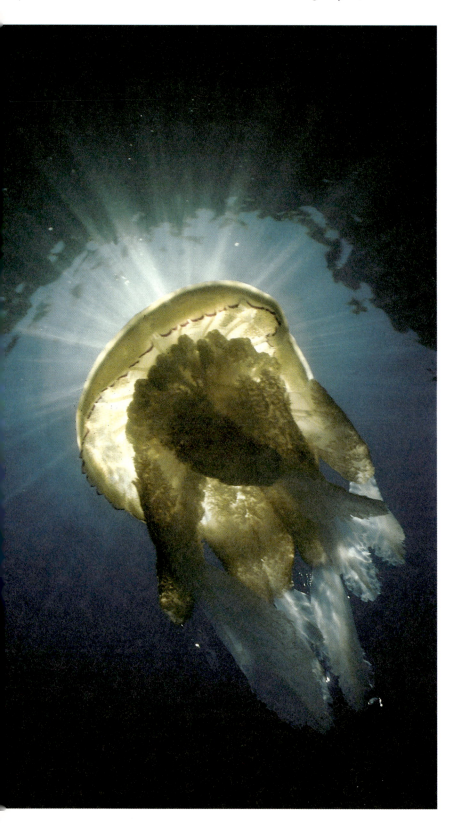

Figure 9.4
One of my all-time favourites. This jellyfish was taken with a Nikonos 111, 15 mm wide-angle lens *f*22 on 1/125 s in natural light on Ektachrome 64 ASA. I did not use a flash. The jellyfish had been stranded in a huge two metre deep rock-pool in Cornwall, England. I was able to stand on the bottom of the pool and snorkel. The potential was amazing. I had always been used to finning furiously in the past in order to photograph jellyfish in the open sea. My buddy Bob Wrobel and I each shot a roll of film before returning the jellyfish into the sea via a small submerged archway. Note the arc of 'Snell's window' and the dramatic effect of sunlight in only inches of water recorded at a shutter speed of 1/125 s.

Figures 9.5, 9.6
You can just about make out the
appearance of a very white and
cluttered cuttle fish lying on sand
and rocks in no more than 1 metre
of water beside the pier on the
island of Sipadan. Consider its
potential for a moment. How many
would you take if you found it in
this position. One, two? If you had
taken many pictures of cuttle fish in
the past I suggest you may not
bother. You have subconsciously
considered its potential and rejected
the opportunity. I did the same (but
took one to illustrate a teaching
point). I too considered its potential
in the location it was positioned as
very low. However I could see a
group of divers entering the water
and putting their fins on. I
considered that if they spooked the
cuttle fish it would rise up off the
bottom and hover in the shallow
water column. How would that
affect the potential? I waited, set
f16 on the 60 mm macro lens, set
my flash guns up. Hugged the
bottom, pointed upwards, anticipated
and waited. The divers did spook it.
It rose up and hovered in the water
column. I popped two shots before it
disappeared. The f16 aperture had
recorded the late afternoon light as
a black background and I got a
cuttle fish shot which pleased me.
Not stunning but worth keeping.
Within a second the potential had
risen significantly. All I had done
was to think about it and consider it
at the time.
Nikon F801s 60 macro lens in a
Subal housing. Twin Sea & Sea YS
50 TTL flash guns set to TTL.

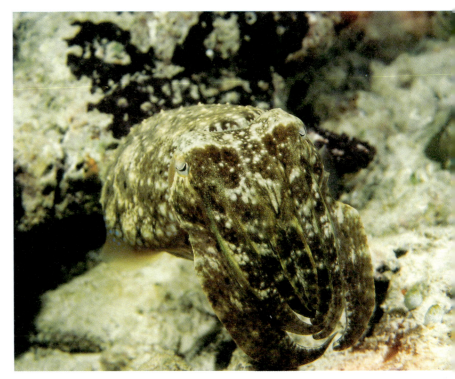

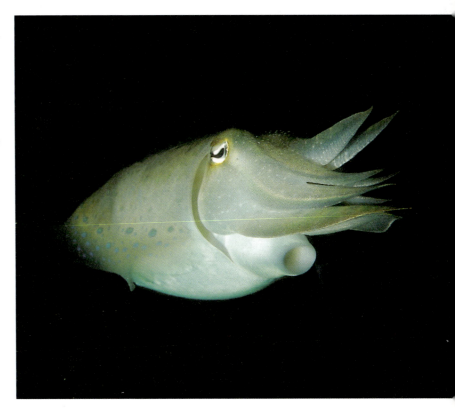

the potential of that subject. Consider it in sequence and continue to evaluate it throughout. An otherwise outstandingly photogenic sea anemone could close up at any time during your preparation. Its potential has decreased. Does this alter your intentions? Only you can decide.

An exercise to increase your ability to 'see'

Choose a subject to photograph. It should be something that interests you. Once you have made your choice, take 36 different pictures of that subject. Vary the camera angle, the composition, the distance, and every other facet of the picture that you can. The first five to ten shots will pass quickly. However, as you progress through your roll of film, you will find that each shot takes a lot more time. Every time you press the shutter you should try to see something different about the shot. When you process your film you will be surprised at the extent of your creativity.

Analyse the potential of other photographs

Scour books and magazines for photographs. With the underwater shots you like, try to analyse the potential of the shot. What things have made it special? Try to put yourself in the mind of the photographer – why pick that particular subject or specimen on that particular dive site? Would you anticipate the subject being in profusion, or one-off? Is it the behaviour of the subject that has created the potential, or simply the position in which it is situated? Try to relate the evaluation of photos you admire to the way you yourself 'see' when under water.

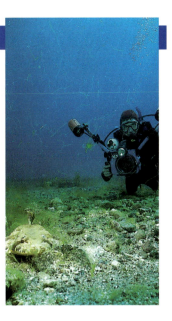

10

Approach

A personal experience

As a very inexperienced but enthusiastic underwater photographer I once left a crocodile fish on a Red Sea reef very much worse for wear! It was lying motionless on the sand when I first saw it. Using a Nikonos III with a wide-angle adapter and an Oceanic 2003 manual flash gun on a long Oceanic arm. I swam in, landed in front of its mouth and could hardly believe my luck when it never moved.

I'd reduced the visibility around me to less than a metre by my clumsy descent, but that didn't matter; everyone caused backscatter, it was the norm – or so I thought in those days.

Remembering the tips from the photo books, I went to work, taking the flash off the camera tray. That was the last I saw of my subject! I pulled the arm from the tray. That was when the tray and the ball joint arm buckled, causing my flash to land firmly on the head of the crocodile fish.

The moral of this story is think and consider before you approach. Now read on. . .

Approach – physically reaching your subject

The word 'approach' as a feature within the TC system is best defined as 'the physical means of reaching a subject'.

Very often you first observe fish and various other subjects from quite a distance away. Depending on the particular subject and, of course, its potential, a decision is then made on whether to photograph it or not.

A fish that is conveniently sitting on a rock and known to be timid should be approached with much more stealth than a still-life subject. This seems to be stating the obvious but it is the main consideration for approaching any subject.

Look at less-obvious considerations

Your first priority is to consider the format of shot that you want from the potential subject. Does it lend itself to the vertical (portrait) or to the more usual horizontal (landscape)? Secondly, do you anticipate hand-holding your flash gun(s) or keeping it fixed to the camera? These decisions need to be made before you move in.

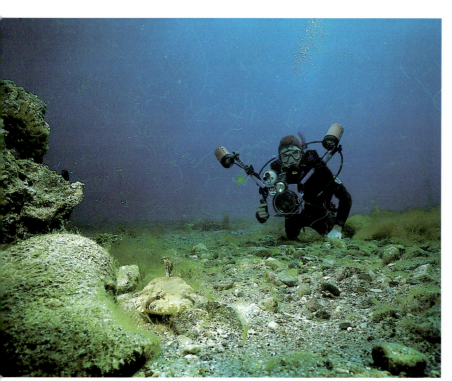

Figure 10.1
The photographer has seen his subject from the rear.

Figure 10.2
By considering the 'angle of approach' I have achieved a better camera angle on the crocodile fish. Everything was set up before I 'approached'. I had visualised the image that I wanted to obtain. If a creature stays around a little longer then be creative and attempt to shift your angle of view; however, appreciate that on many occasions movement of this nature will almost certainly disturb it! Nikon F2 camera 55 mm micro Nikkor lens in an Oceanic housing. Oceanic 2003 flash on half power. f11 at 1/60 s shutter speed. Ektachrome 64 ASA. Red Sea.

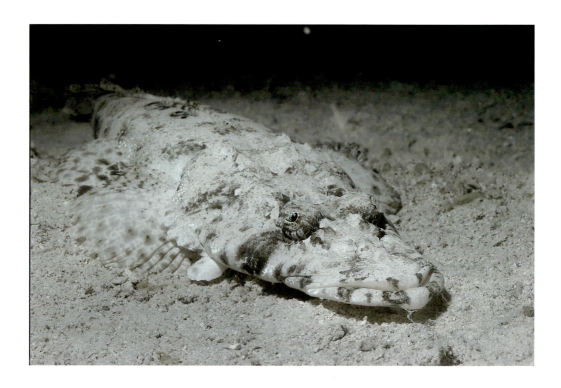

So many opportunities are missed when trying to work out the format of the shot and adjusting and readjusting flash guns and flash arms too near to the subject. It's either spooked and swims away or making the adjustments causes so much backscatter around the subject that the shot is disappointing.

Backscatter is a prime consideration and must never be underestimated. Whenever possible, approach the subject against or across the tide. In this case any particles disturbed by your approach will be carried away in the opposite direction.

Always remember to make a slow, methodical, tidy *approach* with as little disturbance to the surrounding area as possible.

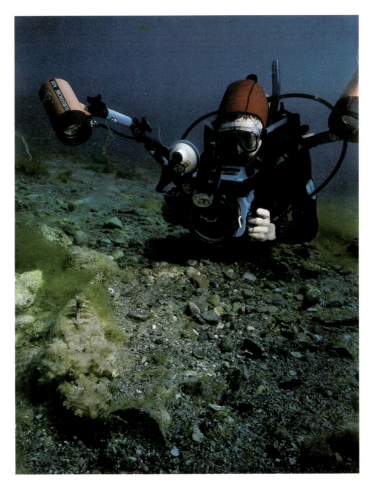

Figure 10.3
Instead of moving around to the front of the subject, perhaps because of excitement and enthusiasm he has 'approached' and found himself behind it. Unless that is the image required, he needs to move to the front. However, movement of this nature is likely to 'spook' it.

Figure 10.4
The approach feature of TC was of paramount importance in achieving this image. I approached to within 15–20 cm of this blue spotted stingray. So gradual and patient was my approach it took 10 minutes. I began on the line that I knew what would be compositionally pleasing. I did not approach from the side or behind. I kept pressing the shutter as I got closer and closer. I composed the eyes diagonally across the frame. Spotted stingrays are nothing new in underwater photography; however, when you get this close to its features the potential increases ten fold. So, how many frames should you use? That one is up to you. For me, I used the whole roll. Nikon F801s. Nikon 60 mm macro f16 at 1/125 s. Ektachrome Elite 100 ASA. Red Sea.

Buoyancy control is rather a cliché in underwater photography books and magazines, so much so that it is often discounted. However, good control is a tremendous asset and when it is used correctly can put you in close proximity to an otherwise timid subject.

In selecting a subject there are numerous angles from which to approach it. Always look for the most suitable place from which to photograph. Consider the terrain. Make sure distractions to your concentration are minimised. Check yourself, your buddy and your dive time before you move in. Look at the direction in which the subject is facing. A stingray resting on the sandy bottom will only allow you one chance of *approach*, for instance.

If you move in to discover you are at the tail end of the creature, you could have problems shifting your position to obtain the best close-up shot. You also increase the likelihood once again of disturbing the sand and causing backscatter.

There are numerous photogenic subjects that can be enticed into more favourable positions. A resident scorpion fish, for example, can often be persuaded to occupy suitable areas of 'negative space'.

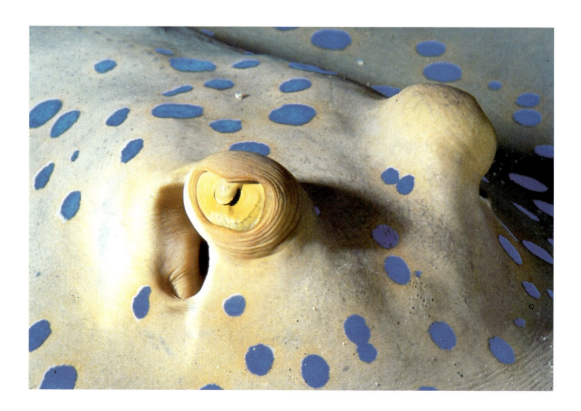

Consider, too if your subject can be moved by you in any way. Many people have a strong moral obligation to photograph a subject where it sits, irrespective of its photogenic qualities. However, many accomplished professional photographers manoeuvre subjects around. But whatever you do it is absolutely essential that your subject is not distressed or harmed in any way.

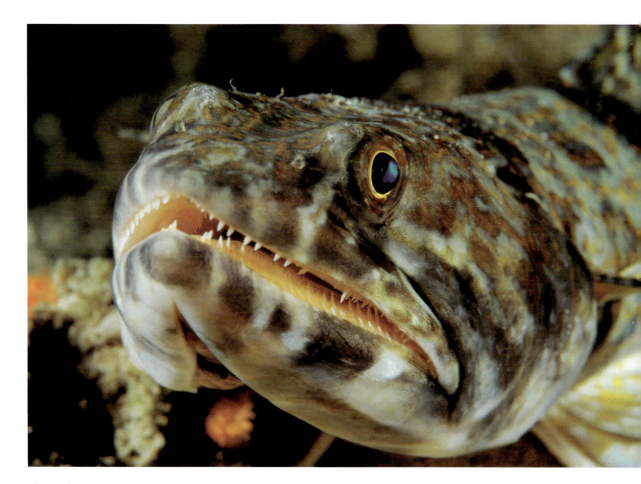

Figure 10.5

During a recent trip to the island of Bonaire I became immediately attracted to the photogenic lizard fish or Sandiver as the locals call them. My experience with the Red Sea variety has taught me to approach them very slowly to avoid spooking them. I was intent on capturing their bright yellow markings. I positioned my twin flash guns above the camera at an angle of 45 degrees. I selected f16 at 1/90 s and chose a specimen resting on the sand. There were numerous to choose from but one in particular caught my eye by virtue of its accessibility, being surrounded by sand and not the reef. I moved in slowly and began to press the shutter when its entire body was filling the frame. I got closer to the head and was delighted that it was allowing me such a close opportunity. My movements were kept to an absolute minimum. I dared not alter my flash arms so close to it. I took about eight shots in total.

The following day I dived beneath Town Pier and realised that these fish were tame and easy to photograph.

Techniques of approach were easy and on occasions we had to encourage them out of the frame whilst shooting other bottom dwellers.

Nikon F90x and 105 mm macro lens on AF. Subal housing. Twin Sea & Sea YS50 TTL flash guns set on TTL. Elite 50 ASA.

Tips on approach

Before approaching closely, consider:

- your buoyancy
- your direction and angle of approach
- the direction of the current
- any backscatter you may cause
- whether you anticipate taking the flash from the camera
- the possible picture format – portrait or landscape

and most importantly

- any effect you might be having on your underwater surroundings.

Figure 10.6
Photographing turtles in Sipadan is relatively easy. However, in 1998 I came upon one which had positioned itself behind a large rock giving the appearance it was 'peeping out' and watching the underwater world go by. Its orientation against the rock was compositionally strong so I decided it would fit into a landscape composition. I positioned my flash guns each side of the housing and selected f11 at 1/90 s. I moved in very slowly, eye glued to the viewfinder and began to press the shutter. It was the position of the turtle peeping out over a ledge which was the 'potential' which I was after. If it shifted its position then all would be lost. I got closer and closer and pressed the shutter when I felt I had the eye contact and rapport between us. I managed just two tight head and shoulder shots before it moved along the ledge and changed its position. The magic was over, I tipped my hat and swam in search of other things.
Nikon F90x 60 mm macro lens on AF. Subal housing with twin S&S YS50 TTL set to TTL. Elite 50 ASA.

Figure 10.7
Many years ago a spear fisherman gave me a piece of advice: 'Approach fish from below, you will get closer to them than descending.' I have always remembered his words and for me his philosophy seems to work. Not every time! But occasionally. This shot is one of my favourites. The Barracuda is George, who once cruised the Sipadan drop off. He would never let anyone get close to him. However, on the last dive of my 1996 trip, with three shots left in the camera I spotted him near to the pier. I set my flash gun for a 1 m distance. Took a meter reading on an area of the under surface and set 1/125 s on shutter priority, knowing the aperture would take care of itself. I moved in from below like my fisherman friend had advised. I got closer and closer. I couldn't believe my luck. He let me approach to within 45 cm and I got two shots off before he disappeared. Both shots worked well, because I was set up, prepared and had **thought and** considered my approach!
Nikon F90x, Subal 16 mm fisheye.

Lighting

The topic of lighting, like composition, can never be complete. Articles, books and papers can be rewritten but there will always be room for development and discussion.

Throughout this book I have purposely presumed many things of the reader, for example, their knowledge of the basic peculiarities of underwater photography when compared to land photography.

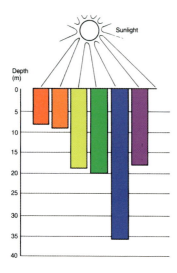

Figure 11.1
The filtration effects of colour according to depth.

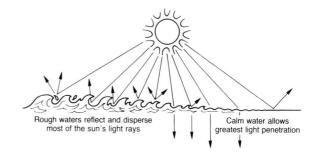

Rough waters reflect and disperse most of the sun's light rays

Calm water allows greatest light penetration

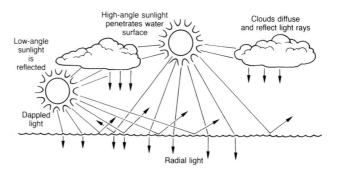

High-angle sunlight penetrates water surface

Clouds diffuse and reflect light rays

Low-angle sunlight is reflected

Dappled light

Radial light

Figure 11.2
The behaviour of ambient/natural light under water.

As the Introduction points out, this book is aimed at those who need more from their photography. It assumes some knowledge of underwater photography, for instance of the filtration effects of colour according to depth, the behaviour of light under water and the problems it creates. You will have some idea of the causes and effects of backscatter (illumination of suspended particles in the water, giving the appearance of 'snow' when illuminated by flash) and the concept of refraction – objects appearing to be 1/3 of their size larger and closer than they actually are.

There are two sources of light under water:

- available light (from the sun)
- artificial light (from the flash gun)

Considering these two sources of light as a feature of the TC system leaves the photographer with various decisions to make.

Available light

The priority in underwater photography is, and always will be, the need to reduce the column of water between lens and subject, whether achieved through wide-angle lenses or adapters, extension tubes, close-up adapters or macro lenses.

Figure 11.3
Right: The concept of 'Refraction'. Below left: Backscatter resulting from the flash being placed too close to the camera. Below right: Minimising the effects of backscatter by correct flash placement.

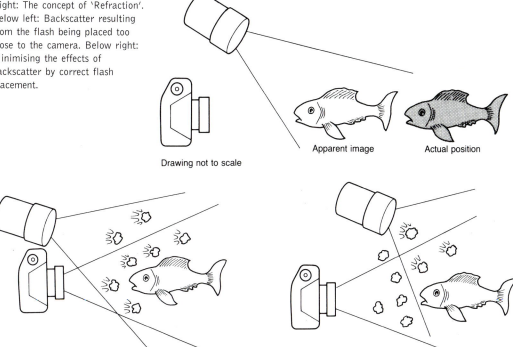

Apparent image Actual position

Drawing not to scale

The number of depth-of-field and aperture options, described in detail in Chapter 3, will usually provide a choice of the colour in which to record the available light or water colour (the exception being night dives). Be it blue in tropical waters or green in more temperate water, there's a choice through apertures of *f*22, *f*16, *f*11, *f*8, *f*5.6, *f*4 to record water colours of black, dark velvet blue, blue, light blue and so on.

Which shade of blue water is better for your subject? It's your decision! Black or dark blue can enhance the impact when combined with a colourful foreground. On the other hand exposing for a blue as seen by the human eye gives depth to your photograph and places a subject in its natural environment.

A natural sunlight exposure will, of course, not always be appropriate when using extension tubes, close-up attachments or Macro lenses on SLR cameras because of a need for small apertures such as *f*22 to increase depth of field, but which results in very dark or black water colour backgrounds.

With housed cameras and macro lenses it is possible to focus on a particular subject at wider apertures, i.e. *f*5.6. However, the point of focus needs to be very selective because of the limited depth of field that wider apertures and the macro lenses create.

Major lighting considerations

Consider the position of the sun in the sky. The time of day, the clarity of water and your depth will all vary and will have different effects on your results.

You need to take into account:

- Whether to shoot towards the direction of the sun to produce a lighter pastel shade of blue or green. If shallow enough you can accentuate the rays of the sun that pierce the water.
- Whether to shoot with the sun at your back and in the opposite direction. This will produce a rich, more intense and darker colour of green or blue.
- Whether to tilt your camera upwards towards the surface to capture the popular 'sunburst' effect.

Sunburst effect

You can choose to record the sunburst as a small pool of white light on *f*22 or increase the size of that pool of light by opening the aperture.

To record the sunburst as you see it through your own eyes take a meter reading to one side of the sunburst and not directly into it.

Dappled light effects

At dawn or dusk the sun is closer to the horizon. The quality of its light changes because of the angle at which the sun's rays enter the water. Dramatic and stunning effects can be achieved at these times of the day. I call this 'dappled light'. However, dappled light requires wide apertures like *f*5.6 or *f*8, since the amount of light that enters the sea at this time of day is greatly reduced.

Radial light

When the surface of the water is flat calm and the sun is quite high in the sky, the sunburst effect has tremendous potential. This is because of the way the rays penetrate the water. There is also not so much light bouncing off the surface of the sea back into the atmosphere, a phenomenon that I call radial light.

Figure 11.4
At a measured depth of 10 m with the sun high in the sky on a cloudless day in the Red Sea. Shooting straight towards the surface and composing the sun in the middle of the frame at *f*22 on 1/60 s using 100 ASA slide film. The purpose of taking a series of reference shots from *f*22 through the apertures to *f*2.5 is a baseline of sunburst exposures on a dive/photo trip. It is an exercise that I insist my students conduct. It illustrates how light and exposure work under water. Notice how as the aperture is opened up, the edges of the picture get lighter and the pool of light that is the sun gets larger.

Figure 11.5
Two stops open at *f*11. Notice that the sunbeams are not as accentuated as the *f*22 exposure.

Figure 11.6
Three stops open at *f*4. The pool of light is too large and overexposed. Bear in mind that this is only 10 m deep; at 20 m a sunburst exposure at *f*4 may be acceptable. All test shots taken with a Nikonos V on 1/90 s manual exposure and a Nikonos 15 mm lens. 100 ASA slide film.

Figure 11.7
When the sun approaches the horizon at the end of the day, the light that enters the water is acute and dramatic. I call this light 'dappled light': the technique is to ascertain the depth that the sunbeams are most dramatic, usually between 1 metre and 5 metres. You simply find a subject to photograph against this outstanding negative space. On this occasion a shoal of bat fish were soaking up the last few minutes of light in a pleasing composition. Work quickly with 'dappled light' as the sun sets rapidly in tropical locations. I took 5 shots on this particular shoal but used a whole roll on the excellent potential of the 'dappled light' and some small reef fish that were scouting beneath the surface. Nikonos RS. 20–35 mm zoom on the 28 mm setting. SB 104 flash gun. f5.6 at 1/125 s. Ektachrome Elite 100.

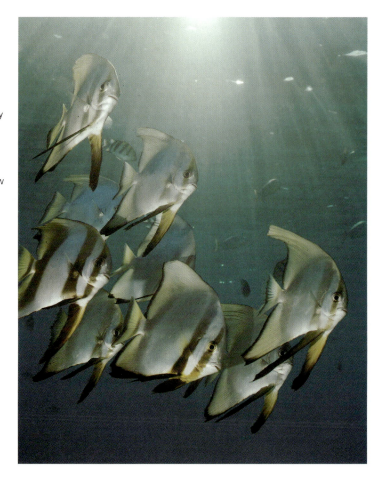

Silhouette

Placing the subject between the lens and the sunburst can produce strong silhouettes. The closer the subject is to the lens the more contrast there is and the stronger (i.e. darker) the silhouette becomes. With a slow film like 100 ASA try bracketing your apertures around f16, i.e. f11 and f22.

Of course, you always have the choice of excluding a sunburst from a picture when shooting towards the surface, by pointing the camera in a different direction or alternatively hiding the sunburst behind a conveniently placed reef or maybe a boat on the surface. If you try to balance the

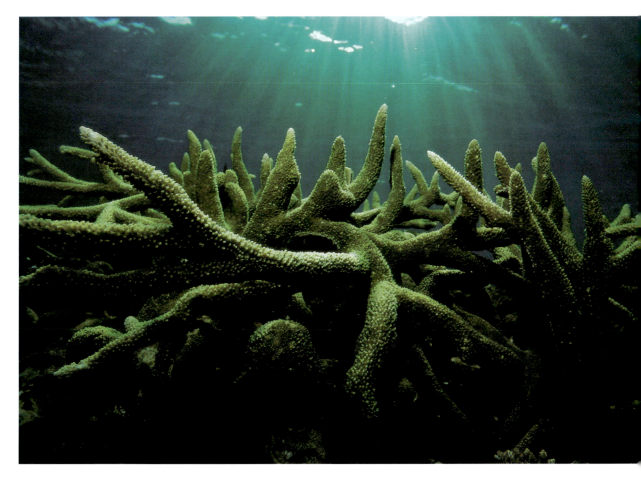

Figure 11.8
This staghorn coral was situated in no more than a few metres of water. The surface was calm and the sun was low in the sky approaching sunset. The corals are captured in natural light. Notice how I have left the sun out of the frame but used the sun-shafts to add a little sparkle without overpowering the staghorn theme.
Nikon F801s 16 mm fisheye lens in Subal housing. *f*8 at 1/60 s using Elite 100 ASA. Natural light.

available light with your flash using apertures around *f*5.6 it may grossly overexpose the sunburst if you decide to frame the sun in your picture (see Chapter 5, Balanced Light). A popular way round this is to keep the sunburst just out of shot but to take advantage of the sun's rays as they streak through the water.

Slow shutter speeds

When light levels are low or when photographing in deeper waters you can still maintain apertures of *f*5.6 or *f*8 by reducing the shutter speed from 1/60 to 1/30 or possibly 1/15 second.

Figure 11.9
The phenomenon known in the UK as 'Snell's window' was labelled after the Dutch mathematician, Willebrod Van Roigen Snell who lived between 1580 and 1626. A professor of maths at Leiden University, he discovered the law of refraction known today as 'Snell's law'. Looking through a wide-angle view finder as you descend, keep your vision directed towards the surface. You will see an 'arc' or, depending on your depth, a half circle, a shade of light and dark tones embossed on the under-surface. This window, arc, circle, call it what you may, is your only visual access to the world above the surface of the sea. Look through the window. If the surface is flat, you may see the sun and clouds in the sky, a boat on the surface, palm trees on the beach. You do not need to be in the sea to recognise this phenomenon; beneath the surface of a swimming pool look up through the window and see your buddy standing on the side. As your eyes glance down, your vision through Snell's window becomes disrupted. I have read many explanations of why this occurs. Here is my explanation, in my own words. The surface of the water is highly reflective both above and below. When you look at the under-surface at a certain angle your vision is reflected back. This means that you cannot see through the window. The critical angle of reflection is any angle less than 48.6 degrees measured from the vertical. Unlike your windows at home, Snell's window is 'circular'. This photo was taken a number of years ago off the coast of Aquaba, Jordan. The day was slightly overcast with clear blue sky interspersed with fluffy white clouds. The surface was flat calm. Returning to the shore towards the end of our dive, my buddy, Bob Wrobel came upon a group of divers photographing a large, inflated puffer fish. It swam towards us just under the surface. I took one shot on f11 at 1/60 s, pointing the camera housing directly up towards the surface as it swam overhead. It was not until I had developed the film that Bob pointed out the dramatic effect that Snell's window had created with a subject of singular shape and colouring. Bob likened the image to a distant planet being orbited by a strange creature. Nikon F2. Nikon 16 mm fisheye lens in an Oceanic Hydra camera housing. Oceanic 2003 flash gun on low power provided fill on the puffer. Film stock was Ektachrome 64 ASA.

Figure 11.10
A further example of how 'Snell's window' can be used to compliment the shapes and forms found beneath the waves. Snell is always more defined when the surface is calm but it is an optical phenomenon and is always present. This silhouette of table coral blends into the arc of the window. It was effective using either portrait or landscape compositional format so I shot both. I metered off the surface which indicated $f16$. I bracketed both aperture ($f11$–$f22$) and shutter speed (1/60 and 1/125) Elite 100 ASA.

In these circumstances the camera or housing has to be held perfectly still or shutter shake will occur. Try bracing the camera against a piece of rock or wreckage. With the Nikonos system use 1/30 s shutter speed or the 'B' setting and hold the shutter open yourself. Some professionals have even been known to use tripods under water to achieve the same result. If you are thinking of trying it then use the technique on a safe site for a specific purpose. Some interesting effects can be obtained.

Figure 11.11
This turtle in silhouette also illustrates what I call 'radial light'. On this occasion the surface of the water off Sipadan beach was mirror smooth. The intensity of light pervading the surface was blinding! I entered the water with the sole intention of shooting turtles in silhouette. I knew that a shutter speed of 1/125 s would accentuate the sun's rays even more. My objective was getting as close as possible to fill the wide-angle viewfinder on my Nikonos 111 camera. I bracketed my exposure with apertures of f22, f16 and f11 around 1/125 s. My film stock was Ektachrome Elite 100 ASA. I left the water on several occasions in order to change film. I shot a total of 4 rolls of film. Some shots suffered from parallax error but I obtained many that pleased me. Working with turtles in this manner I found it much easier to use a Nikonos than an SLR camera in a housing.

Artificial light (flash)

Front lighting

The standard angle of flash illumination adopted by virtually all beginners is to attach the flash to a base plate with an arm or bracket. This provides front lighting from an angle of 45 degrees above and to the left of the camera. Front lighting simulates a sunlit scene as you might see it on land. It's very easy to use your underwater equipment in this set up. However, there are many other lighting techniques that can be applied which will keep backscatter to a minimum and, when used correctly, can enhance the quality of your work.

Top lighting

To light from the top the flash is placed directly above the subject. It creates good contrast and an added sparkle, particularly with light-coloured subjects, that complements the shadowed areas cast at the foot of the subject. Your flash is held at the same distance as with front lighting. This is a very popular angle of light with many of the world's best underwater photographers.

Figure 11.12
Another example of radial light but
on this occasion the sun shafts are
not as well defined as Figure 11.11.
The reason for this is a combination
of the surface (it was not as flat),
the shutter speed (a faster shutter
helps to define the sun shafts) and
the depth (the shallower the better).
I exposed for the sunburst and
bracketed each side of *f*11 at
1/90 s. Notice the simple
compositional orientation of the
colourful feather star and the
sunburst. The two colours also
compliment each other within the
colour circles i.e. blue and yellow.
Nikon F90x 20 mm wide angle. One
S&S flash YS 120 TTL set to TTL
on a long Subal arm system placed
above the housing. Elite 100 ASA.

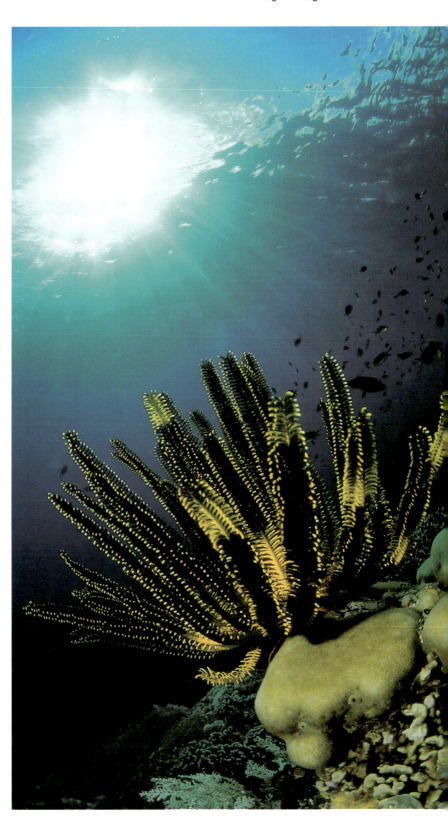

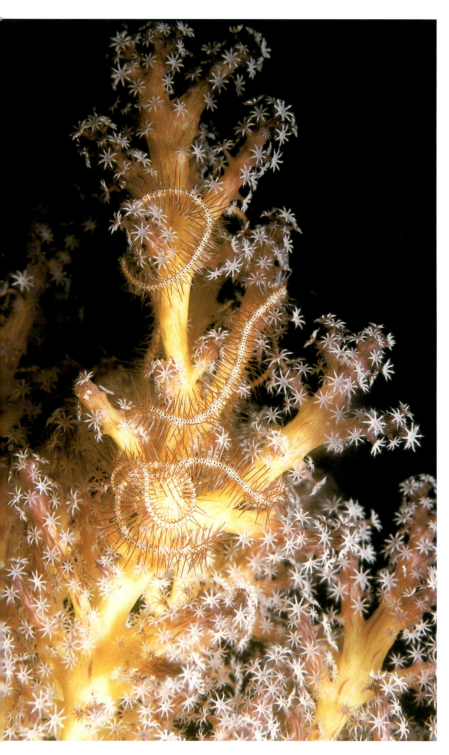

Figure 11.13
Top lighting on this soft coral simulates the effect and direction of the sun above the water as we are conditioned to expect to see shadows below the subject emanating from the sun and clouds. Subject selection was essential. I chose a specimen that could be lit from a variety of angles. The potential is enhanced by the presence of the brittle star. I will use this image in the future as a Christmas greeting card. Nikonos V. SB 103 flash. Nikonos close-up kit with 28 mm lens, *f*22 at 1/90 s. Ektachrome 64 ASA.

Figure 11.14 (opposite page)
I know from experience that the translucent tentacles of cup coral lend themselves to extreme lighting angles, i.e. top light, side light. I selected this particular specimen because it was growing proud of the pillows beneath Town Pier in Bonaire. This allowed me to place my flash gun at virtually any angle of my choice.
Nikon F90x 60 mm macro set to AF. One Sea & Sea YS 50 TTL set to TTL. Flash angle was extreme top lighting, *f*16 at 1/60 s. Elite 50 ASA.

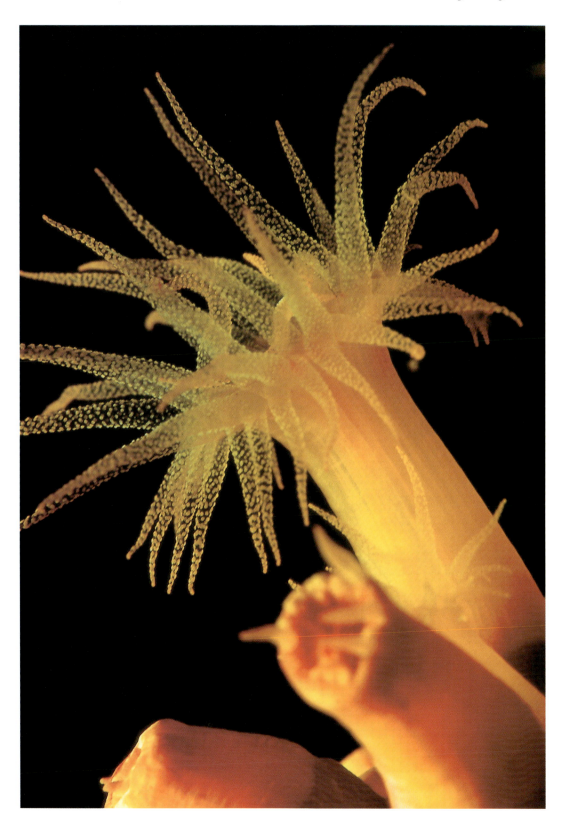

Figure 11.15
The angle of frontal lighting.

Figure 11.16 (right)
The angle of side lighting.

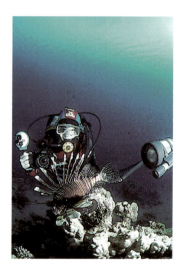

Figure 11.17
The photographer is lighting the subject without thinking of the subject's orientation.

Side lighting

This produces a similar effect to top lighting but, as the title suggests, from the side. Again, it creates a sparkle and also long shadows on the opposite side of the subject.

One must ensure that the side chosen (left or right) will complement the subject and its position. At its worst it can leave 50 per cent of the picture in shadow. It's an excellent choice of lighting angle with translucent subjects such as jellyfish, shrimps and certain soft corals. Once again remember to keep the same distance of flash to subject.

Side light and top light are two of the most popular angles.

Top/side lighting

This combination falls somewhere between the two and aims to produce a similar effect, depending on the shape and texture of the subject.

Many professionals prefer this angle as opposed to extreme side lighting because, once again, it can simulate light from the sun. The shadows appear in the correct place, without disturbing the eye of the viewer. It is also less likely to cast a shadow of the extension tube post or close-up framer. Some solve this problem by turning the extension tube framer on its side with the open end of the framer facing the flash, or alternatively cutting the top frame from the Nikonos close-up kit.

Backlighting

This is sometimes confused with an angle of light that points directly into the lens of the camera. Backlighting is in fact achieved when the flash is held above or to the side of the subject but about 10–15 cm behind it.

It should achieve a 'halo' effect or a rim of light around the edges of the subject. It is very creative and has tremendous impact when used with subjects that have a fine, delicate surface.

Figure 11.18
I was looking for a suitable image that illustrated the technique of back lighting a subject. Taken by my friend Steve Bartholomew, the fire coral is captured in all its glory. The exquisite quality of this type of light was achieved by positioning the flash at the back of the coral, pointing down at 90 degrees to the camera lens. Experiment with different subjects that you think may lend themselves to this acute angle of light. Try to avoid pointing the flash into the lens of the camera unless that is the effect that you want to achieve. Nikon F801S SB 103 flash gun. 60 mm macro lens. Fugi Velvia. Photo by Steve Bartholomew.

However, misjudge your flash position and accidentally angle the flash too much towards the lens of the camera and it will usually result in drastic overexposure at close range.

The lighting of each and every subject should be carefully considered from various angles. A fish placed between a 28 mm frame of the Nikonos Close-Up lens facing from left to right would have a partial portion of its eyes and face in shadow if lit from the left-hand side as is often considered normal practice.

Flash held high from right
Hand-hold the flash in your left hand and always be prepared to bring the flash across your body to light from the right-hand side, if you think the subject needs it! In this way the fish can be illuminated, particularly around its most important feature (i.e. the eyes) which so often form the focal point of fish close ups. Indeed, the way eyes appear on the final print can make the difference between an average and an outstanding shot.

Wide-angle lighting
The flash angles previously described can be used to optimum effect when taking close-focus wide-angle photographs. However, when trying to illuminate a seascape, for instance, it is optimistic to attempt to light it from the extreme side or the top in view of its distance away from the camera, maybe 1.5 m or more.

Figure 11.19
This jellyfish is typical of the scenario laid out on the previous pages. I saw the subject, under the light of my torch, suspended at a depth of 1 m below the surface just offshore at St Abbs, Scotland. A light meter reading against the mid-water background, facing towards a cloudy bright surface, indicated f5.6, 1/60 s (using Fuji Velvia Slide Film-50 ASA).

My first decision was whether I wanted it on a green, dark green or black background. I then had to decide from which angle I would shoot. I chose a dark background and selected f11 bracketing to f16 because I felt it would contrast better with the orange jellyfish. The day was overcast, so I shot towards the brightest area of the surface and this has been recorded in the finished picture.

It was taken using a Nikonos III with 15 m wide-angle lens, a Sekonic light meter and Oceanic 2003 flash on half power on a long 0.6 m Oceanic ball joint arm. The flash angles were bracketed between hand-held side light and top light at a distance of about 0.6 m. I took about 7 shots, all of which were well exposed and sharp. The composition of the picture is better than the other shots. The vertical format was an obvious choice in view of the shape of the jellyfish. Other photographers with me passed the subject without taking any pictures at all. Back on dry land one asked me why I had spent so much time with it and I gave my reasons as its potential in relation to its vivid colour which could be shot against good negative space.

A single wide-angle flash gun can be aimed downwards at an angle of 45 degrees from in front and above the camera. This spreads light evenly across a horizontal (landscape) picture. There is also less chance of getting the flash gun in the shot. Lighting from the side can cause underexposed dark areas on the opposite section of the landscape format. There is also more chance of the flash gun invading the picture. However, try it by all means as it can produce some interesting effects.

When framing a picture in the vertical (portrait) format make a conscious effort to keep the flash out of the top portion of the picture and to continue lighting as before, above and slightly in front of the camera at a downward angle of 45 degrees. If your

Figure 11.20
The following three pictures were taken to show the way that ambient and artificial light behave under water. They were all taken at a measured depth of 9 m beneath Moses Rock in Eilat using a Nikonos V, a 15 mm wide-angle lens and an SB 103 flash gun on TTL. The Nikonos V was set to 'A' (automatic). Film stock was Ektachrome 100 ASA. At f16 the water colour is dark blue. At f22 it was black. The flash was held about half a metre from the soft coral and TTL has correctly painted in the colour.

Figure 11.21
At f8 the blue water has become lighter. The soft coral exposure is maintained because TTL is coping with the situation well.

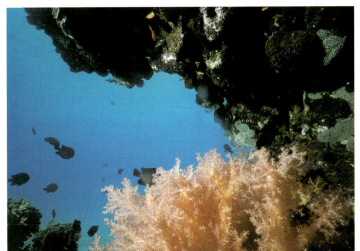

Figure 11.22
At f4 the blue water has become even lighter, some would say (including myself), too light. Notice how the soft coral is a little overexposed. This is because the TTL flash was too close to 'quench the light' given the large aperture. At 0.5 m the flash had difficulty coping with being that close, even on TTL. I should have taken the flash back to about 1 metre from the subject.

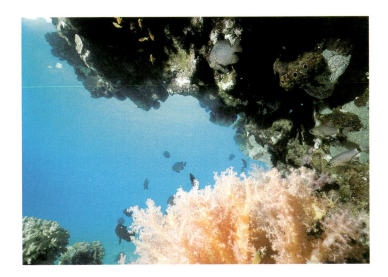

subject is 1.5 m or less from your lens, experiment with all angles of light. These techniques are only guidelines to enhance your creativity. Bracket your flash-to-subject distances, but remember TC – Think and Consider – How shall I light this subject? Then consider it again before your approach!

An exercise

Practise lighting angles in a swimming pool, particularly with close-up subjects. Use plastic flowers attached to a lead weight, a small colourful children's cuddly toy or, for a little more realism, wooden painted fish.

Try all the different lighting angles you can – think of hand-holding your flash gun and practise this as an essential technique.

When you process your results, examine any ones that you like from a lighting point of view, then go back into the pool and attempt to achieve the same successful effect.

All this practice will result in you making a choice of subject in the sea and thinking, for instance, how good it will look with top lighting. This is because you have taken time out to see your intended result in your mind's eye. Apply the lessons and experience you gain from your pool practice sessions.

Ten tips on lighting

1. Shallow water gives highest light levels.
2. In low light levels consider slow shutter speeds (i.e. 1/30 or 1/15 s).
3. Use upward camera angles to where light levels are higher.
4. Hand-hold your flash gun whenever possible.
5. Invest in a light meter (even if you use a Nikonos V camera).
6. Bracket apertures and flash-to-subject distances to ensure correct exposure.
7. Experiment with different flash angles but remember to consider the orientation of your subject.
8. Flash guns can disturb and damage corals. Be aware of the environment.
9. Learn and practise alternative sunburst effects.
10. Aim your flash so that the water between the camera and subject receives minimal illumination.

Composition

Some time ago another keen underwater photographer and I were discussing prints on display at a national underwater photographic competition. The subject of composition arose and I asked his view on one particular photograph. 'I never bother with all that stuff underwater, I've got too much to think about with *f*-stops and backscatter to worry about imaginary thirds and the like.' His own work was competent, so how did he tackle the subject? 'When I get my film processed I examine the results and throw the badly composed ones out.' He understood composition but for his own reasons chose not to consider it at the time of taking the photograph. Whether this attitude is right or wrong, good or bad, is a matter of opinion.

I have also quizzed all kinds of people of various abilities on their outlook on the subject of composition. The question which I always put to them is: 'What thought do you give to composing a picture under water before you press the shutter?' Perhaps the most common answer is: 'To arrange the elements until they look pleasing.'

Many people also refer to thinking about which picture format to use – portrait or the more common landscape. But more often than not, although the subject of composition is understood, for some reason it is not considered at the time of taking underwater pictures. Perhaps this is to do with concentration, or the lack of it – one of the key elements of the TC system.

The TC system was developed from questions and conversations such as these. Many accomplished underwater photographers were able to explain their own preferred techniques but

not able to give clear explanations or systems for how they arrived at them.

However, it seems that the more successful underwater photographers do consider many compositional elements at the time of taking the photograph under water.

These are in no particular order or priority.

The picture format

From the very first time you pick up a 35 mm camera you become conditioned to view a scene through the viewfinder either horizontally (landscape) or vertically (portrait). To begin to arrange and compose the elements of a photograph competently we must consider the format – vertical or horizontal – to decide which is the most pleasing.

To make this decision look at the orientation of the elements. They usually lend themselves better to one format or the other. If in doubt, shoot both ways.

Figure 12.1
A slight movement of the turtle's head shifted the composition from a landscape to a portrait picture format. Note how the turtle is 'head up' sitting proud and dignified in the frame. The diagonal orientation was achieved by a slight tilt of the camera housing. When in doubt shoot both vertical and horizontal format. Nikon F801s. 60 mm lens. SB 24 flash gun. *f*11 at 1/60 s shutter speed. Ektachrome Elite 50 ASA.

The diagonal line (see Chapter 27, Abstract Images)

Vertical and horizontal lines under water can often cut a picture in half, making it look very unnatural. However, the diagonal line is dynamic and takes you into the picture, so adding depth. The diagonal is present in so many published underwater photographs, whether the format is landscape (horizontal) or portrait (vertical). It can be 'Snell's window' arcing from left to right in a smooth curve, the line of a boat floating on the surface, the directional lines on anemone tentacles, or the position of a jellyfish, starfish or a reef wall. The repeated diagonal theme of coral formation keeps the eye moving across the image. The diagonal line is most useful when photographing wrecks, where a sense of depth is achieved so easily. The diagonal can be used subtly when no obvious composition tool is present.

a

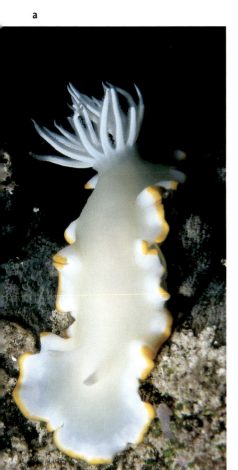

Figure 12.2a and b
As this 10 cm long Nudibranch moved along a small area of reef so did the compositional format alternate between (Figure 12.2a) portrait and (Figure 12.2b) landscape. It is essential that your camera rig is configured to cope with instant alternations of format. This is one reason I use the popular bendy arm flash system for macro and close-up photography. It's easy to position it whichever format you have chosen. Nikon F90x, 60 mm macro lens on AF Subal housing. Twin Sea & Sea YS 50 TTL set on TTL. f16 at 1/60 s, Elite 50 ASA.

b

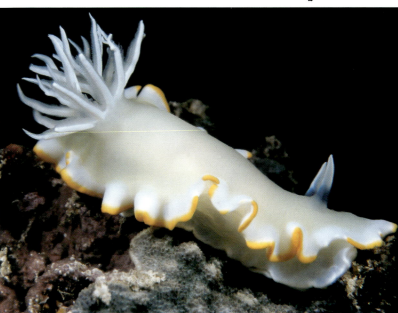

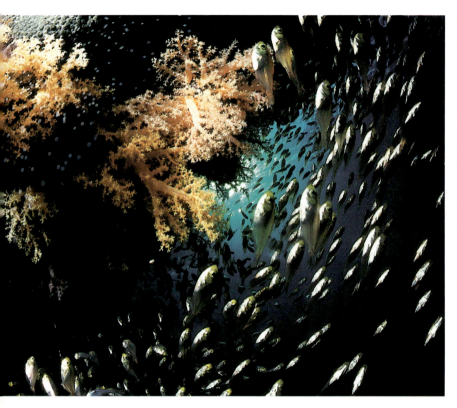

Figure 12.3
Extreme close-up using a Nikonos 111 and 15 mm wide-angle lens on its closest focusing distance of 22 cm. I recorded the sunburst at *f*22 at 1/60 s. I diagonally orientated the reef wall composing the sunburst behind it. Parallax was not a problem for the wall as it was situated about 1 m from the lens. The copper sweepers were only a few centimetres in front of the lens so the viewfinder could not be relied on to accurately compose them. I took about 10 shots of the fish sweeping backwards and forwards. Their formation and feeling of movement (peak of the action) have made this image superior to the others. Ektachrome 64 ASA. Eilat, Israel.

The law of thirds (or golden mean)

The law of thirds is one of the most basic rules of composition. This proposes dividing the picture frame into thirds and placing the main action or focal point at the place where the thirds divide. It gives a feeling of balance and harmony and prevents the focal point from occupying the middle of the frame, which can often look so boring. It's a principle which many attach great importance to, but, when asked, how do you explain the logic of placing a fish which occupies the majority of the frame in one of the 'thirds'? When a person observes his fellow man or beast they search for the eyes. It's one of the laws of nature. Divers do the same to marine life so if you have a co-operative fish posing for you consider placing the focal point – its eye – on one of the thirds. Distant divers, for instance, can comfortably occupy the remaining space as can the sunburst which is often used in wide-angle photography. Check out underwater photographs for yourself. Consider the first place in the frame where your eye is drawn; you will begin to notice the thirds rule in so many of the images.

Figure 12.4

The form of some creatures can really test your compositional ability. Octopus, squid and cuttle fish adopt some bizarre shapes and it can be difficult to decide how to position them within the picture frame. This profile occupies a portrait format quite naturally, but, as previously stated, it can move a fraction and demand a landscape format. I remember composing this cuttle fish and placing the focal point (the eye) on the top left third intersection. I took one shot before it swam away.

Nikon F90x 60 mm macro lens on AF. Subal housing twin Sea & Sea YS50 TTL flash guns set to TTL. Elite 50 ASA. Mabul, Malaysia.

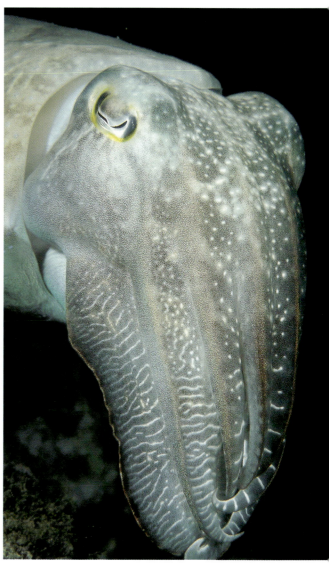

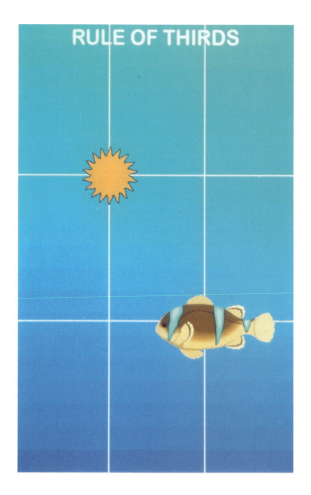

Figure 12.5

The law of thirds. The focal point is the place where the thirds divide. (Reproduced by kind permission of Linda Dunk.)

Figure 12.6
The red coral in reality ran from left to right horizontally across the frame. In an effort to increase the impact of the image I intentionally tilted the orientation diagonally from top left to bottom right. The centre of interest or the focal point will always be the eye of the blenny which is composed on the right hand 'thirds line'. Nikon 801 60 mm macro lens. SB24 flash gun. f16 at 1/60 s. Eilat, Israel.

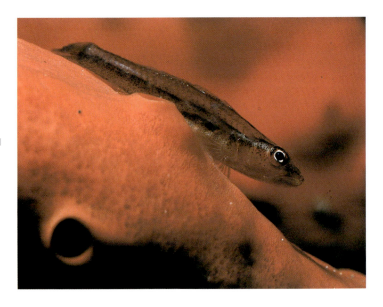

Image depth

A photograph by definition is not reality, only an illusion. So it's strange to talk of creating depth on the surface of a two-dimensional image. So depth in a photograph is not reality, only a representation of it. Of course you can get a feeling of depth by using the diagonal line to lead into the picture. Other techniques are perspective, distance and scale.

Perspective

One of the most effective perspective techniques used on land is the popular one of parallel lines, from the viewer's standpoint, which converge at a point on the horizon. A good example of this is a wide section of a road that stretches far into the distance. Under water, this technique can be related to a reef wall that appears to stretch out into the blue water, to rocky gullies that lead the eye along them and to sides of sunken wrecks that appear to end on the range of your visibility.

Distance and scale

This technique is excellent and quite easy to apply. It works by repeating a large foreground object or figure in smaller versions, the smaller being the more distant. A classic land example is a person in the foreground with others in the background. The size of the two groups is so obvious the viewer cannot help but know the small figures are further

Figure 12.7
I vividly remember my compositional thought process for this shot of a Bonaire blenny. Looking through my viewfinder I asked myself 'What is the centre of interest, where will the viewer look first?' Obviously the small blenny and in particular its eye. I composed it on the top left intersection of the 'thirds rule' looking diagonally into the picture. My next decision was how much space to allow around it. I noticed several blemishes on the hard coral so I moved in slightly and eliminated them. I was aware of the diagonal orientation of the magnified coral valleys. I tilted the camera to emphasise this. I took three shots and varied the point of sharpest focusing around the blenny. Nikon F90x 105 mm macro lens on AF. Subal housing one Sea & Sea YS50 TTL flash gun set to TTL. Elite 50 ASA. Town Pier, Bonaire.

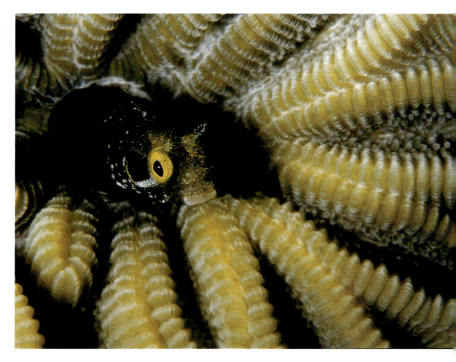

away. Under water you use various subjects. For example, soft coral in the foreground repeated in the background, shoals of fish that lead into a picture and, most obviously, a diver at different distances. The recognisable form of a model in the background creates an enormous feeling of depth under water. National Geographic underwater photographer, David Doubilet, uses this idea to great effect in many of his photographs. He has taken it one stage further and regularly equips his diver/model with a hand light which is directed towards the picture's centre of interest. This allows the viewer's eye to examine the distance while always returning to the main subject.

In conclusion

Don't forget that rules of composition are there only to serve as a guide to give you better and more precise pictures. Once you have mastered the rules you will know how to break them. Then you can deliberately obtain unconventional but often exciting images. If your consideration of compositional technique is limited when you are under water, then take time out to give these techniques a chance. You will surely develop a good eye for underwater images.

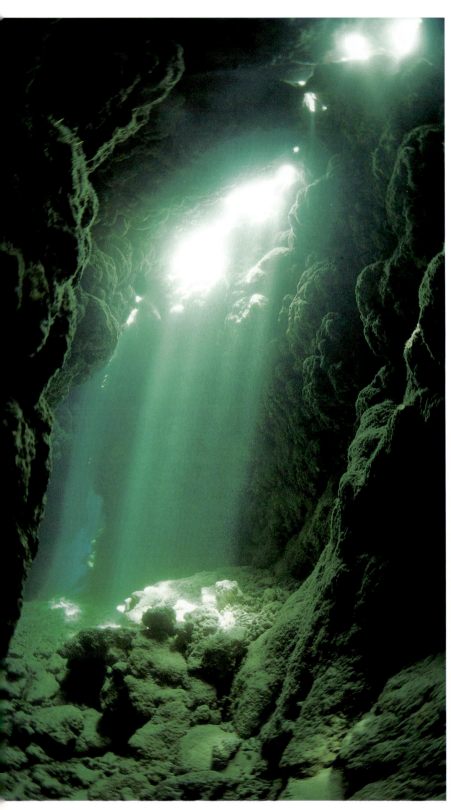

Figure 12.8
A cave situated several miles north of Ras Muhammad in the Red Sea has numerous holes situated in the ceiling. At certain times of the day the sunlight penetrates these gaps and provides the most exquisite of light, offering great potential. I used a 16 mm fisheye lens on an F801s on a home-made tripod, quickly constructed on the dive boat in anticipation of a glorious opportunity. I selected five different compositions within the cave. I bracketed apertures and shutter speeds around $f11$ and $f8$ with 1/2, 1 and 2 second shutter speeds. The composition is quite deliberate with diagonal rays of light from top right towards bottom left of the frame. The floor to the cave leads the eye from bottom right through the image to top left and out towards the cave exit. The bubbles from my regulator were a constant source of frustration throughout the session. I did not want evidence of man or fish in the photograph to diminish the impact. This image is about composition and light and the beauty and dramatic effects that light creates beneath the sea. Ektachrome Elite 100. No flash.

Figure 12.9
This leaf fish has been captured in a portrait format with the camera tilted to give a diagonal orientation. The focal point (the eye) is situated in the middle of the frame but the image still works despite the suggestion that a central focal point is 'against the rules'!
Nikon F90x 105 mm macro lens set to AF. Subal housing. Two Sea & Sea YS50 TTL flash guns on TTL. ƒ16 at 1/60 s. Elite 50 ASA.

Figure 12.10
I find the features of scorpion fish fascinating. On this occasion I adopted a downward angle. I set my twin flash guns to illuminate each side of its face and moved in. I chose a portrait format and positioned the eyes across the top thirds line and the mouth slightly below the lower thirds. I composed tightly on the face to avoid including the white sand which the fish was resting on.
Nikon F90x 60 mm macro lens on AF. Subal housing. Twin Sea & Sea YS50 TTL flash guns set to TTL. Elite 50 ASA. ƒ16 at 1/125 s. Red Sea.

13

Visualisation

I practise by photographing everything with my inner eye all the time.

Minor White

An underwater photographer must be able to see the desired result in his mind's eye and then create this vision onto the piece of film.

Martin Edge

This is the only quote which I can lay claim to throughout this book. However, it is a fundamental element of everyday life – and a necessary feature of the TC system.

Visualisation is simply the ability to form a picture in the mind. It's an ability everyone has and one they exercise constantly. You visualise what the day ahead holds; you visualise an impending meeting with a friend or a partner perhaps. Maybe you visualise an impending visit to a restaurant, the cinema or somewhere even more exciting and interesting.

Everyone has tried to imagine what a holiday destination will be like: the hotel, the beach, and so on. How many times have you coated a wall of your new home with just one stroke of paint and thought: 'Won't it be nice when it's finished?' In each case you are visualising the finished article. So with photography both above and below the waves, you subconsciously take in the elements you are looking at and visualise the intended result.

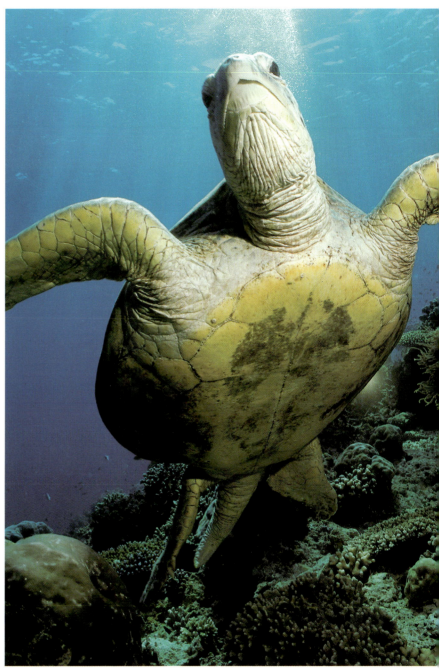

Figures 13.1, 13.2
Whilst preparing for a photo trip to the Island of Sipadan, I came across a children's candy cigarette card that depicted what I considered to be an outstanding 'angle of view' on a turtle (above). Whenever the chance arose I visualised this angle of view in my mind's eye and attempted to recreate that vision onto film (right). I envisioned a vertical orientation in a portrait format with a blue background, devoid of clutter. I attempted the shot many times but was constantly frustrated by bubbles and other divers in the background. However, this image closely resembles my visualisation of what I wanted to achieve. Nikonos RS 20–35 mm zoom, SB 104 flash f8 at 1/125 s. Ektachrome Elite 100 ASA.

The difference between Minor White and the vast majority of photographers is that he *consciously* visualises a photographic opportunity. Underwater photographers, with all the distractions of diving, may visualise subconsciously but often fail to make the right conscious moves to produce the desired results.

Conscious visualisation

Consider the elements of the picture and take a moment to visualise the picture you would like to obtain. Then just attempt to transfer that vision on to film. Eventually you will begin to achieve the result you intended in all areas, i.e. light, colour, composition etc.

a

Figure 13.3a and b

Learning to visualise how your endeavours will record on film is the key! I advocate to all my students to take a moment to form a picture in the mind of how you wish to record your subject. Visualise the parameters of film chemistry, e.g. a wide-angle subject shot at f22 may record the underwater background as black whereas the reality of what you see is a much lighter shade of blue. You must learn to visualise the former and consider its effects on the picture. I drew a rough sketch (Figure 13.3a) of a seafan which we passed every time we entered the water from shore. During a discussion with a student I sketched my intentions to illustrate the picture which I had formed in my mind's eye. Later that day we went out to record on film the 'visualisation' (Figure 13.3b). We both succeeded. Nikon F801s, 16 mm fisheye, Subal housing. Two Sea & Sea YS 50s TTL on TTL. f11 at 1/90 s. Elite 100 ASA. Sipadan, Malaysia.

b

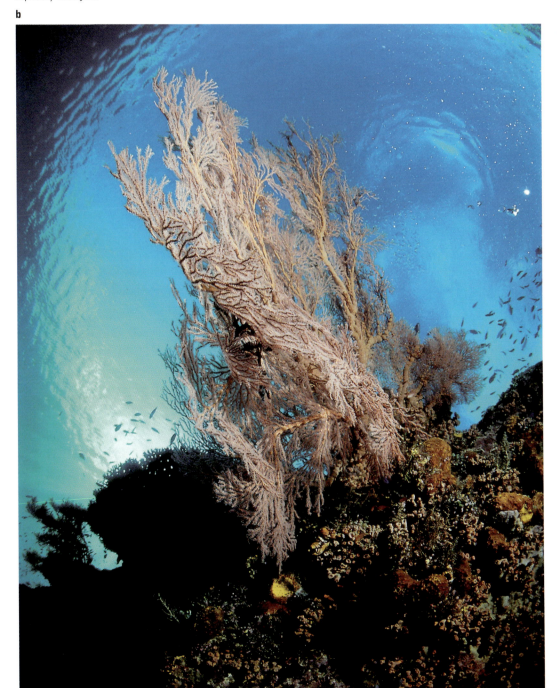

Patience

Patience is a constant requirement throughout the TC system: patience in preparing your dive, patience in your approach, patience in waiting for the peak of the action, even patience in evaluating your results.

By virtue of the subject you have selected to shoot and its possible potential, you have a conscious decision to make regarding the amount of time you are prepared to spend in approaching your subject. This is before you even think of composing the picture and pressing the shutter. Look at some authentic scenarios.

The 'Temple' off Sharm El Sheik in the Red Sea, is home to a very large, colourful and relatively tame scorpion fish. He's well respected by divers and photographers and will regularly pose for the camera. However, he has no understanding of negative space and is often found resting in a cluttered depression of the reef. This poor angle reduces the potential of an otherwise excellent subject. Many divers take a few shots then give up and move on. However, if you have the patience and are prepared to wait until he lands in a better place, the potential is excellent.

I once spent 45 minutes following this particular scorpion fish around a small coral head knowing that if I could provide the patience it would provide me with the opportunity. It finally landed on an outcrop that had a clear, uncluttered background, in other words excellent negative space.

There are numerous occasions when creatures have a mind of their own and will not stay in the same spot long enough.

Figure 14.1
This scorpion fish was taken using a Nikon F801. 60 mm macro lens. Sea & Sea YS 50 TTL flash gun. f16 at 1/60 s. Ektachrome Elite 50 ASA.

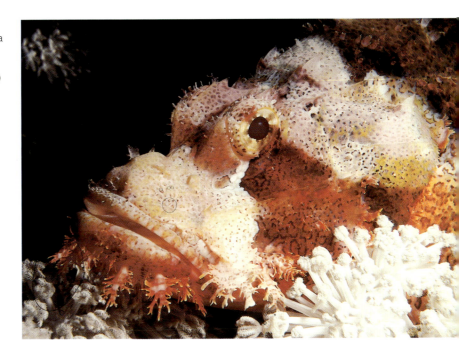

Moray eels are a good example. They can move only a matter of centimetres from their holes yet they offer excellent potential.

Timid fish like the long nosed hawkfish rest on fan corals. Moving in to those creatures tests your powers of patience to the limit. The slightest sudden movement will spook them.

So ask yourself: does the potential of the shot justify the patience and time required to take the one you want? The decisions are personal. Only the photographer can make them at the time.

The importance of patience

Patience is essential within the TC system, not only when shooting marine life, but also when you relate it to other features of the system, particularly peak of the action (see Chapter 15). In conjunction with peak of the action patience is of paramount importance! It's a cliché, but patience really is a virtue under water. Let's imagine a scenario whereby while diving along a reef you see an ordinary, everyday reef fish acting in a particularly interesting way. If captured on film it would make a good shot.

It's well known that if a creature does something interesting once it will do it again, providing it's at ease with any intrusion

into its territory. So you wait. And you apply your patience. But how long are you prepared to wait for the right shot to occur – 20 minutes, an hour? How long is it worth?

Retrace a mental path through the features of the TC system and consider potential. Ask yourself, just how good could the shot really be? What is the potential of the situation? Maybe you've already got boxes of shots like the one you're waiting for or is this a one-off stunning image.

The TC system is simply a means of disciplining yourself to think and consider various elements like this before you press the shutter. Once you have got into the habit of using the system then the quality of your results lies in your hands! It will no longer be because of unforeseen circumstances, luck, forgetfulness or the 'I never thought about that' attitude.

Hundreds of my students and I employ the TC system under water. I am bound to say that it has developed their vision and perception, enhanced their skill of composition and widened their knowledge of light and the effects of light simply by giving thought to topics like potential and patience.

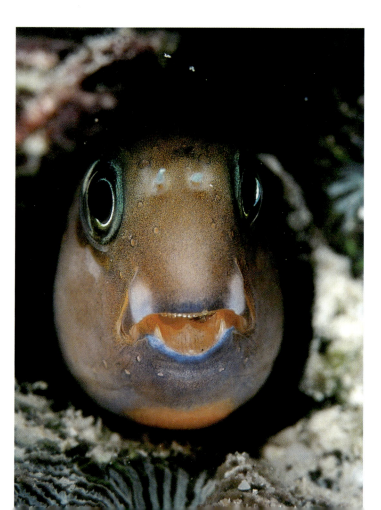

Figure 14.2
How much patience have you? How long are you prepared to wait for a small blenny to appear from its home in the coral? This opportunity was pointed out to me by another student. I decided that I would spend the entire photo-dive on that one subject. You see, it was a species of blenny which I had never photographed before. It was very accessible and I was attracted to its facial features. For me – this was good potential and I invested the time and effort to satisfy myself. F801s, 105 mm macro lens on AF in a Subal housing. One Sea & Sea YS 50 TTL on TTL, f16 at 1/90 s. Ektachrome Elite 50 ASA. Sipadan, Malaysia.

Peak of the Action

To take photographs is to hold one's breath when all faculties converge in the face of fleeting reality. It is at that moment that mastering an image becomes a great physical and intellectual joy. To take photographs means to recognise simultaneously and within a fraction of a second both the fact itself and the rigorous organisation of visually perceived forms that give it meaning. It is putting one's head, eye and heart on the same axis.

Henri Cartier-Bresson

There is a definitive moment for a photograph but it's only a fraction of a second. It's like a tennis match. You have to anticipate it.

Henri Cartier-Bresson

That's how the master of land photography describes what is here labelled *peak of the action*. It is that definitive point in time when you choose to press the shutter and stop the action of the underwater world in your lens.

Often referred to as top of the action, timing or anticipation, it is a skill, and professionally often a necessity, usually associated with sports and fashion photography. That split second's anticipation that allows the photographer to capture on film an action packed moment – the perspiration exploding from the face of a boxer as his opponent lands a decisive blow, the determination on the face of the tennis player as he lunges to play the stroke or perhaps just a raised eyebrow or sparkle of personality from a fashion model.

In underwater photography to capture action of that speed and quality is rare. Many people only recognise the obvious, such

Figure 15.1

It is unusual to see a Spanish dancer during daylight hours. If you are fortunate enough (I have never been so) take full advantage of the encounter. Do not just take 3 or 4 photographs, take a whole roll. The only thing between success and failure is film! When they dance their movements are very jerky, remember the 'peak of the action' – that moment when to stop the action will produce a more exciting image. A subject such as this will test your ability to the limit. Press the shutter at the wrong time and the Spanish dancer resembles a blob of red jelly thrown from the dive boat. Consider the moment when it is most graceful. You will be lucky to achieve this in less than 10 shots. If you are not convinced then try this simple exercise at home. Obtain video footage of a Spanish dancer 'dancing'. Try stopping the action with the remote control 'pause' button on your recorder. See how often you can get it looking good! Nikonos 111. Oceanic 2003 flash on half power. Nikonos close-up with 28 mm lens, f22 at 1/60 s. Ektachrome 64 ASA. Egyptian Red Sea.

as a Moray Eel feeding on a smaller fish. The moment that the Moray strikes is considered the peak of action. Then you achieve an exciting shot. Other examples have an obvious action point and it's instinctive for a photographer, even a beginner, to recognise the 'action' and to wait for or anticipate the 'peak'.

We must consider the word 'action' to be a loose definition, but in every photograph you take there are ways in which it can be identified.

Is the subject you have chosen to shoot capable of moving or has it any moving parts? For instance, these might be the tentacles of a sea anemone or the polyps of certain soft corals that open and close as they feed.

If it does not have movement then take the picture when you are ready. But if it does, then is there a certain moment in time when in pressing the shutter you will gain a better, more pleasing picture?

It does not have to be fast action, or any action at all. But consider the following situations and see the difference capturing the right peak of the action can make. Pressing the shutter at the correct point in time to photograph a Spanish dancer portrays grace and beauty. At the wrong moment a blob of red jelly is a more fitting description.

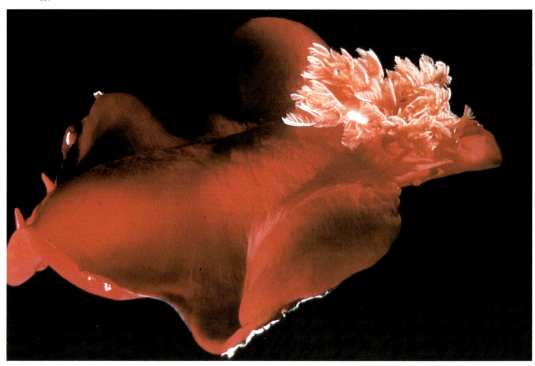

Visualise a cleaning station with various species of fish queuing to have parasites removed from their scales. When the mouth and gills of the fish open and the 'cleaner' pops inside – this could be the precise point in time that will make your picture more interesting than those of the photographer who never considered that precise peak of the action moment when to press the shutter. Or it could be the pulsating tentacles of a jellyfish with a uniform upward and downward movement of the skirt.

If the cycle lasts for only two seconds when will you press the shutter? When does it appear at its best? Here's where patience, too, comes in once again.

In a swell or current, however slight, the tentacles of anemones sway back and forth. For most of the time it's a tangled mass, but there is usually a moment when they all come together and appear balanced with grace and form.

Imagine the wings of Eagle rays or Manta rays in flight, a Nudibranch crawling along a branch of coral or copper sweepers. All manner of situations have that definite point in time when pressing the shutter will make a better picture.

Always look to get an extra something out of a subject, to reinforce its personality and character and make it stand apart from other shots of the same species. Occasionally you might be fortunate enough to catch the creature with its mouth open. This is the moment, the peak of action that makes a better picture. It only needs a movement of your subject to make a major difference to your finished photograph.

Peak of the action and composition

Make sure you do not confuse 'peak of the action' with 'composition'. Striving for your 'peak' while ignoring composition may by no means achieve your ideal shot. Placing a distant diver on one of the thirds intersection in a still life, close-focus wide-angle shot is just a principle of composing the elements of the picture. However, waiting for the diver to exhale, sending a plume of bubbles to the surface may be the peak of action that will enhance the photograph.

A couple of tips

Before pressing the shutter look at your subject. If any part of it is capable of movement then consider: is there a definitive moment in that movement that will make for a more pleasing picture? Compose, wait for the 'peak' and/or press the shutter. Remember to *concentrate*; remember to be *patient*.

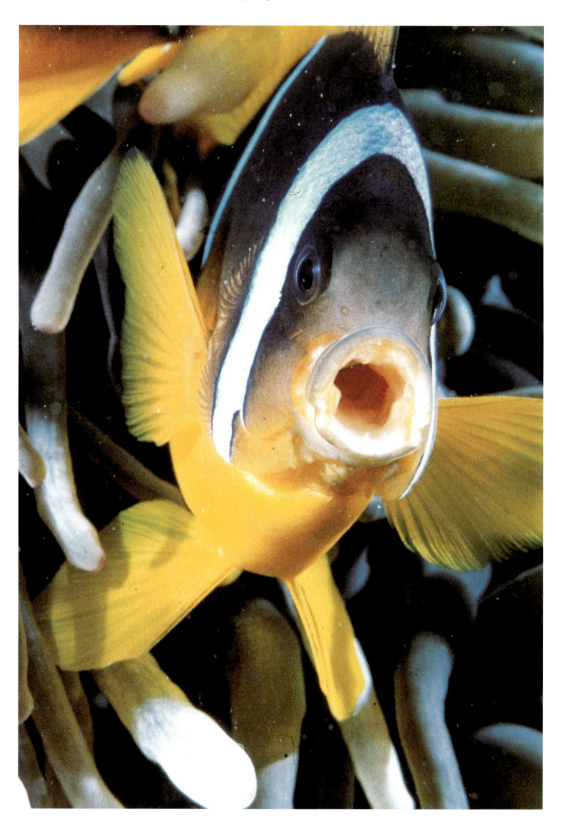

Shoot

There will be numerous occasions when you take a photograph spontaneously: a seal darting out of the green water, Manta rays, sharks and dolphins may only pass your lens once. When they do you point, shoot, and hope you are lucky. If the subject stays around longer, then you have time to give more thought to the composition of the picture you visualise.

At other times certain features of TC may be inappropriate, (e.g. 'approach' or 'peak of the action') and you are able to dismiss them from your mind in an instant.

Consider when someone first learns to drive a car. Every manoeuvre is a major decision: selecting a gear, releasing the clutch, applying pressure on the accelerator, changing direction,

Figure 15.2 (opposite page)
I use this image when conducting workshops to illustrate the essence of 'peak of the action' and 'potential'. The clown fish has to be the most photographed fish in the Red Sea, so it can be a challenge to get a shot that has impact. Swimming over a shallow and very damaged reef off the beach of Aqaba, Jordan, the clown fish emerged from its anemone and elongated its jaws only centimetres from my face mask in an aggressive manner. I never knew why it picked on me, I would never have noticed it otherwise. 'If a creature does something once, there is no reason why it should not repeat its behaviour.' For 30 minutes I remained quite motionless, camera trained on the anemone to where it had returned, just waiting for a repeat show. It rewarded me but the 'peak' was a fraction of a second. Many times I pressed the shutter, many times I knew I had missed it. However, one shot worked in regard to the peak, exposure and sharpness, creating a strong personality all of its own. Without this 'peak' you have just another mundane clown fish picture. Remember to recognise the 'potential'. Consider the features of the TC system, especially patience. How much patience is it worth for you to get the shot: 2 minutes? 20 minutes? How many shots are you prepared to take? All that I advocate is to TC – think and consider it, not after the dive when you have returned to the dive boat but there and then as the opportunity arises. Nikon F2 in an Oceanic Housing. 55 mm micro Nikkor lens. Dual lighting in the form of an Oceanic 2000 flash and an Ikelite MS flash with EO leads connected to the Housing. Kodachrome 64 ASA.

Figure 15.3
There were literally hundreds of large, brightly coloured sea urchins on the rocks, many extended, feeding on the plankton. I looked around for about 5 minutes and selected one that looked in good condition, on top of the reef with the green water behind it. I noticed that the tentacles were forever tangled in the current. However, several times in a minute they would remain static and appeared balanced. This was the peak of the action. I tilted the orientation of the Nikonos framer to evoke a diagonal tilt to the urchin across the top of the rock. I took 5 shots, maintaining the same aperture and composition but trying different dual lighting angles. The aperture of f16 has darkened the green water background to black. Nikonos V Nikonos close-up framer with 28 mm lens. SB 103 flash on TTL

overtaking, reversing and so on all seem to demand enormous mental application. But within weeks of passing a test they perform these tasks instantly and without a moment's thought.

With practice the TC system is nothing more than making decisions in the same way as you do when driving, or carrying out some other everyday task.

Figure 15.4
To look at this lobster you would never think that the element which was relevant to the 'peak of the action' was its antenna. As I composed through my viewfinder the antenna was continually obscuring the eyes. Nothing else was moving, so I chose to press the shutter when these 'moving parts' were enhancing the picture as opposed to detracting from it, which was when I had an unrestricted view of the eye. Nikon F2. 55 mm Micro Nikkor lens. Oceanic Hydro housing. One manual Oceanic 2000 flash and a Sunpack Marine flash on slave. f16 at 1/60 s. Kodachrome 64 ASA. Swanage Pier, UK.

Figure 15.5 (opposite page)
Having dived in Sipadan for the last five years I have seen thousands of images of turtles. One common mistake made by all is when we fail to consider 'peak of the action' and press the shutter when the turtle's face is obscured by its 'wings' in flight. I distinctly remember this opportunity and shooting every time the wings reached the top and were reflected in the under surface.
Nikon F90x, 20 mm Nikon lens set to manual focus. Subal housing. One Sea & Sea YS 120 TTL on TTL and a long Subal flash arm. f5.6 at 1/125 s. Elite 100 ASA.

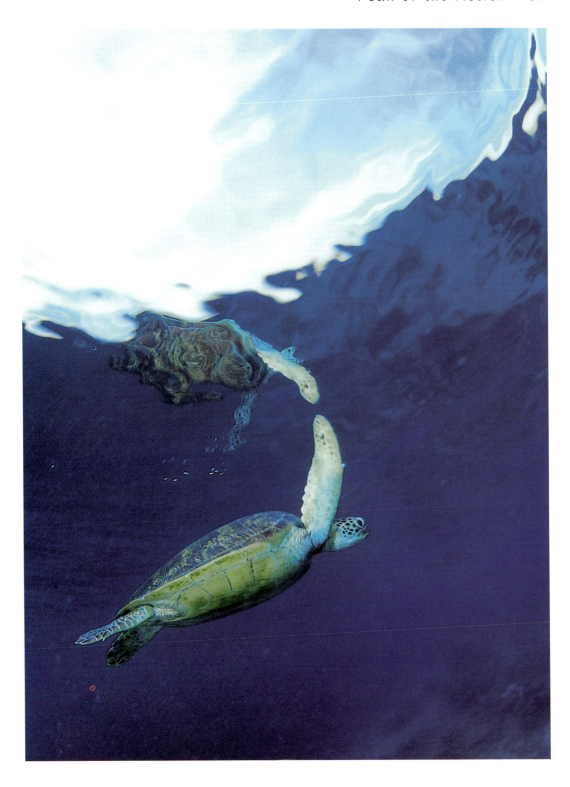

Evaluation

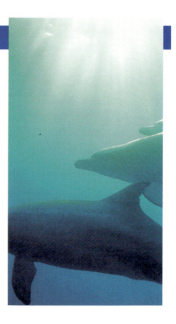

In many books and magazines you can evaluate the equipment and the technique used to take a photograph by the technical information provided, i.e. Nikonos V on *f8* at 1/60 s using 100 ASA film. But, in my opinion, the essence of how the shot was perceived is an essential which is missing.

Photograph evaluation

In the excellent book by Howard Hall (*Guide to Successful Underwater Photography*) the author describes how every photographer can evaluate underwater photographs in books and magazines by considering the techniques used and the equipment required, and categorising under a particular heading, i.e. macro–close up–wide angle, etc.

He also gives an in-depth and detailed observation of not only the equipment used to take particular pictures, but also what the intentions and attitudes were at the time, along with the various decisions he was required to make before pressing the shutter.

In this book I have also included details of my own attitudes and decisions which accompany all of the colour photographs. These are structured around the TC system and apply various features of this system which related to the subject matter at the time.

Will it ever be known how many attempts it took David Doubilet to achieve the stunning images that grace the covers of *National Geographic*? Can you imagine the patience needed

by Christopher Newbert in obtaining the fine images in the book *Beneath a Rainbow Sea*? What made them choose that particular subject? How long did they wait? Why did they choose to light it in that particular way? Did they see the intended result in their mind's eye before they pressed the shutter? Just how close was the resulting image to the picture in their mind's eye?

Every photographer, from master to beginner, is different and unique. If you see an image that you admire and have the opportunity of communicating with the person who created it, keep in mind the words of Rudyard Kipling:

'I have six honest working men
They taught me all I knew
Their names are Why, What, When, How, Where and Who
I send them over land and sea
I send them East and West.
When they have done their work for me
I give them all a rest'.

It is a well-established practical way of putting a question in such a way as to elicit an explanation instead of a simple 'yes' or 'no' answer.

For example you can ask the same question in one way:

Q. Did you light the fish with flash?
A. Yes.

Or another:

Q. What made you choose to light the fish in that particular way?
A. The answer begs an explanation not a monosyllable.
Q. Why did you photograph that particular species of fish?
A. The answer is an explanation.
Q. What would you like to drink?
A. The answer may provide the opportunity for more discussion.

Evaluating your own work

All too often as underwater photographers we consider the ability and the work of those we admire. But how often can we say that we consciously consider our own strengths, weaknesses, dexterity, proficiency or perhaps our shortcomings?

The appraisal chart overleaf will help you to consider your own skills and abilities. Down the left-hand side are listed various abilities and discussion points. Score yourself on the scale of 1 to 10 as to how happy or unhappy you feel with each particular skill. It's not a question of how good or bad you yourself

	Unhappy									Happy
	1	2	3	4	5	6	7	8	9	10
Enthusiasm for u/w photography										
Diving skills										
Photographic equipment										
Focus estimating										
Subject selection										
Ability to recognise potential of subject										
Patience										
Stability techniques										
Lighting fixed position										
Lighting hand-held position										
Imagination/flair										
Compositional ability										
Understanding backscatter										
Understanding stop										
Understanding shutter speed										
Understanding depth of field										
Bracketing techniques										
Panning techniques										
Parallax correction techniques										
Ability to recognise peak of the action										
Pressures of competition										
Pressures of holiday										
Pressures of recently purchased equipment										
Use of extension tubes										
Use of close-up										
Use of wide-angle										
Use of fisheye lens										
Concentration										

think you are. That's too subjective. Ask yourself: are you happy with that aspect of your underwater photography?

Be brutally honest with your answers. When you have marked a cross in each box on the 1 to 10 scale join the crosses together in the form of a graph. Look at the results: they may surprise you!

Each and every person's vision is unique. It influences any shot that is taken. The enjoyment of a picture, like your vision, is very selective whether the shot belongs to you or someone else. For instance, I do not expect the reader to appreciate all the pictures in this book. The photographs depicted have various strengths and weaknesses. However, every picture is designed to illustrate a particular example or technique that the reader may wish to take advantage of in his or her own work.

Do not spend too much time pondering whether or not you like a particular photograph. This should be irrelevant to your understanding of the point that it illustrates.

The one way to becoming a better photographer is by learning from the shots that didn't work. Eliminate the very best shots from your portfolio, then look at the hundreds of near misses or failures. Trying to see where you went wrong will give you a better understanding of how to correct for the future.

Evaluate your work objectively otherwise unnecessary frustration will creep in and may harm your efforts. Compare your work with others by all means, but always be aware that each published photograph may have been the result of hours of patience and several rolls of film. If you have taken three pictures of a fish in 40 metres of water over a 2 minute period don't expect it to be in the same class as others on the dive who remained in 10 metres of water for an hour longer with the same species. It more often than not won't be!

Try to visualise the intended result in your mind's eye before you press the shutter. When your work begins to resemble more closely what you intended then your creative imagination, vision and perception of the 'underwater world' are the only things that can inhibit you in producing images to compete with the very best!

Why take underwater photographs?

Have you every asked yourself what stage of the whole underwater photographic subject you like the best – is it actually taking the pictures underwater? Or looking forward to seeing your results, or seeing them? Is it doing well in a competition? Or pleasing your friends when you give a slide show? Think about it – your answer might surprise you!

Have you ever asked yourself who you take photographs for? When you are commissioned for a particular picture or portfolio you must obviously please your employer and your opinion of the work you have produced for him comes second. Picture editors decide which photographs they wish to publish regardless of what the photographer thinks of them.

But the vast majority of people take underwater photographs for a hobby. They indulge in techniques and methods because they want to, not because they have to. You begin to walk a very fine line when you try to please everyone – yourselves, your loved ones, your peers, the public and in competitions, the judges.

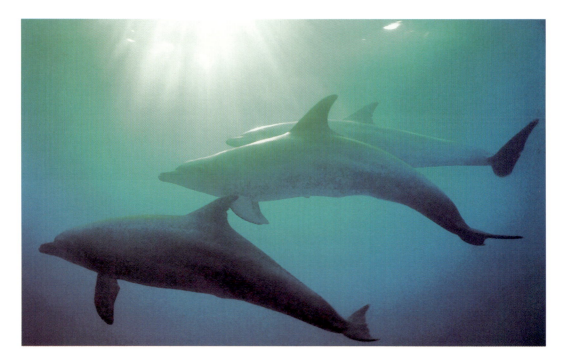

Figure 16.1

To have an encounter with perhaps the most exquisite creatures found in the sea offers great potential. When the sun is on the horizon at the end of the day, the light that pierces the surface has a unique 'dappled' quality to it. The dolphins circled me once and were gone. I had set 1/60 s at ƒ5.6 on my Nikonos 111 and focused at 3 m with the 15 mm Nikonos lens. I took about 10 shots. Every so often an underwater photographer gets lucky. On this occasion I got very lucky! The formation of the dolphins and the sunbeams that illuminate their bodies were unseen and unplanned and the result was more than I could have wished for. A great underwater photographer once said: 'If you do not get into the water, you will not get lucky!'

In conclusion

Everyone has personal opinions, personal likes and dislikes. I find it very difficult to please everyone with my work. I used to try but I found frustration would take over and soon realised that I was putting myself under unnecessary pressures, and for no real reason.

I now take pictures for myself. No-one can take the blame for my failures. My attitude has taken away numerous pressures, but I still seek perfection. It's what stops me getting bored. I never seem to get everything right. There's a moment when the film has been developed and I can see that things have worked out well. I see a shot that at first glance looks the one! However there's always, always something wrong. If ever the day came when I was completely satisfied with my work I would give up!

Putting it All into Practice

This Part contains some of the most popular areas of photography such as wreck and fish photos. It gives an excellent insight into how the basic skills and techniques of Part 1 can be enhanced by the TC system of Part 2 to produce satisfying shots for publishing or just for yourself or even for competition entry.

Fun with Fisheyes

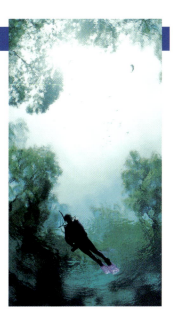

The biggest shift which I have witnessed in the 20 years I have been taking underwater photographs is two fold.

1. The popularity of housing SLRs as opposed to using non-reflex cameras.
2. The popularity of fisheye lenses.

The two go very much hand in hand.

In the late 1970s and early 1980s, very few underwater photographers in the UK used fisheye lenses. Those who did constantly amazed their audience with the amazing 180 degree view which they produced.

To my knowledge there were very few fisheye lenses or adaptors designed to work on the Nikonos range of cameras. One exception was the Nikkor 7.5 mm ƒ5.6 lens in a Seacor Super-Eye adaptor for the Nikonos camera. This lens was preset at ƒ8, and light differences were handled by changing shutter speeds. The angle of view was an incredible 180 degrees, producing an image on 35 mm film in the shape of a circle.

Other photographers opted to place a Nikon 16 mm full frame fisheye lens in an underwater camera housing. Those classic images were unusual and creative but at times the gross barrel distortions which fisheyes produced were occasionally more comical than creative.

Due to the surge of popularity of housing Nikons at the beginning of the 1990s, fisheye lenses became more available and

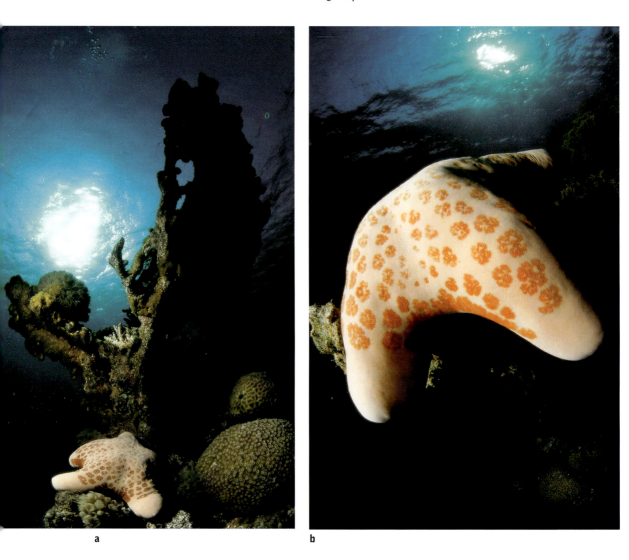

a b

Figure 17.1a and b

Figure 17.1a shows the starfish taken at about 38 cm away from the lens. If that is your intended subject then one can see it is far too small in the frame. You need to get closer. Figure 17.1b is the very same starfish taken with the same equipment and on the same roll of film as Figure 17.1a. I have moved in to a distance of no more than 10 cm port to subject distance. The starfish fills the frame and the forced perspective of the starfish is hardly noticeable. The aperture of f22 has provided immense depth of field and darkened the bright blue water to almost black. Taken in 6 metres of water, off Coral Beach, Eilat. With a Nikon F801s 16 mm fisheye lens. Oceanic 2003 manual flash gun. f22 at 1/60 s with Ektachrome 100 ASA.

popular. Sea & Sea introduced a unique 12 mm full frame fisheye lens designed for the Nikonos range of cameras. It covered 167 degrees – twice the width of a 20 mm Nikonos lens.

As we approach the millennium, the current workhorse of fisheyes include the Nikon 16 mm, the popular Sigma 15 mm and the Sea & Sea for the Nikonos.

Super fisheye ports are available for all the popular makes of housing and many of today's recreational underwater photographers use the fisheye as their first wide-angle lens.

This can often be a mistake. Let me try and dispel some myths.

1. A fisheye is often just too wide for many wide-angle subjects. It is a specialist lens that comes into its own with wreck photography and underwater seascapes.
2. A fisheye lens should have a close focusing capability of no more than 10 cm from the port to the subject. If it cannot focus this close, consider a diopter on the back (inside) of the lens. Alternatively check out the correct size of dome port recommended for the housing/lens in use. This may improve the close focusing of the lens underwater.
3. If you are prone to NOT getting close enough to your subject when using a wide-angle lens then you are in real trouble when you use a fisheye! You will often work at

Figure 17.2
Fisheye lenses are an excellent tool to capture 'Snell's window' I was no more than 60 cm beneath the surface just below Sipadan pier when I spotted a dive guide showing a tourist the scenery. The surface was glass calm. I held my breath to avoid bubbles spoiling the surface and the view through the 'window'. To anticipate this opportunity is difficult. The view looked nothing like this to the eye. I advocate with fisheye lenses that you keep your eye to the viewfinder as much as possible to witness what the lens is 'seeing'.
Nikon F801s 16 mm fisheye. Subal housing. No flash. f8 at 1/125 s. Elite 100 ASA.

between 15 cm and 60 cm camera to subject distance. Your camera and buoyancy skills will have to be well developed.

4. **Lighting with a flash gun**. Fisheye lenses take some getting use to when using artificial light to paint in the colours lost to refraction. Also, it is a common fault (mine especially) to get the flash in the corner of the picture. A flash gun with a beam angle of less than 90 degrees can cause a harsh spot light effect on the subject. The SB range of Nikon land flash guns are particularly prone to this. It isn't the flash gun's fault, but the user in expecting too much out of a flash which has a beam angle that only covers a 24 mm lens. I have witnessed many photographers struggle to provide adequate and consistent lighting with Nikon speedlights in underwater flash housings. I refer specifically to SB 24 through to the SB 28. See Chapter 18 on fisheye lighting.

So why use fisheye lenses at all? Why not just back off a metre or so and shoot the same scene which you see through the viewfinder of a 20 mm lens or a Nikonos 15 mm wide-angle.

Reducing the column of water between the lens and the subject is a fundamental and essential part of successful underwater photography. A fisheye lens reduces this column of water more effectively than any other wide-angle lens. As a result the subject is comprehensively saturated with colour and silhouettes are sharper and more clearly defined.

Because of the inherent bending of straight lines, the capability of 'seeing' an amazing 170 degrees and sometimes more makes this lens uniquely artistic and creative. In land photography these gross distortions are a disadvantage because of the many straight lines in man-made structures. Underwater, however, nature has blessed us with curves and spheres. The only straight lines we encounter are generally on human intrusions such as shipwrecks. By anticipating the disadvantages and using this lens wisely, the underwater photographer has a uniquely powerful and artistic tool.

Learning to 'see'

For most of the year, the majority of underwater photographers indulge their passion from the comfort of their arm chair. Mounting and viewing images from their last trip. Choosing shots for various competitions, perhaps writing an article or two for the national scuba magazines. We all get accustomed to seeing underwater images in a variety of different colours. We all do it. It's human nature! But the underwater world is not like that in reality. We may see the colour of corals at the end of a torch beam or in the fraction of a second it takes a

Figure 17.3
Taken by Bob Allan in Ginnie Springs, Florida. This shot illustrates the fabulous effects which can be obtained. A 16 mm fisheye lens has given a forced perspective of the dive site which creates dynamic impact. The composition of the diver (his wife Denise) is compliant with the rule of thirds, being situated on the bottom left intersection. This distant diver provides a sense of scale, perspective and exploration and strengthens the image considerably. Nikon F801s. Fisheye lens. Subal housing. *f*8 at 1/60 s.

burst of flash to illuminate a subject, but otherwise we see the underwater world in different shades of blue, grey and green!

I have witnessed underwater photographers become panic-stricken during the first few dives of their photo-trip where the colour, clarity and saturation of their pictures back home seems just an illusion! When the face mask dips below the surface during the first day's check out dive, the reality is those familiar shades of blue and grey!

With every aspect of underwater photography:

> We must learn to see colour in our 'mind's eye' and practice visualising.

I take the view that this ability regularly divides the skilled, successful underwater photographer from the rest of the field.

This is never so more important than with ultra-wide-angle underwater photography. Learning to anticipate or 'see' what may be recorded on film is not easy given the extreme distortive effect of the lens.

The successful photographer has the ability to 'see in pictures'. They may stop and examine a formation of coral and view the scene with a completely different perspective than their buddy, who may be photographically blind to the creative opportunities which are all around. This type of photographer has all the latest equipment, all the technical 'know-how' all the enthusiasm but lacks that underwater inner eye so essential in recognising a subject's potential.

I have often buddied with photographers who swim over glorious opportunities because the corals do not appear to their eye to justify so much as a second glance! Oh, if only they could view the scene through the wide angle viewfinder in their 'inner eye' and take a moment to visualise how things may be recorded on film, they would discover a wealth of possibilities right under their nose.

Fisheye and Flash

I feel that the concept of using a flash gun with a fisheye and other ultra-wide-angle lenses to be so important I have chosen to dedicate a chapter to this single theme.

Whilst teaching in the Red Sea during 1996 an experienced photographer placed a crop of slides on my desk taken with a recently purchased Nikon AF full frame fisheye lens: 'They all look like I have used a car head light, that is the last thing I want.'

He had used a Nikon SB 26 flash in a housing covering no more than a 24 mm spread. I had to agree with him! To view more than 40 transparencies, side by side on the light table made me realise the distinct **disadvantages** of using narrow beam flash guns with fisheye lenses. His compositional endeavours, subject selection and focusing, were faultless. His appreciation of background blue water exposure was sound but the light falling on the foreground subject was harsh, inadequate and uneven.

I dived with him that afternoon to pay particular attention to his wide-angle lighting techniques. He used his fisheye lens on a Nikon f4 in a Subal housing and continued to persist with the Nikon SB 26 land flash in a housing. I could not fault his technique. He hand held the flash on an Ultra Lite flash arm high above the camera, spreading light over the subject. When we examined this particular roll of film it was disappointing to see beautifully composed orange sea fans with a spot light effect emanating from the centre.

This caused me to consider my own work with a fisheye lens. For more than a decade I had used a single Oceanic 2003 manual flash gun. In 1995 I opted for the Sea & Sea YS 120

TTL. I closely examined my own images and although I considered my flash techniques competent and effective I was alive to the fact that maybe I could do better.

During the last three years I have experimented with various combinations of flash techniques pertinent to ultra-wide-angle lenses. In the main I have used Nikon cameras in Subal housings with dual bulk-head flash connectors. I used one of the most unforgiving fisheye lenses of all. A Nikon 16 mm full frame fisheye. My reasoning was simply a 'get it right with this lens and you have solved the problem' type of approach.

I invite you to consider my findings.

Whilst effective fisheye lighting can be achieved with one wide beamed flash gun, the use of two guns can improve the quality of light significantly. Two flash guns (correctly positioned) can:

- reduce the effects of backscatter
- provide more even lighting over the wide area covered by a fisheye lens
- enhance the quality of light falling on the foreground subject thereby increasing the impact of the image.

I have explored the combinations of two flash guns, twinning a Sea & Sea YS 120 with a Sea & Sea YS 50. Also two different models of Ikelite flash guns. Whilst twinning two different models can work, it is not ideal and I would not recommend it.

I have found that two identical strobes positioned left and right form the best union. A beam angle of 90 degrees is preferable

Figure 18.1
The author with specially constructed/adapted tripod arms. Minimum extension from the housing is 1 m, maximum extension is 2 m. By Mike Jefferies.

with both TTL, full, and half power manual settings. In a perfect world and with a perfect bank balance, this combination is my idea of perfection and my choice would be twin Sea & Sea YS 120s.

Flash arms

I have written thousands of words regarding the subject of flash arms. In almost every aspect of underwater photography the importance of this topic is continually underestimated.

With twin flash applications and fisheye lenses it is absolutely essential that your choice of flash arm will 'do the job'.

- I advocate arms which will extend at least 1 metre from the camera and which can be positioned easily and at a variety of angles to the subject.
- Arms which can be positioned so that the flash reflector is level with or behind the lens will significantly reduce flare in the corners of the picture due to the flash being accidentally

Figure 18.2
Taken by Ken Sullivan at the commencement of experimentation with combinations of flash guns and flash arms. The weather was appalling, the visibility was low and the natural light in the sea was almost non-existent. Ken took a meter reading on the background and selected *f*3.5 at 1/60 s. Using twin YS50s on TTL he extended the arms to their maximum of 2 m. The results were encouraging but when I tried this same combination in Bonaire I failed dismally. I extended the arms to their maximum but the background blue water was brighter and I used *f*11 and *f*8. As a result the flash guns were too far from the subject to light it given the small aperture. The result: ten rolls of rubbish!

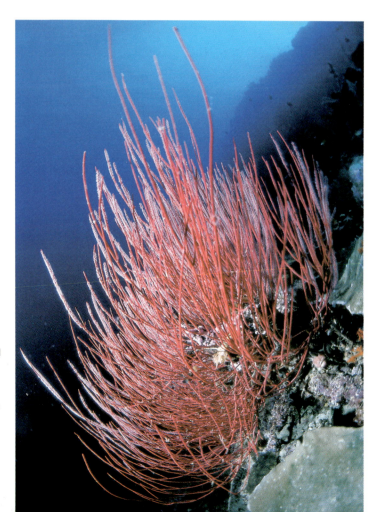

Figure 18.3
The table coral is 2 m across. I used two YS 120 flash guns on TTL. The flash arms were extended 120 cm from the housing. Apertures were chosen to compliment the blue surface detail in the background. The lighting is even and covers the entire angle of view. *f*8 at 1/125 s.

positioned within the picture frame. With a fisheye lens this is without doubt the most common fault that occurs.

I use a two specially adapted tripod arms which can extend from between 60 cm and 2 m from each side of my housing. I also recommend the TLC flash arm system and Ultra Lite system. Many of the world's top underwater photographers continue to use one or the other of these makes. For those photographers who prefer to hand-hold the left-hand flash gun it is imperative that the right-hand flash arm is given plenty of thought.

Using two flash guns on long flash arms is not easy! They are particularly cumbersome. They create significant resistance when finning from A to B and if placed in the wrong hands they are a potential source of damage to the fragile corals.

I never embark on twin-flash, fisheye photography without having dived the site before. Without exception, whenever I attach my 'long arms' to my housing, I have satisfied myself that:

- the photo-site has something to offer
- I will not exceed a certain depth
- I know which subjects I will be photographing
- I know the direction of any current
- there is no possible chance that damage can be caused.

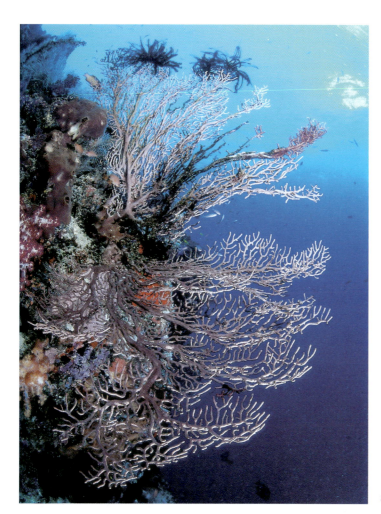

a

Figure 18.4a and b
Both photographs were taken with twin Sea & Sea YS 120 TTL flash guns set to manual half power. I positioned them on the flash arms extended to between 90 and 120 cm from each side of the housing, 45 degrees facing the subject but overlapping to a small degree. Using aperture priority I was able to manipulate the aperture and shutter speed to maintain the colour of the background and bracket the flash fill falling on the subjects.
f8–f11–f16 at 1/125–1/60–1/30 s with Elite 100 ASA.

b

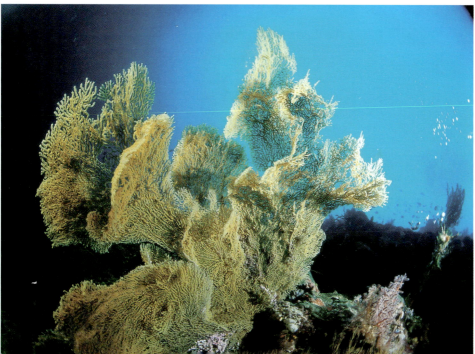

I would strongly advise anyone using this technique to have knowledge of the photo site and exactly what your objective is before you enter the water. These techniques, although rewarding, can be too cumbersome to speculate on 'what you might find down there'.

Flash techniques

I learnt my wide-angle flash techniques in the early 1980s before the advent of TTL. However, as a result of my recent experimentation I have reverted to manual flash settings instead of TTL. Using 'manual mode', i.e. full and half power, I have found that I can control the output of both flash guns onto the subject much more effectively than I could using TTL.

For example, let's take a large fan coral suitable for fisheye photography. At a depth of 15 metres, I check the ambient light levels looking up towards the surface. The meter in my Nikon F90x indicates f11 at 1/125 s using 100 ASA film. I take time to position both my flash guns 1 metre out to the side both left and right just above the housing. I ensure that the flash guns will not intrude into the picture. I set full power to the left flash (Sea & Sea YS120) and half power to the right flash. Presuming this is an ideal balance between the two flash guns I control the ambient light by manipulation of the shutter speed and aperture to either bracket the colour of the blue water background or bracket the exposure of the flash illumination, i.e. f11 at 1/125 s as indicated above, or f8 at 1/250, or f16 at 1/90.

On a roll of 36 exposures I rarely attempt more than five or six different subjects. For the experienced underwater photographer who is confident with their understanding and manipulation of aperture and shutter speed combinations, the manipulation of the full and half power settings will prove more reliable than TTL and give you infinite control. Trust me on this!

For the less experienced use both guns on TTL.

Underwater photography to this degree uses lots of film and requires lots and lots of patience and time in the water. Stay shallow for more bottom time, choose your subject carefully, think and consider your potential and composition and bracket exposures to achieve quality images. For those underwater photographers who grew up with TTL flash I can appreciate the belief that forsaking all of the current popular technology appears daunting and pointless.

TTL will produce excellent results, and I am not decrying that. The reason I am encouraging you to try alternative methods of fisheye lighting is simply to illustrate the precise control which you have on the quality and quantity of flash falling on the subject.

Never forget that TTL is just another tool in your bag of tricks.

Some facts about flash-guns

1. Two small flash-guns are not ideally suited to fisheye photography.
2. Don't be fooled by manufacturers' claims of beam angles of 120 degrees or more. It is unlikely that the coverage will be even.
3. Most TTL flash-guns produce a maximum output on TTL which is about one half stop less than they produce when set to manual full power.
4. Ready lights often come on before the flash capacitor has fully charged. The flash can be fired, however the output may be reduced by as much as one stop.
5. Underwater photographers who continue to persevere with narrow beamed flash-guns for fisheye work should treat themselves and upgrade to a wide beam model

All the photographs in this chapter were taken with a Nikon F90x. Nikon 16 mm fisheye lens. Subal housing. Elite 100 ASA.

Figure 18.5
I have included this picture even though it is something of a reject. Notice the intrusion of the flash gun in the bottom left of the frame. This happened when the arms were extended too far from the camera, i.e. 150 cm and beyond. The flash guns are again twin Sea & Sea YS 120s on manual full power. Apertures were bracketed around f4, f5.6 and f8. Other than that particular fault, the lighting is evenly spread and in my opinion is a great improvement over narrow beamed flash guns. The question you need to consider is: Is it worth the money? Is the bulk and unwieldy use of twin flash guns for wide-angle and fisheye underwater photography worth the effort? Once again reader, it's your choice!

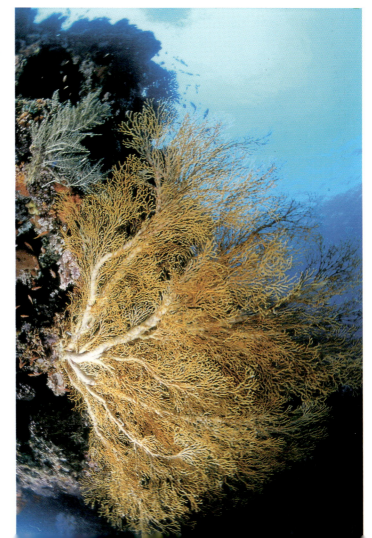

Photographing Shipwrecks

Photographing wrecks is a demanding and rewarding aspect of underwater photography which, if approached with enthusiasm and commitment, can soon become an obsession. It's a theme that often appeals to the general public. Giant, intact sunken ships offer a 'Boy's Own' fantasy that never fails to inspire a feeling of awe. Many non-photographic divers scoff at photographs of fish or coral, and that sunburst image that you have been working so hard at is often thought to be too pretty for an underwater environment that is more often than not cold and hostile. However, see the eyes of all those 'wreck ferrets' light up when they view images of wreck exploration. 'Now that's something worth taking', you often hear them say.

Priorities in wreck photography

A prime consideration of your approach to photographing wrecks is, of course, the depth at which they rest, and the amount of opportunity you have to repeat a particular dive. For example, a wreck of considerable size situated in 40 metres of water in Scapa Flow, Scotland, presents a problem if you are unfamiliar with her and you have only one or two opportunities to dive and photograph her. On such a dive, your priorities are your times, depth and, most importantly, yourself! Can you really give the amount of concentration necessary to photograph her to your complete satisfaction? I would suggest not: I certainly couldn't. In such circumstances I would take my camera to record the dive. If I obtained a good shot, I would consider it a bonus and evaluate my results accordingly,

bearing in mind the limited time that I could spend diving the wreck. However, if the opportunities to photograph such a wreck were plentiful and I became familiar with her, then the potential for obtaining some exciting images would greatly increase. These are various options available in wreck photography. Wrecks which are virtually intact, in shallower waters, offer the greatest potential, but in European waters these are few and far between. Wherever your chosen wreck lies use at least one dive solely for exploration. You need to consider the most photogenic sections, the existing light levels at your particular depth, locations of recognisable features of the wreck – winches, masts, rigging, for example – and the photographic potential of those features. You're looking for the very best potential of that particular wreck so you know that your actual photo dive will consist of shooting what you consider to be the best bits. By finding and shooting recognisable features of the wreck you give the viewer something to relate to. A broken lifeboat hanging from its davit is recognisable to both divers and non-divers. However, replace this feature with a piece of sheet metal and the viewer could be forgiven for thinking it was taken in a 'scrap metal yard on a dark night'. If possible, give your shots a green or blue water background. This again puts the wreck in its environment. And by including a diver in the scene you can also give the viewer a sense of scale. Remember, be careful not to make the divers too obtrusive or all the viewer's attention will go to them. Make the wreck the centre of attention and use the diver to reinforce it.

Equipment for wreck photography

This book constantly refers to the use of wide-angle lenses and adapters to allow you to get closer, thereby reducing the column of water between the lens and the subject. In wreck photography this concept is an absolute necessity. Wide-angle lenses of 20 mm or even wider are a must. The 35 mm or the 28 mm will be quite inadequate in capturing the sheer size of the wreck. Attempting to 'back-off' to get it all in will simply reduce clarity and definition. If you do not have use of such a wide-angle facility, then take the shots by all means, but appreciate the limitations when your shot is compared with those of your buddy who was using wide angle. The 28 mm lens is, however, ideal for capturing various features, like small anchors or portholes.

Lighting

When trying to capture the size and bulk of a wreck the use of a flash is unnecessary and can, on occasions, spoil a picture.

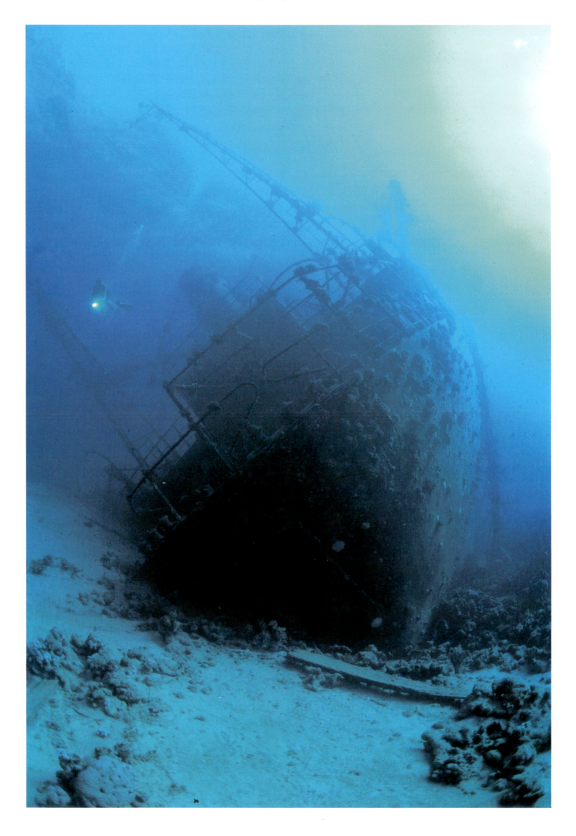

After all, a wreck is the biggest object in the sea that you will ever have cause to photograph. When shooting a coral reef you may light a selective area and allow the background to be balanced with natural light. But even given the size and power of the largest flash guns available today, to illuminate a wreck sitting upright on the sea bed with flash is almost impossible. You can use flash to fill in the colour on those recognisable features you have selected to shoot but use the available light to record the detail of the wreck.

Available light

In other chapters of this book we discuss opening up *f*-stops/apertures to control the colour of the background water. To recap, 100 ASA film at *f*22, 1/60 of a second under water, will reduce to black anything that is not lit by flash by virtue of the restricted light that is allowed to enter the camera. As you manipulate the aperture through *f*16, *f*11, *f*8 and *f*5.6 you allow more light to enter and record detail in the column of water, be it green (temperate) or blue (tropics). The technique to be employed with wreck photography is to open up the water column even further, thereby bringing out on film the natural details in a wreck. For example, the eye sees the dark shape of the wreck in blue water. By overexposing to a degree the colour of the water, we also bring out on film detail of the wreck that was not detected by the human eye.

This deliberate overexposure can be made in one of two ways:

- using large apertures, i.e. *f*2.5
- reducing the shutter speed from 1/60 of a second through 1/30, 1/15, 1/8 etc.

The disadvantage of reduced shutter speed – e.g. to a 1/15 of a second – is the greater possibility of blurred pictures because of camera shake. (With housed cameras the decrease in shutter speed is a good option if you are able to hold the camera firm and steady.) Compromise is the answer! Maintain an adequate depth of field using apertures of *f*4 or *f*5.6 with shutter speeds of 1/30 or 1/15 of a second. You will often get away with very steady hand-holding. A popular and much-used technique is to brace your camera firmly against a piece of wreckage in a similar fashion to placing your camera on a wall or tripod for land photography.

Figure 19.1 (opposite page)
A 16 mm Nikon fisheye lens on an F801s has allowed me to get within 4 m of the stern of the 'Giannis D' in the Red Sea. My intention was to open up the blue water column to achieve even greater detail in the wreck structure. I could not get the sun any further out of the composition, such is the ultra-wide view of this lens. I opened the water column by two stops without grossly overexposing the sun. The diver is equipped with a video light and has been positioned within the frame on the 'thirds intersection' by a series of hand signals. I was at a depth of 17 m. Visibility was about 20 m. I took about 8 shots using various apertures and shutter speeds in order to get the optimum exposure. *f*4 at 1/30 s second. Ektachrome Elite 100. No flash.

Choose a faster film

Another consideration is to choose a film with a faster ASA rating, perhaps 200 or 400 ASA, depending on the conditions. In such circumstances your shutter speeds will not suffer, because the speed of the film will allow you a greater latitude.

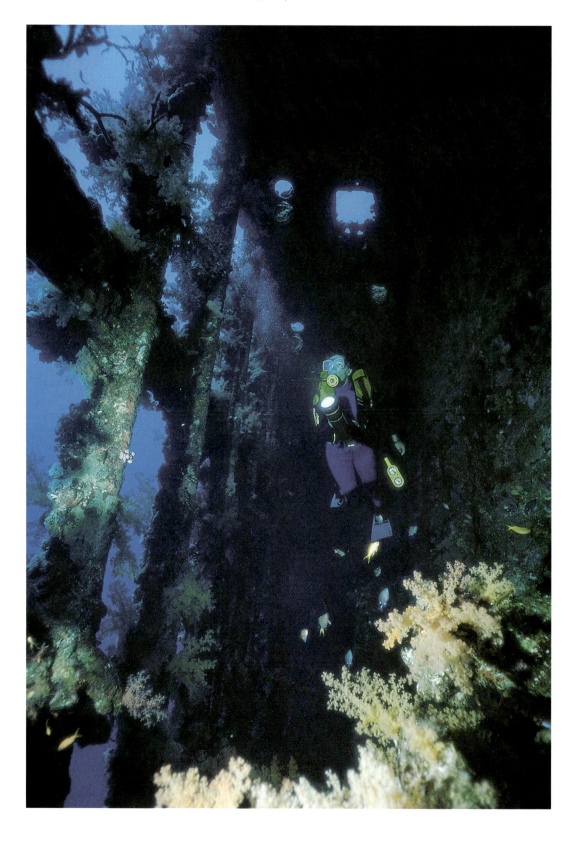

Figure 19.2 (opposite page)
The meter reading of the blue water outside the wreck has been overexposed by one stop just to lighten the shade. A flash has been used to paint in the colours of soft coral as a diver swims through the scene in exploration.
Nikonos 111, 15 mm wide-angle. 2003 Oceanic flash gun on full power. *f*4 at 1/60 s. Ektachrome 64 ASA. Red Sea.

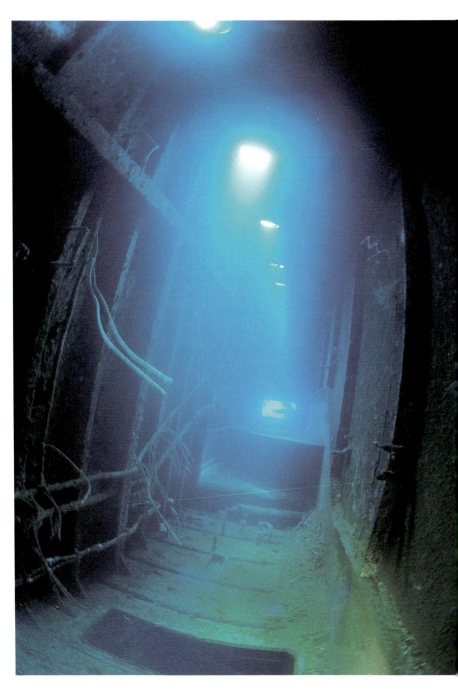

Figure 19.3
Portholes *Giannis D*. Just inside the corridor of the wreck there are rows of portholes. Using a 16 mm fisheye lens on a Nikon F801s I braced the housing against a piece of wreckage to keep it absolutely rock solid. I set *f*8 to ensure sufficient depth of field and metered off the floor of the corridor to give a bright exposure of the interior. The camera indicated 2 s at *f*8 on the manual exposure mode. I bracketed that exposure using 1/2, 1, 2 and 4 seconds. Being able to hold the camera steady is essential when using such low shutter speeds: however, to achieve the natural atmosphere inside the wreck slow shutter speeds are a necessity with 100 ASA film. Note the leading diagonal orientation of the portholes filled with sunlight. Depth was 10 m, visibility was about 20 m. I took four shots, bracketing as described. Ektachrome Elite 100. No flash.

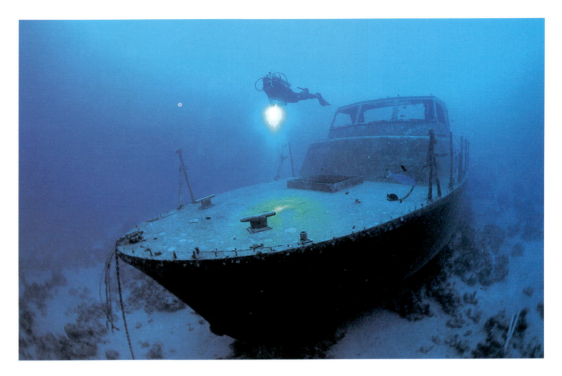

Figure 19.4

Using the 16 mm fisheye, I was able to capture the full length of this gun boat situated in 30 m of water off Coral Beach in Eilat. I was no more than 2 m from the bow! Although the visibility was 25 m the colour of the blue water was quite dark. The wreck appeared even darker to the eye and its detail was non-existent. I set f5.6 in manual mode and metered off the area of the deck. I then opened the shutter even further to record the detail that could not even be recognised by my eye. Because the water colour was dark blue the slower speed has lightened its colour. I have not overexposed it. This downward angle of composition is effective because detail can be enhanced and the sunburst is not within the frame to cause gross overexposure. I took about 20 shots, hand-holding the housing at shutter speeds between 1/15 and 1/2 second. Some suffered from 'shutter shake'; others I got away with! The pool of light cast by the diver's video light was a bonus and a trick that I have used many times since. The position of the diver within the frame is not accidental but achieved by careful planning and a series of hand signals. Note the compositional positioning of the diver on the upper thirds and the diagonal orientation of the wreck through the frame. Ektachrome Elite 100. No flash.

However, do remember that a faster film will produce an increase in grain which may not be to your liking. Only you can decide, but grainy images definitely can evoke that mood of wreck exploration that you might be seeking.

Angles of view and composition

Many photographers, myself included, always advocate using upward camera angles under water to aid separation of the subject and the background. However, personally I have found, at the expense of numerous wasted films, that this concept of upward angle shooting takes on a different perspective with wreck photography. On one occasion several years ago, I dived a completely intact supertanker in blue tropical water. Applying

the normal, well-practised technique I adopted low angles of view shot up towards the lighter regions of the sea. When my efforts were processed I found silhouettes and outlines of wreck superstructure, but the essence of the subject (the wreck) was missing. I pondered the problem and came to the conclusion that the angle of view I had automatically adopted was for most of the time incorrect. How many times on land do you look at a sizeable ship from the hull? In harbours, marinas, rivers and estuaries we are used to viewing decks and the ship's interior from eye level. On my return to Aqaba in 1989 I took the opportunity to test this theory on the photogenic pleasure boat wreck near the 'Cedar Pride', which is a comfortable shore dive. Upward camera angles were still used to create a dramatic silhouette effect, but where the angle of view was more effective shooting downwards on to the subject then this technique was attempted. The rules and guidelines were broken but, in my opinion, the composition and the impact were definitely enhanced.

A practical approach

You are diving with your regular buddy on a familiar, photogenic wreck in 20 m of water. Visibility is reported to be excellent! Brief your buddy topside that the first shot you want is of him descending on to the wreck with a hand light. You have a Nikon 801s in a subal housing, with 16 mm fisheye lens and 100 ASA Ektachrome slide film. The sun is high in the sky. You descend, visibility is 20 m. You adjust your buoyancy to suspend just off the bow section. Your light reading pointing towards the subject indicates 5.6 at 1/60 second. Consider your exposure. You know that using this f-stop will leave the wreck looking dark without contrast. You have two options, increase your f-stop or decrease your shutter speed. Compromise! 1/30 second at f4 will give you two stops overexposure on the blue tropical water, but it should hopefully increase the detail on the wreck. Depth of field could suffer so accurate focusing is another consideration. Intending to use natural light only you turn your flash to the 'off' setting. Your buddy is in position. You indicate to him or her to point their hand light down on to the wreck and not into the camera. At this point you should also be mindful of the fact that any surface detail or hint of any sunburst will be grossly overexposed. You shoot, bracketing your composition and your f-stops through the range to f5.6, holding your camera very steady in view of your reduced shutter speed.

When using natural light on deeper wrecks, consider using film of a higher speed, for example 200 or 400 ASA. With such an increase you might as well leave your flash in the boat. On my own camera using a medium-powered flash gun on low power with 400 ASA film at f8 I would need at least a 2 m arm to hold my flash that distance away. Hardly practical!

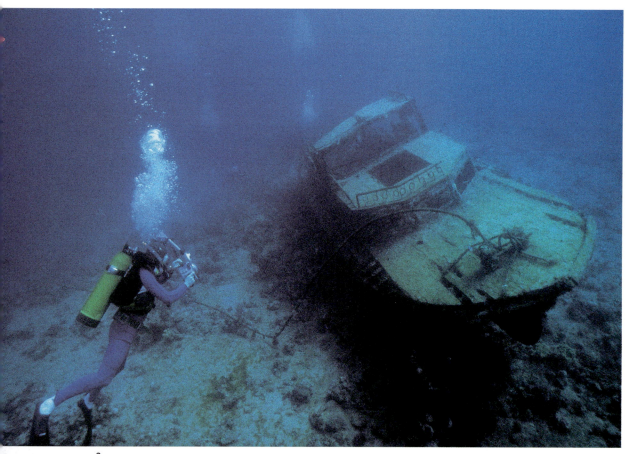

a

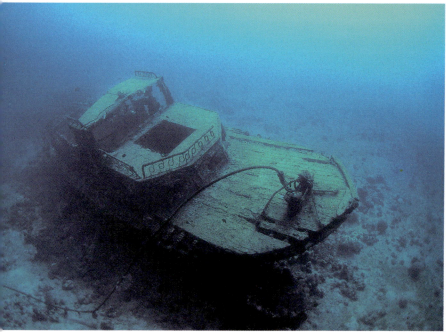

b

Figure 19.5a and b
Two almost identical pictures but compare the exposures! Figure 19.5a is taken at the exposure indicated by the light meter, e.g. *f*4 at 1/60 s with Kodachrome 200 ASA film. Figure 19.5b is the same composition but the exposure has been increased by two stops in order to bring out detail which was not obvious to my eye when I viewed the scene. *f*3.5 at 1/30 s, Kodachrome 200 ASA. Aquaba, Jordan.

In conclusion

Wreck photography is addictive. Apart from the drama of the wreck itself, wrecks also play host to every conceivable creature you may desire to photograph. Dramatic lines and structures will test your compositional skills to the limit. There is scope for everything from 1:1 extension tube size subjects to marine life to diver shots and still-life studies. Find a wreck that suits your needs, easily accessible and preferably in shallow water. Explore it, get to know it and the creatures living around it. Discover its most photogenic aspects and angles. Then get to work with your camera.

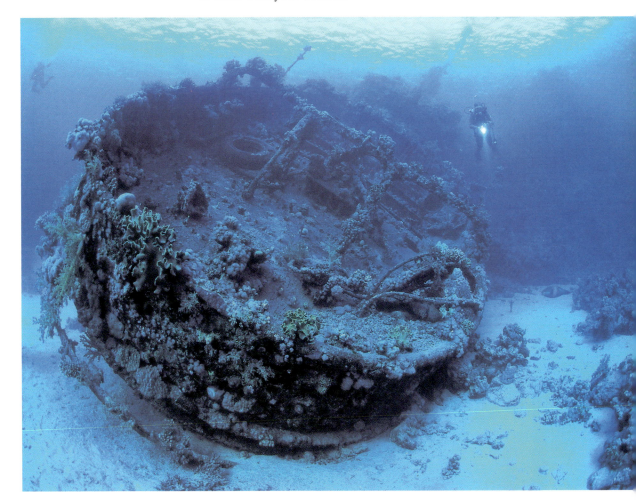

Figure 19.6
Taken by Ken Sullivan. This tug boat from the southern Red Sea has been captured using the same technique. Shooting slightly downwards, keeping the surface and sun out of the frame to avoid overexposure and opening the aperture by either one or two stops, depending which one suits your taste when you have examined the roll.
Nikon F801s. 16 mm fisheye lens, no flash gun. Fugi 100 ASA. *f*4 at 1/30 s.

Photographing Divers

It would be correct to say that children are the most widely photographed subjects throughout the world, but with underwater photography it would be difficult to say whether diver pictures or fish pictures are the most popular. Both give the viewer that feeling of being there. They transport divers or non-divers alike all over the world from the comfort and security of their everyday lives to that splendid world beneath the waves, which only a tiny percentage of the world's population ever experience for themselves. They may arouse in so many of us who do dive feelings of hopes, aspirations, ambitions and memories. The underwater photographer may choose to capture his spouse or buddy on film, or to illustrate interaction with marine life. The inclusion of a diver may be used to add impact, drama or scale to an existing scene. However, remember that including a diver in a seascape shot which already stands up for itself, greatly increases the probability of that picture ending up in the bin if the diver detracts from the main subject.

For simplicity's sake different types of diver photographs are dealt with separately.

Interaction with marine life

This can be one of the most testing, but most rewarding type of shots. To capture a special picture it is absolutely essential to have a co-operative buddy who knows precisely what you intend to do.

Equipment can range from wide-angle lenses or adapters to the close-up framer. Your buddy must look good in the water, that is not to say he or she must wear a bright gaudy coloured wetsuit, and matching accessories!

Eye contact

Eye contact is a primary consideration in this type of picture. A mask which allows a clear undistorted view of your buddy's eyes is important. He or she should look happy, interested and

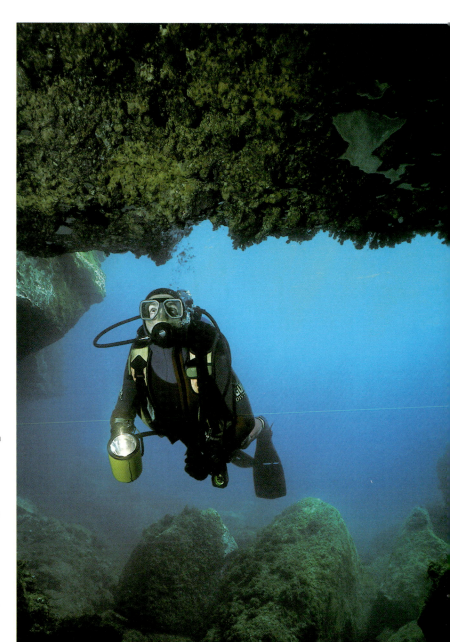

Figure 20.1
The golden rule when photographing divers: always, always direct their interest and gaze towards a secondary point of interest. Do not allow them to stare into the lens. If at all possible compose the focus of their attention within the photograph and not out of shot. In a shallow cave off Barrillos beach, Lanzarote, I composed the ceiling across the upper third line. The eyes reinforce the illumination of the inside of the cave. I balanced the natural light of f5.6 at 1/60 s with the flash output set on TTL, creating a natural image and a feeling of depth through the picture. Nikon 801s. Nikon 20 mm lens. Isotecnic flash. Ektachrome Elite 100 ASA.

at one with the subject, whether it be a fish or a still-life study. Eye contact should be directed at the subject and wherever possible the photographer should endeavour to get light into the mask by means of a flash or by natural light. This may necessitate careful consideration of the flash angle required.

Positioning the subject between the camera and the model will make the picture more dramatic, but always take care not to overpower such a photograph by the presence of the diver. He or she should add to the scene and not detract from the main subject.

There are far too many photographs of female models clad in scanty bikinis and gaudy masks and fins which simply detract from the intended theme. This technique can be understood when used to sell a specific brand name or for a particular type of modelling or magazine shot, but otherwise it's overkill.

The distant diver

An excellent technique for adding scale to an existing scene is to try to separate the diver from any cluttered background and surround him or her with blue or green water. You can do this by obtaining a low viewpoint, and shooting up into mid-water.

Whether you choose a vertical or horizontal format, remember composition and the rule of thirds. For instance, your buddy could be simply placed in one of the thirds, using a hand light to direct the viewer's attention to the main subject.

As your experience of taking this type of photograph develops, think about pressing the shutter when the model is exhaling. Bubbles create further interest, another plus factor. However, with so many other things to think about it is a feature which is often neglected.

A closer view of your model

As a distant diver swims closer towards the photographer considerations and objectives begin to change. At distances of 2 m or less you should be aware that the light from your flash gun may fall on your model.

You should also consider:

- the direction of movement of the diver
- the appearance of the diver
- the position of the face mask in relation to the lens axis
- if the diver is using props think too about the role these props are to play.

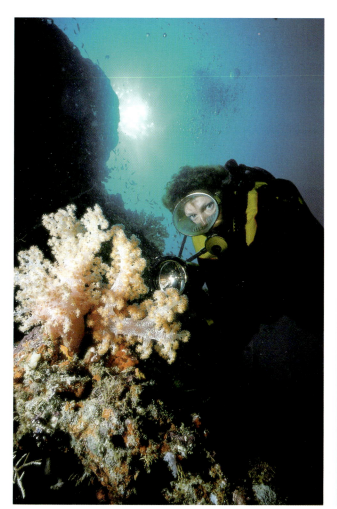
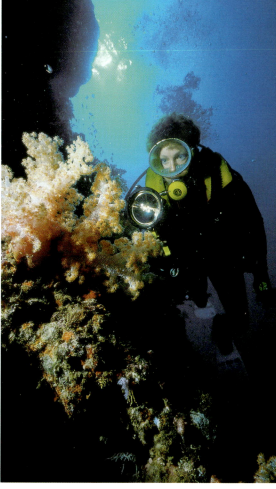

Figure 20.2
These two shots illustrate the model looking for instructions: 'Where shall I look', 'What shall I do'. The second example is correct. My wife Sylvia is exploring the colourful reef. With the two pictures side by side, it is easy to see the negative effect that staring straight into the lens has on the viewer.
Nikonos 111, 15 mm lens. Oceanic 2003 manual flash gun. Ektachrome. Maldives.

Lighting

You intend to balance the available light (*f*8) with fill-in flash on the soft coral. You choose selective sidelighting in order to illuminate the subject without including the wall around it. Standard front lighting would only light a wide area around the coral and leave your model in shadow. Instead, your intention is to allow the viewer to ponder: 'has the torch lit the coral?'

This type of shot is not limited to tropical waters. Wrecks and reefs around the UK can be used to the same effect, simply by substituting anemones and deadmen's fingers for soft coral.

A practical approach

You have spotted a specimen of soft coral growing from a reef wall and your buddy is going to pose for you in order to add scale and depth to the photograph. Your equipment is a Nikonos III camera with a Nikonos 15 mm wide-angle lens and an Oceanic 2003 flash gun. Frame the soft coral as you wish through the viewfinder. Then, if you can, let your buddy view the scene in the same perspective: it will help communications if he or she has an idea of your intentions.

Consider the exposure! You want to balance the flash exposure on the soft coral with the available light in the water. You take a light reading on the blue water which surrounds the soft coral. It indicates f8, 1/60 s. You are aware that by decreasing the aperture through f11, 16 and 22 you will darken the blue water into black. You choose a natural, realistic approach to the shot and set the f-stop at f8, as indicated by your light meter.

From the outset a diver who is prominent in the picture must be doing something interesting or looking at something if the shot is to work. If your buddy is looking into the lens the picture is simply saying 'Hello – I'm a diver'. Any other subject matter will be lost. Try equipping your buddy with a powerful hand light to act as a prop and reinforce the main subject – the soft coral. By using a variety of hand signals familiar to you both, you indicate what you want to happen:

1. Swim through the scene
2. Maintain eye contact on the subject
3. Direct the hand light in the same direction.

Check your camera aperture, speed and focusing. Compose the picture, leaving the area in the bottom right hand corner for the model.

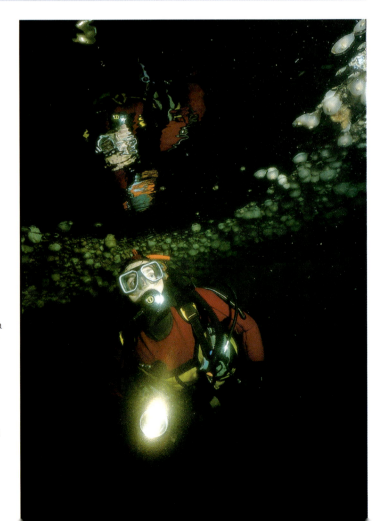

Figure 20.3
I positioned my model beneath an airlock at an excellent photo site called 'The Cathedral' off St Abbs, Scotland. The reflection has added a sparkle to the picture. The eyes are well defined, bright and provide a strong focal point in which to attract the viewer's attention. The diver appears interested in what he is doing and the feeling of exploration shines through.
Nikon F2. 16 mm fisheye lens in an Oceanic Hydra housing. St Abbs, Scotland.

Figure 20.4

This is a planned shot taken beneath Town Pier in Bonaire. I was instructing two students in wide-angle diver photography and modelling. I took a whole roll on co-ordinating two divers by means of a top-side briefing and a variety of hand signals. The purpose of the shot was to capture the mood beneath the pier. For that reason I wanted to avoid the two divers being too close to the lens and causing a distraction to the viewer by pulling their interest away from the super structure of the colourful pillars. There must be many identical images circulating the UK as my students each took a whole roll depicting a similar theme. Nikon F90x. 16 mm fisheye lens. Subal housing. Sea & Sea YS120 positioned on the right-hand side of my housing on a 120 cm flash arm. f4 at 1/30 s. Elite 200 ASA.

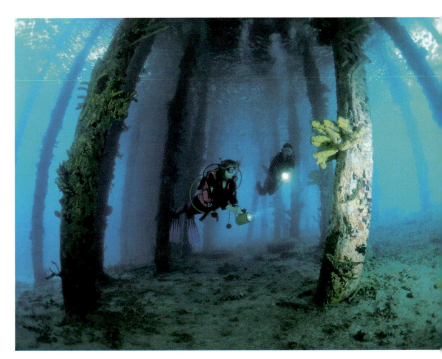

Figure 20.5

Balancing the natural light with the artificial light (flash). The exposure on the blue water indicated f8 at 1/60 s. I indicated to my wife and model Sylvia to angle the video light and her eyes towards the soft coral. On no account was she to stare directly into the camera. I hand-held my flash gun at such an angle that would illuminate the soft coral and the eyes within the face mask, depicting the notion that the light had lit the soft coral, the eyes of the model reinforcing the discovery. It's important to remember when photographing divers that to shoot them too close can often overpower the main theme of the photograph. Consider what it is that you are trying to achieve: an undersea subject with a diver adding scale and reinforcing that subject, or a diver swimming towards the camera. Balance the presence of divers without them overpowering the picture. Note the composition of the light on the third intersection and the soft coral in the other corner. See how the eyes are diagonally implied across the frame to the subject. Nikonos 111 15 mm Nikonos wide-angle lens. Oceanic 2003 flash gun f8 at 1/60 s. Ektachrome 64 ASA.

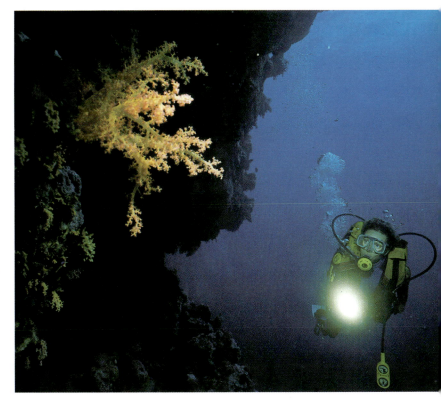

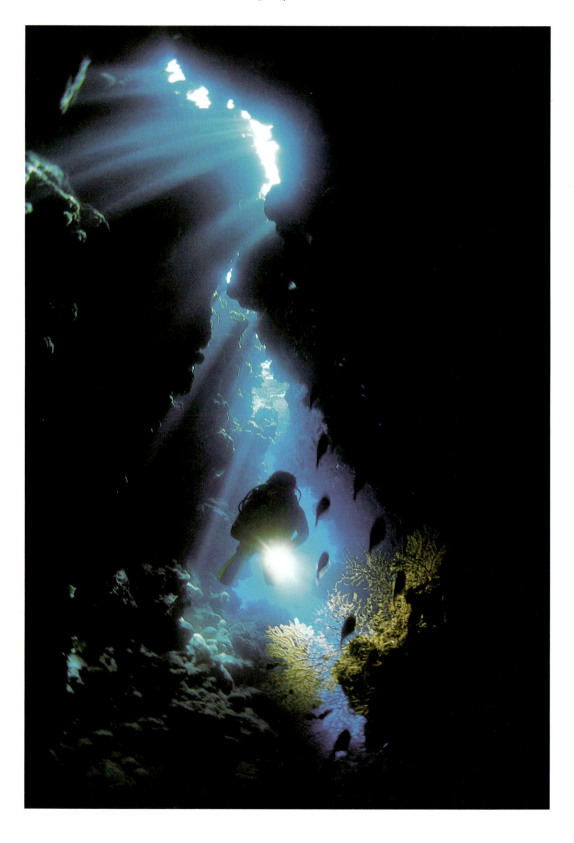

Figure 20.6 (opposite page)

Although photographed in a different cave this image has similarities with the one in Chapter 12 on 'Composition' but I have included a diver in the frame. The image is all about sunlight through light and shade, design and composition. The shutter speed of this image is 1/250 s. The aperture was set wide open at $f2.5$. I got away with the limited depth of field because of the 16 mm fisheye lens that I used. Even at apertures of $f2.5$ the lens produces a reasonable depth of field. The fast shutter speed has increased the sharpness and accentuated the rays of light. After all, it is this quality that has made the image. I tilted the cave entrance to make it appear diagonally orientated. In reality it was vertical. I took at least 8 shots without a model, experimenting with various fast shutter speeds before I noticed a small gorgonia in the bottom right third of my composition. My buddy on this occasion was taking photographs behind me. He indicated his willingness to model and I allowed him to view the scene through my viewfinder whilst I adopted the pose with the light that I wanted him to adopt. We changed places ensuring we did not 'kick up the sand'. The image looked terrific and I took at least ten shots, attempting to get the perfect composition on the model the gorgonia and the sunbeams. I tried the shot with flash but was of the opinion that natural light would best evoke the theme that I was trying to achieve. As it happened the flash-lit shots ruined the mood and were dreadful. Notice how the inclusion of a diver has not overpowered the image. Nikon F801s. 16 mm fisheye lens, $f2.5$ at 1/250 s. Ektachrome Elite 100. Oceanic 2003 flash gun switched off.

Ten tips for diver photographs

1. Your model should always avoid looking directly at the camera.
2. Try to create the feeling that your model is doing or looking at something, and wherever possible include the source of interest in the picture.
3. Various props, i.e. torch, camera, lifting bag, often reinforce your model's role in the photograph.
4. A method of communication between you and your model is absolutely essential for this type of shot to work.
5. Use upward camera angles to separate him/her from a cluttered background.
6. Capture your buddy while he or she is exhaling. Bubbles are most effective!
7. Ensure your buddy looks tidy under water.
8. Briefings and de-briefings above water are essential when a particular effect is required.
9. Remember, it is not mandatory to fill space with a diver if the shot stands up for itself. Always consider that the use of a model could ruin a shot entirely.
10. Plenty of thanks and praise go a long way at the end of a photographic session. Treat your model with respect!

Photographing Fish

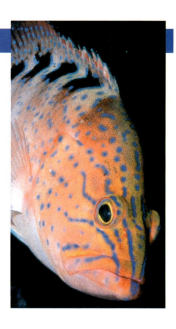

One piece of advice given to me several years ago by a renowned underwater photographer has had a profound influence on my approach to fish portraits: 'You must endeavour to show the animal or character you wish to photograph, you must get personal with your subject, as if to develop an almost silent rapport. Be concerned with making its very essence and personality jump out of the piece of film and on to the printed page.' Over the years I have come to understand this advice more and more. I can best explain the concept by comparing similarities between land and underwater photography.

Consider a photograph taken for your passport, an unflattering picture taken for identification purposes only. Now take a walk down the High Street, pop into a photographer's studio and study the portraits displayed. With the advantages of quality optics, studio lighting and so on, the studio photographer has the means to cajole expression and attitude from his subjects. Apply this concept under water. The side view of a fish, though well lit, often looks static and flat with very little impact. This type of picture is ideal for identification purposes, but not much else.

The alternative is the animal portrait – an image approached and captured in such a way as to breathe life and character into the subject. To appreciate this concept in a positive way is the secret of success. The photographer sees the subject and is able to apply his own set of principles. Certain techniques, however, can help to achieve your goal.

Figure 21.1
A vertical profile of the faces of fish create dramatic impact, but you have to experiment with species of fish that fit the format. It's habit to shoot fish on the horizontal, but with practice and a vertical portrait format some of the most common and mundane fish in the sea can be photographed like never before. The square jaw and steeply angled forehead of the soldier fish make an excellent subject. When a fish such as this poses and provides the opportunity, recognise the potential and take full advantage. An Exercise. Using an empty slide mount, scour your fish ID books. Place the slide mount in the vertical format around the profile of the fish. The idea is to recognise the shape of fish heads that work better than others. Nikon F801s. 105 mm Nikon Macro lens on AF. *f*11 at 1/60 s. SB 24 flash gun on a flexible arm. Ektachrome Elite 50 ASA.

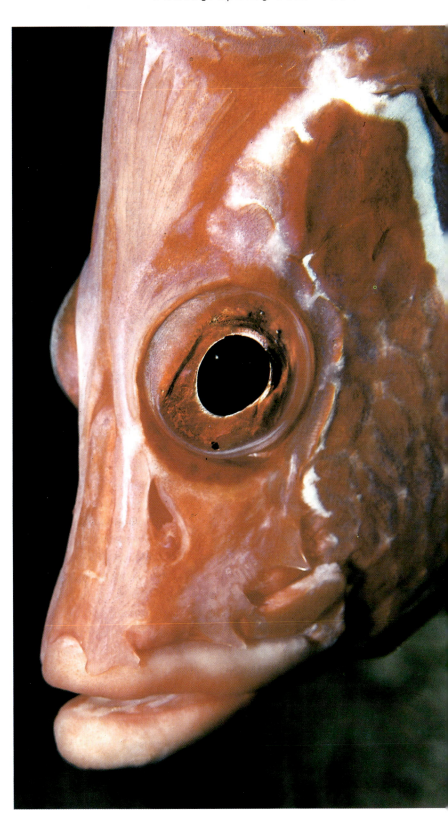

The approach

Every book without exception will strongly advise the underwater photographer not to chase after fish. We all know this advice is sound but we have all been guilty of it and often knowingly so. It should be stressed yet again that it serves no purpose whatsoever other than to frustrate and exhaust the photographer, not to mention the subject.

As soon as you see a potential subject (i.e. a fish), stop and consider the following:

- The location of the fish
- The image you would like to obtain
- Possible lighting angles
- Your angle of approach
- The backscatter that you may cause with your method of approach.

Remember that you are invading the fish's territory and so your approach should be very gradual. If possible, stand back and observe its routine. To obtain those better pictures is to anticipate behaviour. This can only occur over a period of time and requires a good deal of patience. If a subject does something interesting once, it will do it again provided that it is at ease with your intrusion into its territory. It's this behaviour that will help to capture a creature's personality – to make it stand out as a special picture. The 'peak of the action' may be a fraction of a second, a moment to anticipate that point of interest in order to turn a good picture into a brilliant one.

Where possible, camera and flash adjustments should be made prior to your approach to avoid frightening the creature away as much as possible. If this does occur, don't chase it. It's tempting but it won't work. Given time it will return and, once familiar with your presence, may provide you with the opportunity you require.

Various books describe how fish pictures should 'speak to you'. They should be face to face, close and looking at the eyes and mouth. Applying the rules of conversation, you don't talk to a person while looking down or looking at the back of their heads. So why do it to a fish!

The eyes

In any portrait, if the eyes of the subject are visible then that is what the viewer will see first. The eyes must be pin sharp or the image will fail. Try to achieve sharpness in features in front of the eyes, i.e. the mouth. The depth of field usually takes care

Figure 21.2
I find the most challenging thing about fish photography is having to make instant compositional decisions on how to frame a fish within the viewfinder to achieve maximum impact. I greatly admire the renowned underwater photographer Chris Newbert. His innovative compositions of fish are inspirational. Check out his coffee table books *Within a Rainbow Sea* and *In a Sea of Dreams*. I for one have taken to my mind's eye his compositional approach to fish photography.
Nikon F801s, 60 mm macro on AF. Subal housing. Nikon SB24 flash gun in a Cullimore housing. Elite 100 ASA. Sipadan.

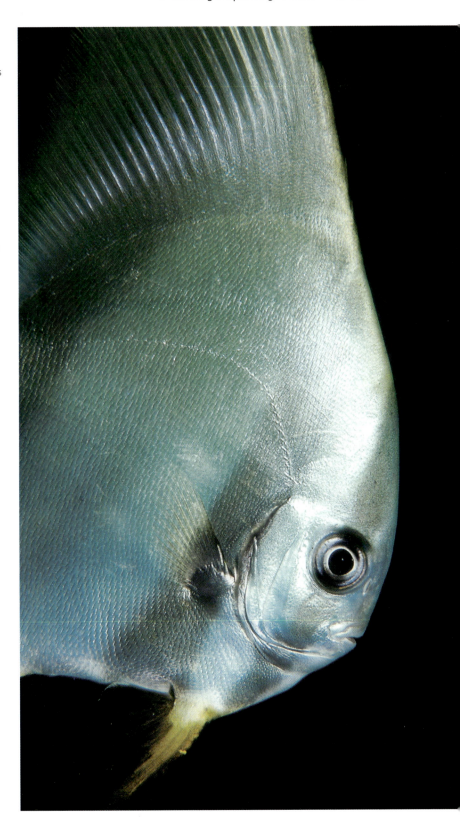

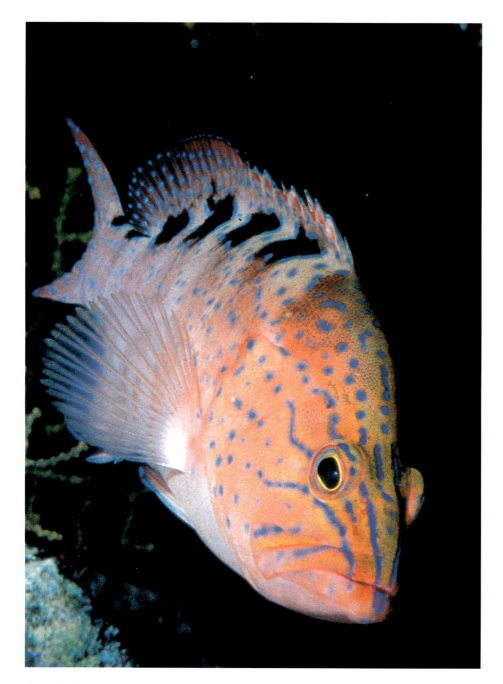

Figure 21.3
I wouldn't want anyone to get the idea that every fish I approach I decide to get slightly below it and shoot upwards at an angle of 45 degrees. Opportunity does not arise in that way. However, I am always, without exception looking for opportunities. When one presents itself I try to take full advantage. If I get lucky and the fish allows me into its territory I consider getting below it and shoot up at an angle of 45 degrees from the front. This coral grouper allowed me that opportunity and I took advantage. It's funny that the more I dive with a camera in my hand the luckier I get!
Nikon F801s. 60 mm macro lens on AF. Subal Housing. Two Sea & Sea YS50 TTL flash guns on TTL. Elite 100 ASA. The Temple, Red Sea.

of this aspect of the picture. It matters not that features behind the eyes are soft as long as the eye is sharp!

A camera angle of 45 degrees looking towards the face and beneath the subject shooting upwards is often recommended. This is a general rule and works well but after a fair amount of practice, I think you will find that every fish has a definitive angle of view which provides the potential for a perfect shot. Given unlimited time and film, you could explore these angles to your ultimate satisfaction.

Occasionally, when looking at a co-operative specimen through the viewfinder and thinking that you have obtained the correct angle, a slight deviation or perhaps a movement of its head will jump out as being perfect. But the anticipation and actually capturing the moment are entirely different.

Lighting angles

Most of the time I use two flash guns (see Chapter 23) positioned at 45 degrees to each side of the subject. These angles frequently change according to the subject's shape and features. However, I always attempt to achieve a catchlight in the eye. This can make a tremendous difference in a portrait as opposed to a lifeless eye which blends into the head. As mentioned already, a fish picture should 'speak to you'. When a person speaks, they open their mouth. A fish, elongating its jaws or opening its mouth (however slight) may be that 'peak of the action' that you've been waiting so patiently for. If you can illuminate the mouth then the picture really begins to talk and you can appreciate the tremendous photographic potential you have before you.

As your photography progresses then you should begin to consider your bracketing technique in relation to the potential of your subject – is it worth three or four shots or even several rolls? The choice is yours. And remember there are several ways of bracketing, not just by adjusting the flash as many think. You can bracket on the basis of flash distance, flash angle, choice of sharpest focus, angle of view, composition and even in anticipation of the peak of the action. All this uses film and you have to consider whether the subject you have selected is worth it or not.

Moving subjects

Moving subjects such as sharks, mantas and others like them are a different consideration. It would be naive to suggest that you should observe a shark swimming past in the hope that it

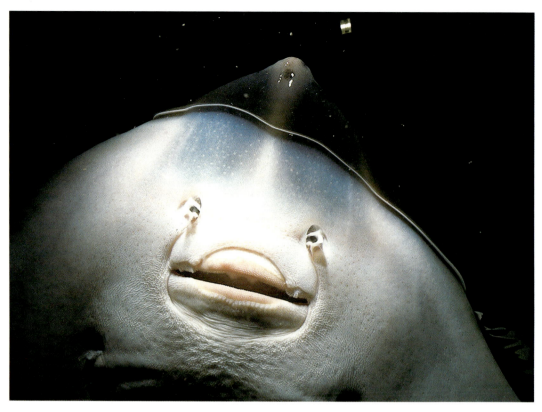

Figure 21.4
Attempting to show the personality and character of the fish which you are photographing is so important. There is no magic wand, rule or guideline in this area of underwater photography. It is just a matter of trying to silently 'talk' to your subject, gaining a hint of recognition and in so doing, a spark of personality. Nikon 801s 28 mm lens SB 24 flash gun. f16 at 1/60 s. Kodachrome 64 ASA.

will turn around and re-perform. It won't. So this type of shot needs to be thought out very quickly, i.e. set your aperture, preset your focus and anticipate its direction of travel. If possible, position yourself on line and hope that other divers don't spook it. Panning is a technique that should be employed in these circumstances, following your subjects' movement with the camera and pressing the shutter while the camera is still moving. This creates a blurred background but puts the creature in sharp focus.

Equipment for fish photography

My own favourite is a 60 mm AF-Nikon lens behind a flat port in a housing, closely followed by the Nikonos system with a 28 mm lens. However, I know many photographers whose first preference is the 28 mm Nikonos because of the more lenient

Figure 21.5

Fish behaviour! An aspect of fish photography which is not my strong point. In the last couple of years I have vowed to give more time to this topic. When I spotted this cow fish feeding on a jelly fish close to the surface in Bonaire I prepared myself for a long wait in order to capture behaviour with the added attraction of a reflection. I was rewarded but it took me 20 shots to achieve it. It's important that those of you just starting out in underwater photography appreciate that not every encounter will provide results. You must realise just how many shots are sometimes required to get the one you're after.

Nikon F90x, 105 mm macro lens on AF. Subal Housing. One Sea & Sea YS50 TTL on TTL (I pointed the other flash away from the subject). f11 at 1/125 s. Elite 50 ASA.

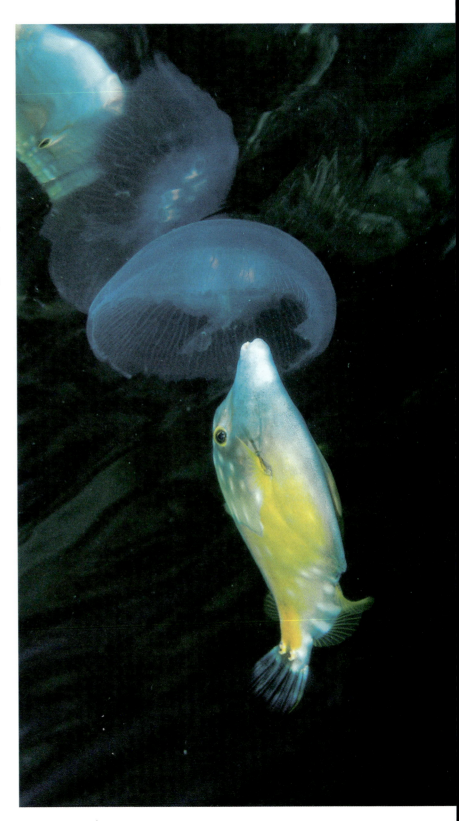

depth of field and increased angle of view. For a true portrait a Nikonos user would probably use a Nikonos Close-Up Outfit on either a 28 or 35 mm lens or a 1:3 extension tube. With patience you can entice the fish into the frame and obtain some stunning shots.

Every aspect of fish photography requires total concentration and loads of patience. Always consider the potential of the subject and be prepared to use lots of film in getting the image you want. The more time you have the better, and staying as shallow as possible will also help to give you this. It's important that you yourself have a standard of excellence, an idea of what a good picture should be and to keep trying until your work begins to match up to it.

In conclusion

The American photographer, Avedon, once wrote: 'A portrait is a photograph of a person who knows they are being photographed'. Apply this concept to the underwater world. You will see many stunning fish pictures which reflect this attitude. Catch the mouth open and illuminate the eye with a catchlight and you could have a winner!

Photographing Schooling Fish

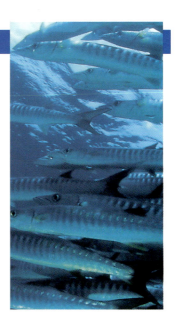

Most scuba diving magazines feature several shots of schooling fish, usually printed large. Pictures of large schools of jacks and barracuda are seen as an ideal way to sell diving destinations.

Over the last five years I have had considerable experience of this type of underwater photography. I have to say it has proved far harder than I first thought. I have extended the captions to the images in this chapter and this will give the reader a true perspective on 'how that shot was taken'.

Initially, the photographer should try to edge as close to the school as possible. The lens should reflect this. A 16 mm fisheye over a 28 mm lens may be preferable if the school allow you close enough.

In my experience, the biggest problem to overcome is how to illuminate such a wide area with artificial light. These are the type of problems which you will need to overcome. Lets discuss them in detail.

- Dive key sites repeatedly to acquaint yourself with the habits of the fish.
- Get as close to the school as they will allow. If you can repeat these photo sites so much the better. You know which lens to choose before you get into the water.
- Using natural light on wide angle can be very effective with big schools of fish, but adding just a hint of flash can lend your image a certain verve.
- A wide-beamed strobe is preferable, attached to a long flash arm in order to get it away from the camera lens and spread

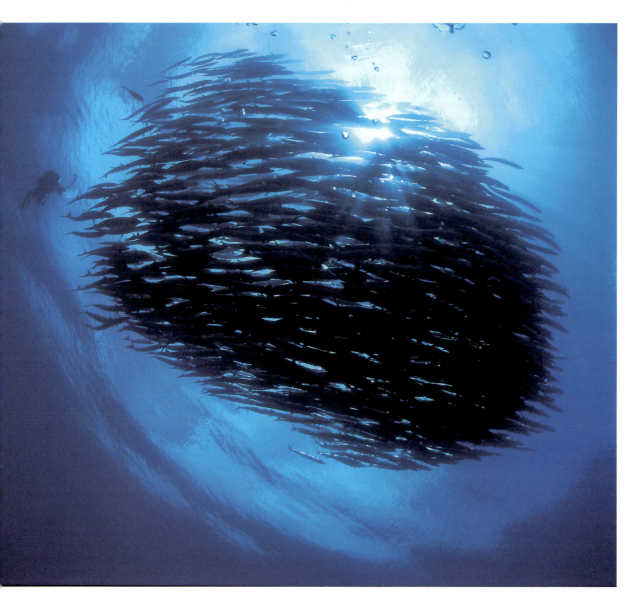

Figure 22.1

The now world famous schooling barracuda can be found (with patience and a good boat-man) on most occasions. I have taken this silhouette type image many times but there was always a misshapen pattern about the fish. On this occasion I saw a lone photographer chasing them and realised a good opportunity of giving the school a sense of scale and perspective. When I looked up through my viewfinder and saw the arc of Snell's window framing the composition and a sharp sunburst dancing around the school, I knew that I would be following below them and pressing the shutter until my film ran out! I was hopeful that I had captured a large school in some assemblage of order. I bracketed my aperture but maintained the same composition. In most of the shots the fish were untidy, in others I overexposed the sunburst. The one above pleased me and on reflection was not difficult. However, be prepared to use plenty of film. Nikon F90x Subal housing, 16 mm fisheye lens. A Sea & Sea flash gun that was pointed the other way because the flash to subject distance was too long. (TIP: If you know that your flash will never reach the subject (no matter how much you open the aperture), turn it OFF so as to prevent backscatter. This will also allow your camera's automation to select shutter speeds below or above the 1/60 to 1/250 range required for flash sync photography. You can turn it off, but remember to turn it on afterwards!)

1/250 s shutter speed bracketing apertures between f5.6 and f11. Film stock was Ektachrome Elite 100 ASA.

Figure 22.2

Take every advantage of the fish that always seem to meander away from the main school. I took this shot in shallow water around Bonaire. I tried shooting the main school but I knew that I had achieved nothing more than depicting 'loads of fish swimming in every direction'. A few stragglers were left behind so I concentrated on them. I picked out six or seven fish and swimming along side alternated between a landscape and a portrait composition. I selected an aperture that would provide a dark blue water background. Using a Nikonos 111, Nikonos 15 mm wide-angle lens, a Sea & Sea YS 120 TTL on manual mode, I had no other alternative than to select 1/60 s shutter speed because of the flash camera sync speed. Apertures were bracketed at $f11$ and $f16$. Film stock was Ektachrome 100 ASA.

the light evenly over the school. If one flash is good then two is certainly better for fish schools. With two you can spread a soft, even light at such an angle that the fish scales do not reflect back into the camera lens like a mirror. Out to the side at an angle of 45 degrees works well but take care not to get the flash in the corners of the frame with wide angle lenses, especially the 16 mm fisheye.

- When shooting a school in mid-water using a slightly upward camera angle and 100 ASA film, it is not uncommon to achieve natural light exposures of $f16$ and $f11$ with 1/60 second shutter speed. This records the school as a part silhouette against the under-surface of the sea and the sunburst. When you use a flash gun/s, these small apertures of $f16$ and $f11$ do not allow the light from the flash to carry more than about 1 metre through the water and back again into the lens. It is very difficult to approach this close to a school. Three to five metres is a more realistic scenario. Using $f11$ will not allow the flash to reach the school. So what is the answer?

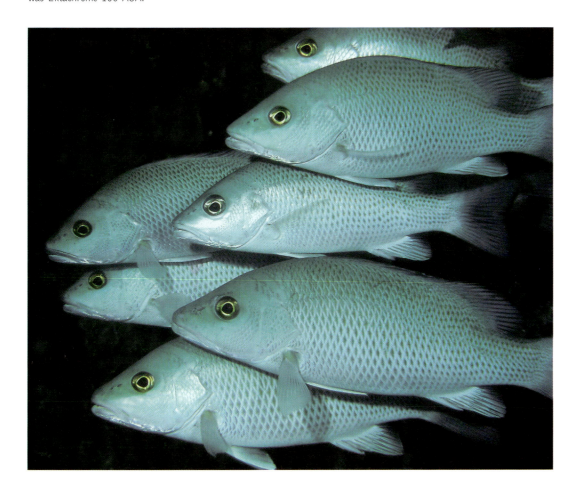

- With a camera that has a fixed flash sync shutter speed, i.e. Nikonos V, which defaults to 1/90 s when using a flash, there is not a lot you can do. However, many other makes of cameras these days have a flash sync shutter speed up to 1/250 s. So, select the fastest shutter speed available with a flash, i.e. 1/250 s. Use aperture priority metering mode and point the camera at the wall of blue water behind the school. The camera will select an aperture based on the natural light levels. As I have mentioned *f*11 is often an available light reading in blue water, looking towards the surface with a 1/60 s shutter speed. So, when you select 1/250 the aperture reverts to *f*5.6/*f*4. This allows the flash to travel much further through the water column and paints in a 'kiss of flash' on the fish scales.
- The faster shutter speed freezes the motion of the school, a great advantage. The only disadvantage is the reduction in aperture which also reduces the depth of field. However, using wide-angle lens which have great depth of field, this should not be a problem.

I describe the art of photographing schools of fish as 'organised chaos'. Unless you are working with a school of fish that is and continues to remain in a tight, orderly assembly, you will have your work cut out. Nevertheless, 'shooting schools' can be a tremendously rewarding aspect of underwater photography. It's exciting, it will test your skills as a photographer as well as showing up your weaknesses. For those images which you do obtain, schooling fish photography can also be particularly profitable.

'Endeavouring to anticipate order, harmony and impact out of a chaotic, disordered and jumbled school of fish.'

Allow me to explain. For those readers interested in photographing marine life, there is a good chance that you have a video at home recorded from a nature programme on television or purchased after a diving expedition.

Find some footage of schooling fish

A video camera will record the behaviour of the school in real time. Concentrate on this footage, watch it several times if you have to. Concentrate on the occasions when the fish are just a chaotic mass swimming together but not as one harmonious unit. Video illustrates this kind of fish behaviour over a matter of seconds or even minutes. With a still camera we have a split second to illustrate the same behaviour. We may have 36 chances of getting it right but the objective is to capture the expression of the school in a frozen moment.

Figure 22.3
A fast shutter speed of 1/250 s as
complimented an aperture of f5.6
with Ektachrome Elite 100 ASA.
This aperture has allowed the flash
to carry all the way to the schooling
barracuda and paint them with
light.
Nikon F90x, 16 mm fisheye lens.
Subal housing. YS 120 TTL flash on
TTL. Long Subal flash arm.

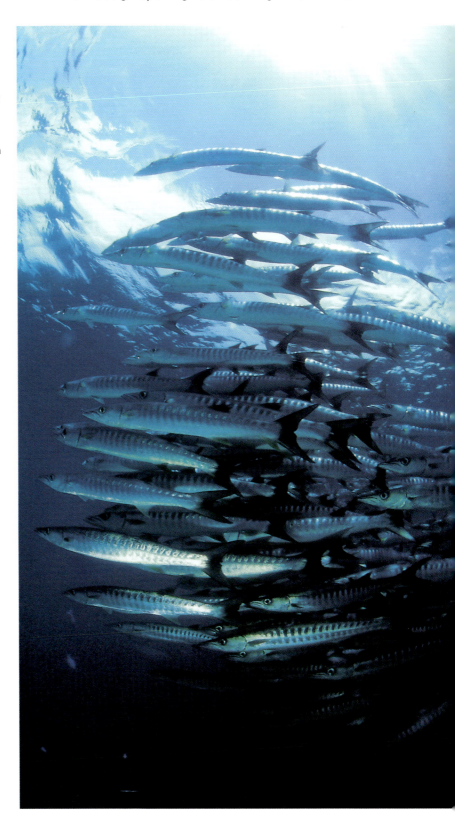

Using your VCR remote control hand set, watch the footage again, and by using the 'pause' button freeze the footage when the school has achieved *order, harmony* or *impact*.

This rationale of achieving 'order' can be found on posters, T-shirts, line drawings, etc. Consider the printed designs on the sweat shirts that are found in their hundreds at national diving shows. The artist/designer is not confined to the reality of a camera. They can sketch all colours, shapes and sizes of schooling fish but one thing that each will have in common is this sense of harmony and order in the visual design that I have described. There is no better exercise to sharpen your photo-perception than to study the design of fish animations on posters and clothing.

The next hurdle is taking this technique into the sea

Whenever you have the opportunity to photograph schooling fish, reflect on the lessons you learned from the VCR pause button exercise.

Order and *impact* are subjective considerations which I have given in order to explain the approach that I adopt and recommend to my students.

Dual Lighting – Macro and Close-up

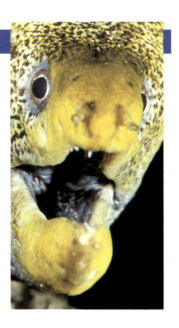

Adding a second flash gun

Most beginners to underwater photography use either a Nikonos, Sea & Sea or SLR in a housing, with just one flash gun which is usually fixed on the left-hand side. On your first few dives even the smallest camera system will feel bulky and inconvenient as you carry it around trying to remember the advice you've been given. There is so much to think about. Indeed, as a beginner I vowed never to take a camera diving with me ever again! I'd taken a roll of lousy pictures, got in everyone else's way and missed all the outstanding aspects of the dive, which everybody else had seen except myself. (Have you ever noticed how other divers are so eager to point out to photographers things that they have missed?)

However, several months later with 20 or so rolls of film under my belt, it became difficult to imagine diving without a camera. I was eager to experiment and in time I became aware of the techniques of dual flash gun lighting. So if you have thought 'Shall I, shan't I?', here are my own views.

Dual lighting, as the name implies, is a very popular technique with land photographers the world over, and underwater photographers have adapted similar techniques with the same ideas in mind. A second flash is introduced not to increase the intensity of light as is often thought, but to:

- reduce the harsh shadows caused by the use of one flash with extension tube and close-up photography
- increase and enhance the quality of light
- increase the area of coverage.

Figure 23.1
Dual lighting angled in such a way as to illuminate the subject without illuminating the column of water between the lens and the subject.

Available light comes from two sources – directly from the sun and indirectly as diffused or reflected light from the sky and clouds. Of these the sun produces strong highlights, while the sky and clouds fill in the shadows with a softer light.

Have you ever noticed the dark shadows in your holiday snaps on land taken around midday in a sunny, cloudless sky? It is because the sun is very directional. On a cloudy, overcast day the light is scattered and lighting is flat without shadows.

Under water, the addition of a second flash placed on the opposite side to the first will fill in the shadows that are so often created in macro and close-up photography.

Second flash in more detail

The second flash technique requires a little closer consideration. The main flash is usually the one connected to the camera or housing by a sync cord and positioned on the left-hand side. A second flash is then introduced in one of two ways:

• as a slave flash gun which fires when its sensor detects a burst of light from the first flash, or
• as an ordinary flash gun with a sync cord also connected to the camera by means of a 'T' connector. This connector attaches both flash guns directly to the camera and it ensures both fire at once.

Of the two the latter option will always be more reliable. The first flash is positioned on the left-hand side by either a flash arm or by hand-holding it in a similar position and at the normal distance from the subject. The second flash should be

attached on the right-hand side by either a flash arm or a bracket (it is impossible to hand-hold the second flash). You should be able to position it in such a way as to fill in the shadows created by the first flash.

Of course, the photographer must consider carefully the shape of the subject and where the shadows will fall. It is not the intention to eliminate the shadows completely just to reduce and soften them. Shadows are often cast over a subject by the close-up framer or extension tube posts. They catch us all out on occasions but a second flash can rectify this.

It is often said that the second flash should be positioned several centimetres further from the subject than the first flash in order to create the softness. This is a very general guideline. It all depends on the make, size and output of the two units. It also depends on your preference as to how you want the shadows to appear on film.

Experiment with flash distances

Experiment with flash-to-subject distances of the second flash and bracket your exposures. I use two flash guns for both Nikonos Extension Tube/Close-Up work and Housing work. However, neither are fixed in any particular position but both can be placed wherever I like within reason.

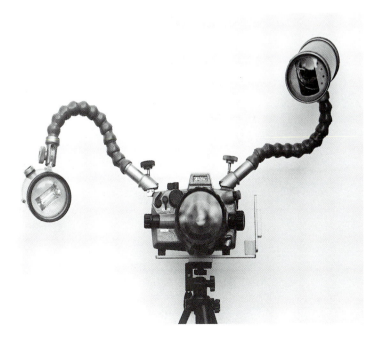

Figure 23.2
UK 'Andy Hirst' flexible flash arms.

Figure 23.3a and b
The angle of light demonstrated by the photographer in Figure 23.3a (left) is extreme side lighting. In Figure 23.3b (right) the photographer's main flash is hand-held as back lighting The fixed slave flash gun on his right is standard front lighting. These are just two combinations; there are many, many more.

Some flash combinations

Some ideas for combinations to use light in this way are:

- 1st flash backlights the subject with the 2nd flash filling in the front of the subject about 2 stops weaker
- both flash gun extreme side light from left and right
- 1st flash left-hand side light, 2nd flash top light or visa versa, depending on the subject's orientation
- 1st flash front light, 2nd flash top light.

You can probably think of many others. Once again, experiment with distances and apertures. One roll of film testing various combinations will provide you with an accurate starting point.

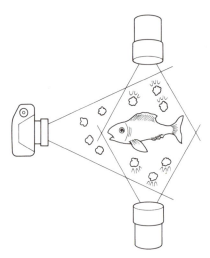

Figure 23.4
Extreme dual side lighting is a good way to minimise backscatter.

A personal view

With Nikonos photography I hand-hold the first flash on the left-hand side. The second flash is attached to a moveable arm on the right. I preset this flash at the normal distance from the particular subject and bracket the flash-to-subject distance with the hand-held flash. I happen to know (through testing) that with my Manual Ikelite MS flash gun with 1:1 tube distance is 10 cm from the subject, 1:2 tube is 15 cm, 1:3 tube 20 cm using a 35 mm lens and a Nikonos Close-Up framer is 30 cm at f22 at 1/60 second shutter speed. Using my Nikon F801s in a housing I preset both flash guns according to the subject, its orientation and the angle and combination of light I feel appropriate. In each case I bracket apertures.

Opinions as to the use or not of additional flash guns are well divided. There are many excellent underwater photographers who use two flash guns and as many others who believe that the extra weight, bulk and reliability is not worth the effort. Once again, like so many other issues it is a personal decision that each individual must make.

Figure 23.5

Perhaps the most superb specimen of plumose anemone that I have ever photographed. Growing proud off a small boulder near to the sea bed the plumose allowed me countless angles in which to compose it and numerous options in which to light it, the sole reason that I chose that particular one. In reality, the ocean around it was emerald green which, if exposed at f5.6 at 1/30 s on 100 ASA, would have recorded it similar to how my eye perceived it. However, due to depth of field considerations and a number of novice divers in the background performing various drills, I closed the aperture to f16 which darkened the green water background to black. Dual lighting from a TTL flash on the left-hand side (hand-held) and a manual slave unit on the right-hand side (flash arm) have enhanced the impact by providing dual acute side lighting. Note the subject's base, the vertical format and slight diagonal orientation. Nikonos V, close-up kit with the Nikonos 28 mm lens. YS 50 TTL flash gun and an Ikelite MS slave flash both on flexible flash arms. Ektachrome Elite 100 ASA. St Abbs, Scotland.

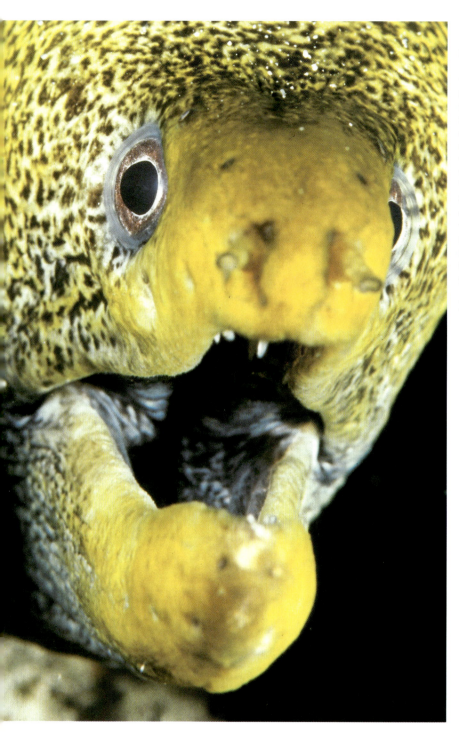

Figure 23.6
Bright and colourful, this yellow
moray was an ideal subject for dual
lighting. The shape of its head has
two definitive sides to it. Extreme
side lighting from right and left has
made the eel stand out from the
negative space, creating a halo
around its features. Note the
composition of the eyes on the upper
thirds and the mouth on the lower
thirds. I asked myself the question:
'Is there a definitive moment that
will make a better photograph?' I
decided that there was and waited
for it to open its mouth as morays
do. Nikon F801s 105 mm Nikon
macro lens. f11 at 1/60 s. SB 24
flash gun and a Ikelite MS slave
flash both on flexible flash arms.
Ektachrome Elite 100 ASA. Eilat,
Israel.

Figure 23.7

This moray was taken thousands of miles away from the one on the previous page but the technique and result are the same. My flash guns were placed each side of the head to give that halo-glowing effect, but beware. If you get one flash wrong the picture can be ruined completely. Consider approaching the subject with one flash turned away or turned off! When you have taken a series of shots and you know that you have 'one in the can' then introduce the second flash. In my opinion this is the best way to start dual lighting for macro and close up. If I had taken this course of action 15 years ago I would have rescued numerous opportunities. Instead, I introduced two flash guns right at the start of the session and as a result ruined many rolls of film.

Nikon F801s, 60 mm macro lens on AF. Subal housing. Sea & Sea YS 50 TTL flash on the left and an Ikelite MV flash gun with EO lead on the right. Elite 100 ASA. Lanzarote.

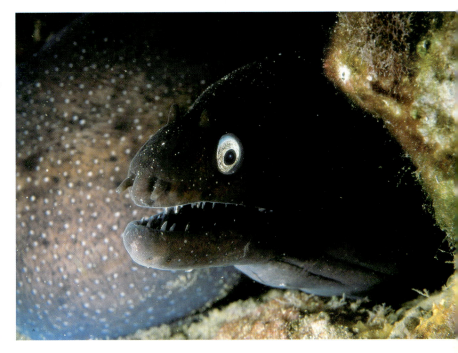

Figure 23.8

Two flash guns were used to light this lion fish in the Red Sea but can you tell the difference between one flash or two. Dual flash is very much a matter of taste and the reader must make a personal choice on whether or not to pursue this technique. Notice the excellent negative space, the diagonal orientation of the subject and the 'Peak of the Action' as it spread its wings in flight. My advice is to become proficient with one flash before you introduce a second. Nikon f801s. 20 mm wide angle lens on manual focus. Subal housing. Two Sea & Sea YS 50TTL flash guns both on TTL. f8 at 1/125 s. Elite 100 ASA. Red Sea.

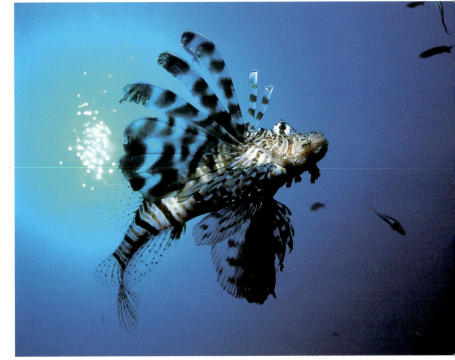

A Ring of Light

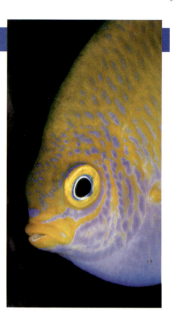

Have you ever had at a time in your life something you wanted to try? Perhaps a goal to achieve, or a problem to solve, which many tried to talk you out of, persuade you against, quoting every reason in the book why they thought this was a bad idea. Does any of this sound familiar to you?

This chapter is all about following your instincts regardless of what the masses say. It concerns an idea which I have nurtured for a number of years in regard to a vital piece of equipment – the flash gun!

More than 15 years ago I read an article in a UK photography magazine concerning macro photography of insects with the use of a ring flash. The author was passionate and enthused at length about the quality of light he had achieved with his subjects.

So was I. I thought the quality of light was excellent and those images have remained at the forefront of my mind's eye ever since. Over the years, numerous papers which I have read and numerous symposia which I have attended have often warned against the dreadful effects of using a ring flash. A very famous land nature photographer once quoted that a 'ring flash should never be used on any account'.

You will now know that I took little notice of these opinions. I followed my gut feeling, discarded everything I felt was not pertinent and became very impatient to try a ring flash on a macro lens under water.

I badgered several of my close friends in the business. 'Make me a ring flash, put it in a macro port and let's try it.'

The concept became a reality in September 1998 courtesy of my friend and photographer Ken Sullivan who runs Photo Ocean Products. A week later and fixed to a Subal housing containing a Nikon F90x and a 105 mm auto focus macro lens, I put a prototype ring flash through its paces in the waters around Sipadan.

Before we go diving, allow me to explain that the ring flash was originally designed for shadow-free shooting of hollows and crevices at close range. Included in that subject matter was medical applications and macro work in nature photography. To that end it has been used in surgical and topside macro photography.

A ring flash does just what its name implies, encircling the camera lens with a flash tube so that the light is projected forward from the camera.

What struck me immediately was its ease of use. In the absence of flash arms and flash guns protruding from the housing, it was far easier to approach small marine life. I can honestly say how little I appreciated the impact that attachments to the rig (flash arms and flash guns) have on the photographer's ability to stalk a subject at close range. *For this reason alone the ring flash must be taken seriously in future underwater applications of macro work.*

Because of the absence of flash arms and guns it became an effortless task to get closer to nooks and crannies which before were placing the subjects in shadow without running the risk of damaging the surroundings.

Other advantages the ring flash has over traditional underwater macro (60 mm macro and 105 mm lenses) are:

- The photographer can rest assured that the light source is not going to MISS the subject.
- The flash position remains constant as the magnification of the subjects changes, i.e. 1:1 ratio (life size), 1:3 ratio (third life size). Choosing the correct aperture for the TTL ring flash becomes a simple routine.
- The photographer is free to concentrate on composition secure in the knowledge that flash arms and guns are not damaging the reef.

Exposures

My prototype ring flash provided a guide number underwater of about 11 (in feet and inches). My preference with macro and traditional flash guns is a slide film speed of 50 ASA. A shutter speed of 1/125 s (shutter speeds have no effect on the quality

or intensity of light emitted from a flash gun). I prefer a aperture of $f16$.

The first test roll using 50 ASA $f16$ at 1/125 s left the ring flash underpowered and under-exposed by about two stops.

On the second test I used 100 ASA slide film, $f16$ at 1/125 s. This again resulted in slight underexposure on all but the closest 1:1 ratio subjects.

For the third test roll, I used 100 ASA slide film at 1/125 s, but this time opened the aperture to $f11$. After these three rolls I was able to select $f16$ for bright subjects, $f11$ for average bright subjects and $f8$ for dark subjects.

The disadvantages

• Because the ring of light encircled the lens a graphic shadow was occasionally created around the subject.
• This flat and even light source occasionally made the subject look like a cardboard cut-out. The light shortens and reduces the appearance of shadows. No matter what distance the subject is from the background (if the size of aperture allows the background to be illuminated), the shadow of the subject falls immediately behind it.
• Backscatter! It only became evident beyond a port to subject distance of approximately 90 cm. This fact astounded me! I was positive that the application of ring flash would be flawed through backscatter beyond 30 cm. It was astonishing that backscatter was absent to this extent.

Therefore, shooting at a flash/port to subject distance of more than 90 cm using a ring flash becomes impractical and the quality of the image becomes inferior.

Conclusion

The crucial question you must ask yourself is:

'Do I like the quality of light that the use of a ring flash produces?'

If the answer is 'yes' then consider it for the future. I will leave the choice to the reader with the following portfolio of images which I have recently taken. I used the prototype ring flash on apertures of either $f16$, $f11$ or $f8$ at 1/125 s with Elite 100 ASA film. 105 mm AF Nikon Macro lens on a Nikon F90x in a Subal housing.

Author's note

At the time of writing details of ring flash ports can be obtained from Photo Ocean Products (UK) details of which can be found in Equipment Suppliers and Useful Addresses at the back of the book.

Figure 24.1

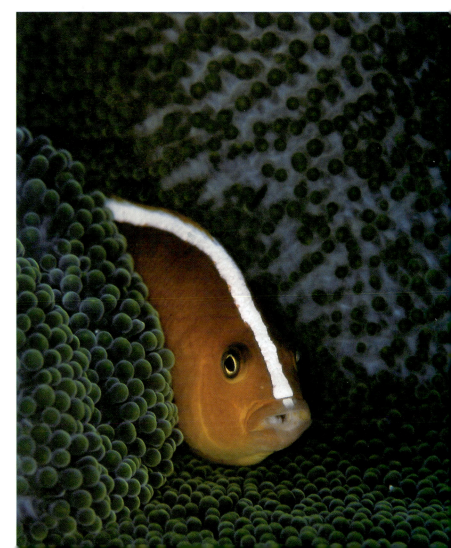

Figure 24.2

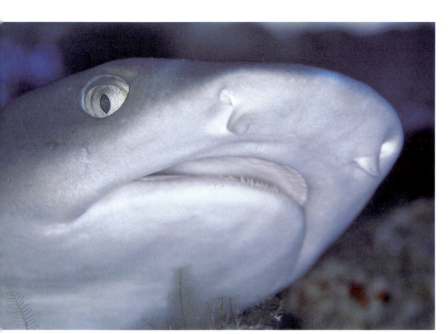

Figure 24.3

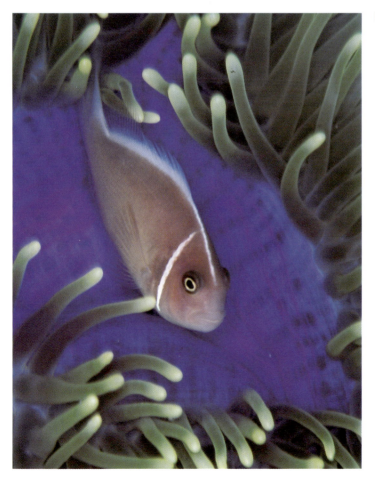

Figure 24.4

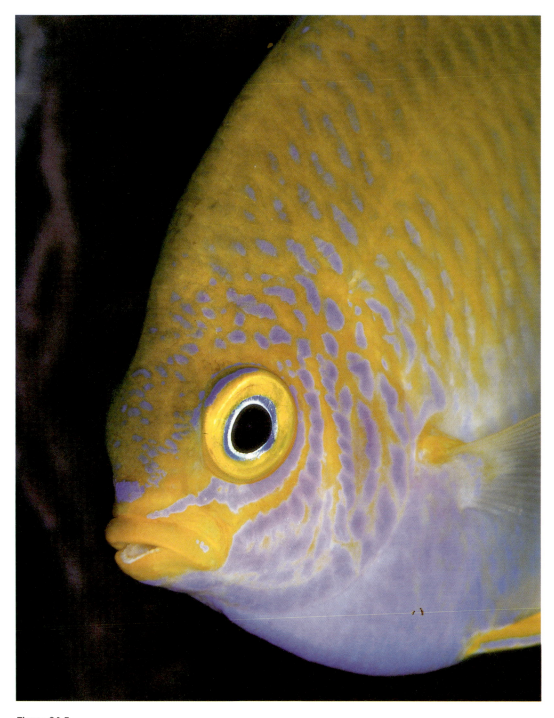

Figure 24.5

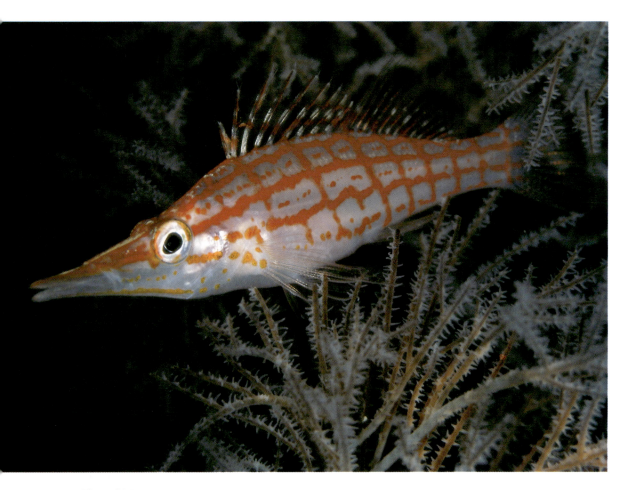

Figure 24.6

Blue-Water Macro Techniques

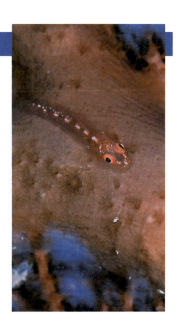

Some stock libraries often disapprove the technique of depicting close-up and macro underwater images against black backgrounds. One library recently described a selection of images as 'always being taken at night'.

We all know that nothing could be further from the truth. However, it is a fact that many small subjects can achieve a greater impact if placed against a clear, uncluttered background. As you will have read in a previous chapter, the blue water column provides an ideal background. For the macro photographer sufficient depth of field for this type of shot is paramount and apertures of *f*22 and *f*16 are preferable.

An underwater flash gun restores the colours to the subject which are lost due to refraction. When blue tropical water is exposed at small apertures (*f*16) with 100 ASA film, a dark blue or black background is recorded. This records excellent negative space (everything in the photograph which is not the subject).

But how can we please the stock libraries? One method is to shoot all subjects against the reef but I can assure you that the majority of your results will look unattractive and cluttered.

There are various methods where it is possible to retain a colourful background but all have disadvantages to some degree.

- I know underwater photographers who open the aperture of a traditional macro lens, i.e. Nikon AF 60 mm macro lens from *f*22 to *f*5.6, *f*4 or even larger. This may provide a vivid

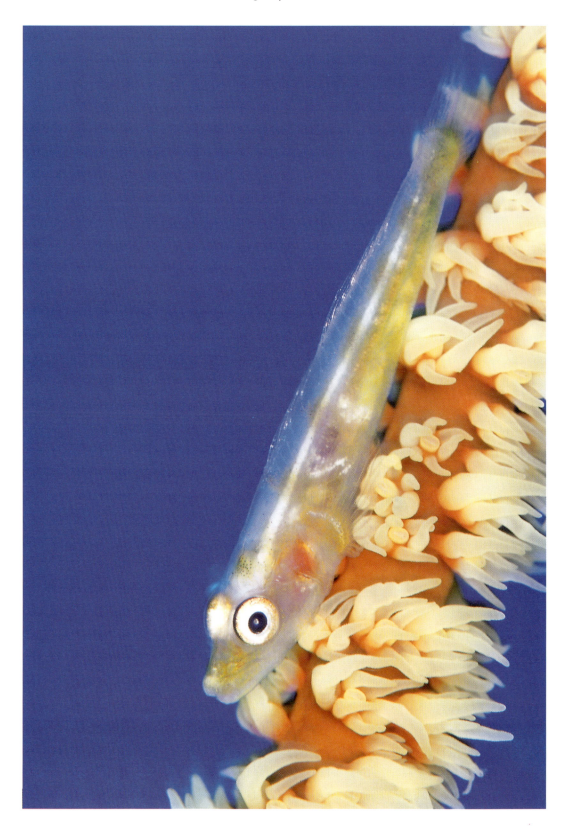

Figure 25.1 (opposite page)
In manual exposure mode I selected either $f16$ or $f11$ and opened the shutter speed to give me an ambient light reading on the blue water background. With my macro lens extended to almost 1:1 ratio, the shutter required at least 1 second exposure. I composed on the diagonal with the eye on the bottom third. I used 'S' single servo AF mode and pressed the shutter. I took at least five shots to be sure of getting one which worked. I bracketed the shutter speed to lighten or darken the shade of blue.

blue-water background however the trade-off is insufficient depth of field.

- Some photographers use coloured filters which they place behind the subject (if circumstances allow).
- Using a faster film speed, i.e. 800 ASA may provide a blue-water background at $f22$ or $f16$. The disadvantage is the increased grain of the film stock.

I have a preference for another technique which is orientated around shutter speed selection. I use Nikon 60 mm or 105 mm macro lenses. I take time to select a subject which I can shoot against a blue-water background. I set a conventional aperture for the film speed and flash techniques, i.e. $f16$ with 50 ASA Kodak Elite film. Using my Nikon F90x in either manual or shutter speed priority mode I position the flash for the subject and then adjust the *shutter speed* so that the camera's meter indicates the correct combination of aperture and shutter speed to record an ambient light exposure. For instance, $f16$ at one half second.

Using this technique I can retain a suitable depth of field at a comfortable flash to subject distance. By bracketing the shutter speed I am able to manipulate the shade of the background water column.

> But what of 'shutter shake' I hear you cry! How can I possibly hold a camera housing still at one quarter of a second?

I can't hold it still! Shutter shake will occur to a degree; however, the duration of light from the flash is thousandths of a second. This split second burst of light freezes my movements of the housing and the subject is recorded in brilliant Technicolor resulting in sharp and colourful subjects against a vivid blue background. The 'fuzzy' areas are recorded much darker due to the interval between the flash cut-off and the shutter closure.

We should all continue to look for ideas which will develop us individually as underwater photographers. I would encourage everyone to experiment with a piece of equipment or an idea even though they think it is pointless, has been done before or is simply plain crazy.

All the images contained in this chapter were taken with Nikon F90x 105 mm macro lens on auto focus, Subal housing with a ring flash in the port. It matters not what type of flash is used. The results of blue-water macro would be the same.

Rear curtain sync flash

With the latest Nikon series of cameras using a dedicated TTL Nikon speedlight such as the SB 28, the flash can be triggered

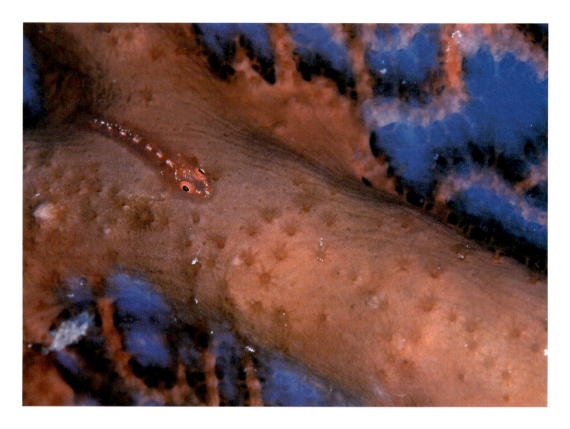

Figure 25.2

This technique can only be effective when there is a portion of the ambient light in the frame to record. If all you see of the negative space is coral or sponge then these slow shutter speeds are not required because the flash gun will illuminate the background. When you see blue water in your viewfinder when shooting macro, appreciate that a flash cannot light up the water column. That is the natural light so, to record the blue, open the shutter until the meter in your camera indicates correct exposure. In this image the colour of the fan coral and blenny has been captured by the light from the flash. The blue background is the blue water column. The dark edges of the coral is the natural light falling on the fan coral after the burst of flash has finished but before the shutter has closed.

at the end of the exposure. This allows us to record a subject's movement following a sharp image of that same subject while using a longer exposure. Land photo journalists and sports photographers are using it constantly so experimentation under water is the name of the game!

On the F90x series, press the flash mode button and turn the command dial until the word '**rear**' appears on the LCD top plate. Now plug into your housing any make of flash, i.e. Sea & Sea, Ikelite etc. Set manual mode and adjust the shutter speed until it reads 10 seconds. Turn the flash on and press the shutter. The shutter opens and the flash will fire at the end of the shutter duration. Presto! Rear curtain sync with any flash gun! Not a lot of people know that!

The Underwater Photographer at Night

I have yet to meet the underwater photographer who is indifferent to taking photographs at night. I have often wondered why this form of photography is so popular. Looking back towards the TC system I believe the answer is visualisation. The night has its own special appeal in the creatures that are never seen during daylight and those that are found making their homes for the night after the business of the day.

As the sun gets lower the water is reduced to shades of blue until it turns to midnight blue and then blackness. We see this darkness much the same as a lens stopped down to *f*22 would record it. Visualisation becomes easier. The need to imagine the clear blue water recorded at *f*22 as black is gone – it's there for us already.

Subjects exactly as you see them

Subjects are found at the end of your torch beam and for once they are dressed in their true colours of perhaps red, orange, yellow, green, brown and silver. There is no confusion as to what colour a species of soft coral will record on film. There's no advantage to looking beyond the length and width of your torch beam in case of sharks parading out in the blue. Forget the sunburst that hours ago was too bright and intense for you to focus on. Subjects at night can be recorded on film exactly as you perceive them to be.

A light attached to your flash is essential in modelling the quality of light you wish to achieve on your subject. There is no

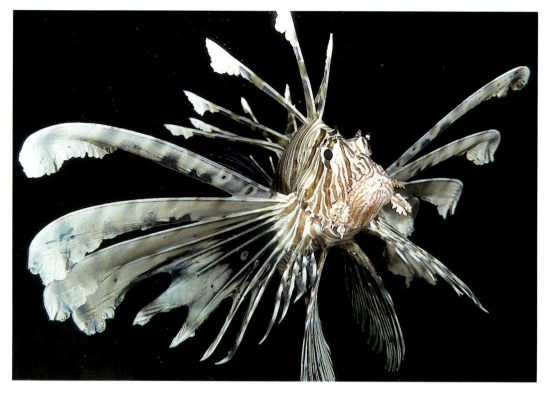

Figure 26.1

Night photography provides terrific potential for certain subjects. This lion fish was feeding in shallow water. In daylight hours they usually hole up inside the reef, upside down with their tails in the air! When you sight a fish such as this hanging out in the blue water away from the clutter and distraction of a reef or sea bed, or perhaps in the black water of night, take advantage! Nikonos V SB 103 flash gun. Nikonos close-up outfit with 28 mm lens. *f*22 at 1/90 s Ektachrome Elite 50 ASA.

better place to learn than in the sea at night, experimenting with colourful subjects and various angles of flash.

Keep to one site

Too many photographers, regardless of the camera they are using, cover far too much ground at night. Get familiar with a particular site and discipline yourself to work around a small area. You will soon begin to see the wealth of marine life that abounds at night. Keep your photography as simple as possible and remove any unnecessary items of bulky equipment.

Dive with another photographer or a buddy who knows what you're trying to achieve. In a perfect world the ideal photo buddy is a spotter, one who leads the dive and so manages both your depths, dive times and direction and who swims a little way ahead to find suitable subjects for you to consider photographing.

Use additional signals

It's essential that whoever you buddy up with you have a set of hand signals for communication (in addition to standard diving signals). Both of you should also be aware of each other's lens choice and objectives.

Many creatures of the night have photophobia – they retreat from any hint of light. You will learn which species of coral and other marine life are susceptible. I tend to view such subjects with the very outside edge of my modelling light.

A friend of mine has a piece of dark cloth which is attached to his torch; it's simply used to cover the torch beam when the need arises.

Consider the environment

Consideration of the environment continues to be vitally important when taking photographs at night. When you kneel on the sand to adjust your equipment do look out for urchins.

Figure 26.2

I found this tiny crab beneath Town Pier, Bonaire on one of the excellent night dives. There were literally hundreds of subjects which could have been recorded on film. I concentrated six of my 36 exposures on this subject, first because I had never seen one during the day, and, second, the other subjects around me could have been photographed at any time. It was this nocturnal creature which I considered to be best potential and a strong feature of the photo site during the hours of darkness. I could have portrayed the crab either climbing up the wall or scuttling downwards. Either angle provides that sense of movement. The third option was to anchor it in the middle of the frame going nowhere. All this movement was achievable by a slight tilt of the camera.
Nikon F90x, 105 mm macro on AF. Subal housing. Two Sea & Sea YS 50 TTL flash guns on TTL. Bendy flash arm. f16 at 1/60 s. Elite 50 ASA. Town Pier, Bonaire – without doubt the best photographic night site I have dived!

Any photographer who claims never to have had a spine or two through their knee or backside is probably not telling the truth.

Subjects

I have had a great deal of success with my own night-time photography by working near the surface. Here numerous creatures are attracted by lights – moonlight, for instance – or dive lights.

Squid, lion fish and puffer fish, for example, are all to be found just beneath the surface of the water. Don't ignore a coral outcrop in an expanse of sand. Creatures will take refuge wherever they choose. So many subjects can be found dozing on the sand. Backscatter against the black water column may hinder your endeavours but don't be put off.

Good subjects to shoot at night, in my experience, are:

- parrot fish – close-up and abstract
- small marine life on corals
- shrimps
- small blennies
- eyes of fish
- squid
- crabs
- fish portraits and profiles

and any other obvious nocturnal subjects which are not around in the daytime.

There are so many subjects that can be successfully photographed during the day. So don't waste film at night shooting subjects that are around at any time of day or night. The *potential* of night-time photographic opportunities should be saved for those creatures that are too skittish at any other time and for things that you never see in daylight.

Figure 26.3 (opposite page)
Diving at night is the only time when you can approach fish and have any chance of shooting ultra-close portraits, eyes and abstracts. This puffer fish was resting on the sand in the Red Sea. Notice that I have composed the eye on the top right third intersection with a line running from top left, diagonally across the picture and out of the frame. Nikonos 111, 35 mm close up lens and framer. Oceanic 2000 manual flash gun. f22 at 1/60 s. Ektachrome 64 ASA.

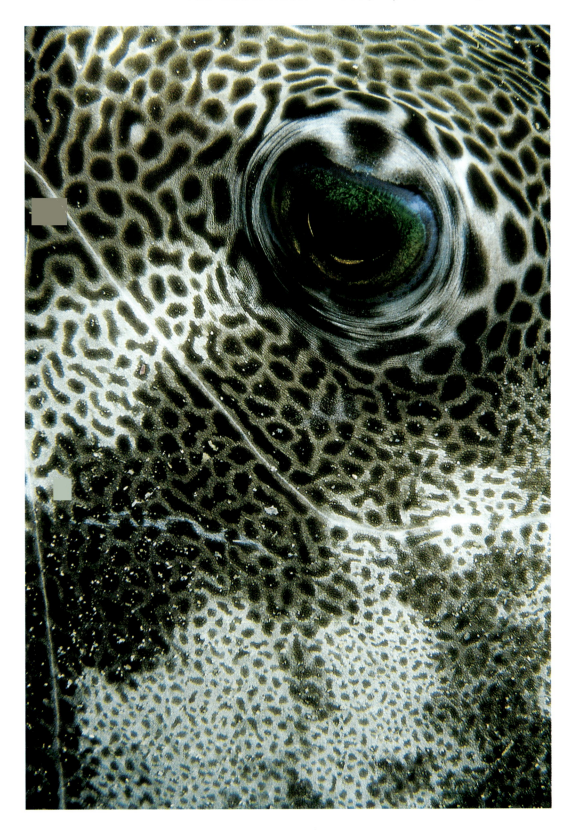

27

Abstract Images

By its own definition an abstract photograph is not a true or intended representation of a subject. The underwater photographer using either a macro or zoom lens isolates a particular area or portion of his subject. By doing so he or she is abstracting and leaving behind what is often a false representation of reality to be recorded on film.

More often than not in this type of photography there is no one centre of interest or focal point. We have all observed people viewing prints or slides. Notice them leaning over to one side or twisting their heads to view the photograph. In abstract photography subconscious attempts are being made to relate the image to something that one can recognise. Viewing images in this way can be as unrewarding as it is enjoyable which in turn is good and bad for the photographer. Some viewers will dislike what they cannot understand and simply dismiss the image at a glance. Others will be intrigued and inspired by the sheer simplicity of the abstract.

In order to provide maximum impact to the viewer, notwithstanding their own personal preference of what they may like or dislike, it is essential that the image has a strong sense of design because, as I have already mentioned, there is seldom one centre of interest.

Visual design for the underwater photographer

The visual elements of design that all photographers work with (often subconsciously) are:

- pattern
- shape
- texture
- line
- colour

Each of these elements has a strong symbolic value in our lives, and form the designs we see all around us in our everyday lives, whether natural or man made. The importance of these elements of design in photography cannot be overstated: to create successful abstracts under water a good understanding of these elements is essential.

Heighten design awareness

A land photographer introduced me to a simple exercise to heighten my awareness of the five elements of visual design. The suggestion is to choose 100 of your own, or friends', photographs and look at them in no particular order. Take a piece of paper and rule five columns with the following headings:

- colour
- pattern
- shape
- texture
- line

As you look at the photographs consider which element of design is strongest in each. After you've gone through them all you should have 100 ticks in various columns.

See which column has the most and which the least. Doing this will illustrate to you your own personal preferences for the elements of design. Texture may be your favourite with the most ticks while shape, for instance, does not feature at all. By conducting this exercise you will determine the elements that your mind and eye do not 'see' well. These are the elements on which you can concentrate in the future.

I have done this exercise frequently on underwater photographic courses using the same set of slides. It's always the case that each individual views the five elements of design differently, each one having their own preferences.

Let's look at the elements of design in more detail.

Colour

My own preferences have always been for pattern and colour. This is ironic because until the film is developed there's

Figure 27.1

Abstract photography continues to give me the most satisfaction, which is ironic because in my experience abstracts are the least type of shot which sells. Nevertheless, it's important that we shoot the type of images which we enjoy as opposed to those which we think we should take. This colourful crynoid was taken with a 105 mm macro lens. I wanted to portray its 'colour and line'. So reader, what do you see? When I first viewed the result I was immediately attracted to the pattern. I was careful to select a portion of the crynoid which completely filled the frame of my viewfinder. I tilted the camera to give a diagonal perspective to the shot. I used a ring flash on all but one of the images in this chapter (see Chapter 24 'A Ring of Light'). Does the reader consider this picture is flat and lifeless? That is the general view of the effect of ring flash for above water macro shots. I have found the use and effects of using ring flash under water to be something of a surprise!

Nikon F90x 105 mm macro lens on AF. Subal housing. Ring flash. *f*11 at 1/60 s. Elite 100 ASA. Sipadan.

Figure 27.2

I have what can only be described as a 'love affair' with clams! I cannot swim over them without taking a few shots. The use of ring flash has improved the quality of light on subjects such as these, ten fold! I have always found it difficult to position conventional flash guns in order to capture all of the subtleties of colour and texture. This image was taken with the same equipment listed for Figure 27.1 at a ratio of between 1:1 and 1:2 magnification. I used auto focus. I chose sharp focus on the mouth of the clam and placed it towards the top left of the frame. My intention was to capture the out of focus lines in the 'valley' of the clam and give an impression of a 'river' with out-of-focus water flowing across the composition and out of the picture. I achieved this by simply opening the aperture from my preferred *f*11 and bracketed through *f*5.6 and *f*4 decreasing the depth of field until only the mouth appeared sharp. This picture was 1/125 s at *f*4.

obviously no way of knowing the true colours of what's been photographed. By looking at this in more detail I realised that, with experience over the years, I have developed an awareness of colourful subjects under water. I can recognise the bright, intense colours of red, orange and purple, though they appear to be very drab and dull. However, when I receive the results it becomes very obvious that they were intensely colourful and vibrant. It's a worthwhile exercise to train your eye to recognise colour under water. Trust your senses, name your colour and then check it with your torch to see if you have guessed correctly.

Patterns

Patterns are around us constantly in our everyday lives. Visual patterns are the clothes we choose to wear, or the ceramic tiles in the bathroom. We see patterns in poetry and music. The patterns and routines of day-to-day life offer us a sense of security. We are creatures of habit and these habits, by definition, repeat over and over again. No wonder we are attracted to patterns – they are part of us!

Patterns can be found under water in every conceivable area. Fish fins and scales, hard and soft corals. On the sand and on the reef, the rust-covered chain that secures the anchor and a host of other patterns that we swim over every time we enter the water.

When you shoot patterns in a subject with the intention of reproducing an abstract image it is essential that you fill the frame or lens with the pattern. If you are using an SLR Macro or zoom lens or extension tubes on a Nikonos ensure that the lens is parallel to the subject. Inconsistency of depth of field of a pattern breaks the momentum and repetition and the pattern is 'broken'.

Shooting a pattern with wide-angle lenses can also prove difficult unless the lens is parallel to the subject. Wide lenses produce a forced perspective and a feeling of depth which, although an advantage in other forms of underwater photography, can decrease the impact of a pattern on the viewer.

Not so long ago I was photographing, as an abstract, the polyps of hard corals when a small blenney landed on the surface of the coral just as I was about to press the shutter. The result was the complete opposite of an 'abstract'. Here we had a small fish – full frame – on a piece of coral. My attraction to this type of image is the excellent negative space provided by the surface of the subject which I intended to capture in isolation. I now look for this type of opportunity when shooting abstracts and close-ups in general. I am not looking for the subject (a small fish) but excellent negative space. If something swims into the frame then 'pop!' – all the better.

Shape

One of the purest and most fundamental shapes is the silhouette. Devoid of light, we use shape to identify the subject. Silhouetted trees on the horizon, a church spire and farm animals back lit by the early morning or late evening sun are all good examples. Devoid of texture, pattern and colour we can still quickly make an identification as a result of our perception of the shape. It is easy to see why silhouettes are the most frequently photographed shapes both on land and under water.

Contrast

There needs to be strong contrast between the shape/subject and its surroundings both when back lighting the shape or when choosing to front light. When frontal lit the viewer experiences the shape for what it is – e.g. a fish or a diver – and sees just that. But what the photographer sees as a graphic shape can be lost when filled with flash.

Mergers

Overlaps between the shape/subject and other subjects in the frame can totally ruin an image when they are allowed to merge with each other. It confuses and anyone looking at it will dismiss the image immediately.

Texture

Texture, like pattern, has enormous symbolic importance in our lives. Rough with smooth, the soft feeling of silk, the hard impression of gravel and sandpaper. We all have our favourite textures that we love to touch. A baby's skin, the material of an item of clothing, the feel of leather. Even rough textures like broken glass, splintering wood and jagged rocks evoke a response.

Have you ever noticed the texture of tree bark and leaves when the sun is low in the sky? Similarly under water the acute flash angle of side lighting is the best directional light to bring out such textures as it rakes across the subject creating light and shadow.

Never underestimate the quality and impact that texture can bring to an underwater image.

Lines

Just like the other elements of design lines are everywhere. Look up from this book and cast your eyes around. You will see straight, curved and jagged lines which may be orderly or disorderly.

Figure 27.3

In an effort to do something different with the popular Red Sea humphead wrasse I isolated a portion of its facial features. Notice the diagonal orientation of the patterns and lines below the eye. I got the idea from shooting extreme close-ups of fish eyes during night dives. The massive wrasse just kept swimming backwards and forwards in front of my camera. I chose the portion which interested me and just kept pressing the shutter. I distinctly remember on one occasion the wrasse revolving its eye as it passed by. This is the image you see here. I took at least 10 shots, selecting an aperture of *f*16 at 1/125 s shutter speed which has darkened the blue-water background. Many of the shots were out of focus by virtue of using a 105 mm macro lens on 'autofocus', which in these circumstances did not lock onto the subject very well. Nikon F801s. Nikon 105 mm macro lens SB 24 Flash gun. Ektachrome Elite 50 ASA. Egypt, Red Sea.

Figure 27.4 (opposite page)

Simplicity itself. Whilst others are concentrating on the clown fish I may be found focusing on the skirt of the anemone. Battling with the dilemma of decisions such as 'shall I make the purple skirt most prominent or the fingers?' Landscape format or a strong portrait! Decisions, decisions. Notice the diagonal orientation of the lines and the balance of space between the purple skirt and pale fingers. Is it an abstract of colour, texture, pattern or line? It's your choice. Same equipment as Figure 27.1. *f*11 at 1/60 s. Sipadan, Malaysia.

Lines that lie on the horizontal when photographed imply tranquillity, rest and relaxation. Vertical lines stand up tall and firm, implying strength and dignity. The world is full of vertical lines.

If a vertical line has a base that is contained within the picture frame then the directional effect on the viewer is from the bottom to the top. If the vertical line has no base the effect is quite the opposite, from top to bottom.

You can evoke these feelings in the viewer by shooting vertically, horizontally or both. In abstracts examine the photograph and turn it 360 degrees to see which perspective provides the greatest impact.

The diagonal line (as discussed in Chapter 12) is dynamic, and like the vertical line the diagonal provokes a strong feeling of movement and is at its best when it runs from left to right. To create even more dynamics compose so that the diagonal line directs the eye from bottom left to top right.

Tilting

Many of the images in this book were deliberately composed on the diagonal. The lines could have been of any orientation but by tilting the angle of the camera a lethargic composition is brought to life. Tilting the camera in this manner will not work with a landscape photograph. Horizons, buildings and trees, for instance, composed on a false tilt would be totally unacceptable to the viewer in the majority of cases. But how many horizons and buildings do you see under water? Even the straight, man-made lines of sunken wrecks can be tilted as long as the background surface detail is not disturbing.

Abstract photography is all about isolating detail and using the appropriate elements of visual design to make the isolation visually stimulating. The opportunities for tilting the camera and composing diagonally are numerous.

Figure 27.5
A wide angle abstract. I can often be found wallowing around in very shallow water. I have become well aware over the years of the potential and possibilities that we often don't notice. After this dive in the Red Sea someone asked me why I was groping around in a metre of water. A month later I was able to show the student this picture: 'Why didn't I think of that, I was diving with you.' I have felt this way in the past when I dived with my mentor. He was photographing seaweed and some stones on the seabed. Some underwater photographers have the eye to photograph things which we mere mortals don't even notice are there.
Nikonos RS. 20 mm zoom, natural light. *f*8 at 1/60 s. Elite 100 ASA. Red Sea.

Figure 27.6
The underside of a star fish, composed in an attempt to provide maximum impact to the viewer. Nikon F90x 15 mm macro lens on AF. Subal housing. Ring flash. f11 at 1/60 s. Elite 100 ASA. Sipadan.

Photographs for Competitions

It's that time of year once again! You are being pestered to enter your underwater slides and prints in your diving club competition. Perhaps the contest is a little more prestigious – a magazine or national competition. Which pictures should you enter? How many? What size? Whatever the event the questions you ask are always the same.

A personal view

In the early 1980s, one of my favourite underwater photos flopped at a particular competition. I couldn't understand it. What was wrong with everybody? Didn't the judges realise the time and effort devoted to obtaining the image? I thought they were the best, so why didn't anyone else? I took myself off into a corner to contemplate my disappointment. There were no kind words of advice for me on that occasion, but since that day I have taken the time to begin to understand the philosophy behind photographic competitions and how they work, both above and below the waves.

Look for the competitions

Underwater photographers are almost unique in their field. While land photographers compete with thousands of other people in their quest for recognition of their own particular talent, we don't. In many competitions the number of entrants fails to exceed 100. Even so there are many underwater photographic contests around. National newspapers and their

Sunday supplements run photographic contests and the photo press is prolific. But magazines and advertising publications are not the only place you will find contests being organised. Travel companies, manufacturing companies, sports councils, film companies and The National Trust are all just part of an almost endless list.

Their themes won't always lend themselves to underwater work, but on occasions they will and then originality and imagination are the name of the game!

Your own photographic talent

After finding a suitable contest you must be brutally honest about your entries. It's a fact that, with judging panels, the majority of entries just do not stand a chance of being short-listed, let alone win a prize. The same reasons for this come up over and over again.

- The quality of printing is poor.
- The technical quality of the image is poor – for example, lack of sharpness; over- or underexposure; poor composition.
- The entrant has broken the rules.
- The presentation of the entry is unprofessional and sloppy (remember, no-one minds an amateur as long as they are not amateurish!).

Someone once told me that a few of my entries had too much 'emotional baggage' attached to them. He explained that I had entered them perhaps because it had been a hard shot to achieve, or it reminded me of a particular dive or trip abroad, or even a fond memory. I have occasionally been guilty of selecting competition work on the assumption that because I like a particular shot, everyone else will. But it is definitely not the right approach.

Learn to be totally critical and brutal about your work for competition. No matter how difficult a shot was to take, if you've a doubt about the subject matter or the technical quality, then don't enter it on the off chance that it may do well. You will only lower your standards of excellence.

Judging

It's important to know how different competitions are judged. The majority of the panel, with the task of selecting winners and places in various categories, will begin by rejecting the entries that are unsuitable because they are technically poor,

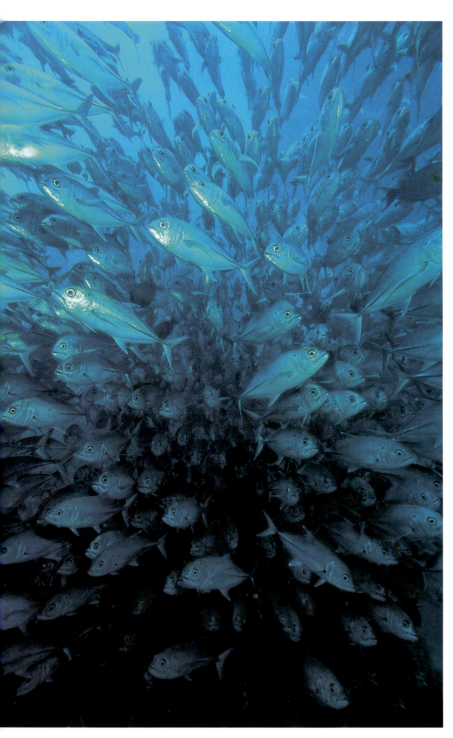

Figure 28.1

In Sipadan there are opportunities galore to photograph schools of jacks. They allow you to get close to them and one may think that the rest is easy. Over the last four years I have taken in excess of 50 rolls of film of the jacks. They school in their hundreds, close to the drop-off adjacent to the beach and at various other sites around the island. It's essential that you study their schooling behaviour. I have swam into the shoal many times but achieving the 'impact and order' of this shot is in my experience a 'one off'. I took this shot off South Point in about 15 metres. I, together with my buddy, had the entire school to ourselves for at least thirty minutes. The school swam towards me as I hovered in mid-water. I remember thinking that I must press the shutter when they were in front of my mask. The reason for this was the 5 second recycle time for my flash. I did not want to miss the 'peak of the action' and see the school swim through me as I waited for the green recharge light to illuminate. There was a moment when the jacks all seemed to look into the lens of my camera. I fired the shutter and three or four seconds later I fired again. I knew that I had a cracking shot in the bag.

I used a Nikon F801s in a Subal housing, 16 mm fisheye lens and an Oceanic 2003 manual wide-angle flash gun. My shutter speed was 1/125 s with an aperture of f8. I developed the film on my return to the UK and immediately scanned the roll for this particular encounter. This image earned me a Highly Commended at the 1998 British Gas Wildlife Photographer of the Year Awards. It has made many sales.

they break the rules or do not fit the theme if the contest has one. Next the judges discuss and weed out their own particular likes and dislikes. This takes them down to a short list. After more discussion, argument and compromise a winner is selected. Whatever the qualifications of a particular panel, it is them that you have to please, not your friend next door or your diving buddy.

Many beginners will enter a competition with their best shots to gauge their ability. If the shot (or shots) does not do well, they might adopt the attitude that their work is poor and they are failing to improve, which in turn leads to disillusion and frustration. But just because a judge thinks four other shots are better it does not necessarily make a particular shot poor. On the day it's only really down to one person's – the judge's – opinion or preference.

At several fun competitions, including the prestigious BSoUP (British Society of Underwater Photographers) 'Splash In' held annually in the UK, everyone in the audience of people who just 'turn up on the day', vote for their favourite first, second and third underwater photographs in various categories. There is a real cross section of underwater photographers, divers and members of the public who, on paper, give an opinion of their favourites.

My advice in these circumstances is to consider the type of underwater photos that the general diving public like. These may be somewhat different from the aesthetically perfected and original shots that a panel of eminent underwater photo judges may select.

'Tips from the top'

Nothing inspires like success. These British underwater photographers have all been successful in numerous competitions:

Linda Pitkin says 'A picture has got to be stunning, but people get carried away into believing that a stunning subject is good enough. Be critical about the whole picture. A potential winner can often be improved by cropping, particularly if it's got a lot of empty space. This, more often than not, improves the whole composition of the image.'

Peter Rowlands: 'Land photographers would call it the 'puppy dog' appeal or 'strokeability.' of certain subjects that stand out to the judges or audience as appealing. I have seen numerous images of seals which have done well in competitions but, as a photograph, have been mediocre. This is because the subject is instantly admired.'

Kevin Cullimore: 'Winning pictures in this day and age have to show more than just technical ability. They should display flair and creativity and the way I advise is by the subtle use of light, with natural sunlight and artificial light (flash).'

Les Kemp: 'Successful entries, in my opinion, require an element of creativity, imagination and enthusiasm to produce one's own style of underwater photograph which would possibly appeal to a judge as being unique.'

Michael Wong: 'You have to be a competent diver and take time to practise shots underwater. With my competition entries I always look for pin sharp focusing, a sense of colour balance and most of all "outstanding composition". It's composition that can make a good shot great!'

My own advice is to give the judges a quality of work that you can be proud of, in both the printing and technical aspects of the picture. A winning picture then is one that is 'timeless', a shot you can live with and one that when viewed, goes from strength to strength. So produce your print a couple of weeks before you send it away, live with it, look at it. Do you still like it? Now you can enter it with confidence.

Equipment

No book on underwater photography would be complete without covering the subject of equipment. However, this section is not intended to be a comprehensive guide on the subject, mainly because the primary aim of this book is to be a guide to taking good photographs with any suitable underwater equipment. Many books designed for beginners and various magazines around the world have in-depth reports and reviews on equipment much more detailed than this.

Over the years I have used all types of equipment, much of which is out of date and only available second-hand. Using manual cameras and flash guns in the late 1970s and early 1980s has helped me over the years to understand clearly why it really is the person behind the camera – using the techniques like those described in this book and their own experience – that really takes the photograph. It is never just the camera itself. No-one should expect to be able to take great pictures just because they have spent a fortune on the latest 'state of the art' camera and housing system

Which one do you choose? The Nikonos V system or the Sea & Sea Motomarine 11EX (Courtesy of Sea & Sea)

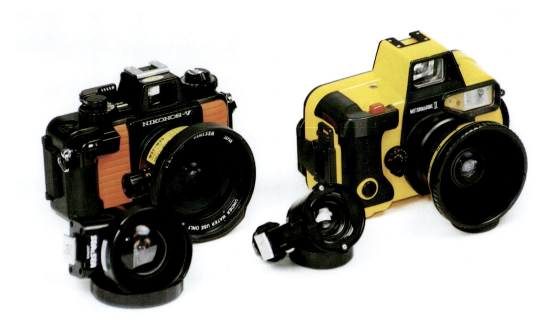

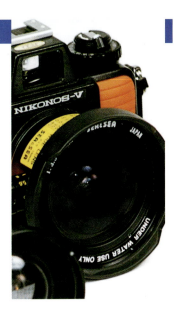

29

Building a Nikonos Camera System

This chapter discusses how to build a camera system with a Nikonos V camera. The opinions stated are based on the author's own experience and knowledge which is better in some areas of equipment than others.

There is nothing that I can write about the Nikonos that has not already been written before. The Nikonos V remains the most widely used underwater camera in the world. However with recent improvements in its rival, the Sea & Sea Motor-Marine 11EX, and the viable reality of housing an SLR camera, sales are reputed to have fallen to an all-time low. At the time of going to press, rumours abound that Nikon intend to discontinue the Nikonos line of products. Unconfirmed reports in the UK indicate that Sea & Sea MM 11EX and Subal housings are outselling Nikonos by ten to one. I personally have seen a reduction of over 70% in the amount of students who bring the Nikonos system to my photo courses both in the UK and abroad. However, the system produced excellent results using accessories appropriate to your subjects.

Figure 29.1
The 'Nikonos V', the most commonly used underwater camera.

Adding a flash gun for macro and close-up work with the Nikonos V

Almost any underwater flash gun can be adapted to fit the Nikonos V. However, here are several of my own favourite units which are recommended for macro and close-up work.

Sea & Sea YS 30 TTL Duo
Excellent for macro and close-up, this flash is the smaller version of the YS 60 TTL. It has become very popular as a

slave flash for macro work. It is compact and lightweight. The sync cord is detachable and inter-changeable with other Sea & Sea flash guns. The recycle time is five seconds and a set of AA alkaline batteries will provide 250 flashes at full power. The battery compartment is sealed from the rest of the electronics. I use one and recommend it without question!

Sea & Sea YS 60 TTL

Sea & Sea YS 60 TTL has just superseded the popular YS 50 TTL model. The specification is similar with the exception of a half power manual setting as well as full power manual and an increase in the beam angle.

Nikonos SB 105 Speedlite

Nikonos SB 105 Speedlite is compact and performs similar to the YS 60 TTL. It has TTL together with a manual facility of full 1/4 and 1/16. There is also a slave facility and, like all of the current Sea & Sea range, the battery compartment is sealed from the electronics in the event of a flood. The manufacturers state that it will cover the area of a 20 mm wide-angle without a diffuser. When a diffuser is added it will cover a 15 mm Nikonos. I feel this is a little bit of an exaggeration!

For details of Ikelite flash guns, see later in this chapter.

Flash arms for close-up

The importance of flash arms have been discussed throughout this edition. When using a Nikonos system I advocate hand-holding the flash gun particularly for close-up work. Sea & Sea flash guns come with a base tray and small flash arm, as do the Nikonos range of flash guns. Find one which you feel right for you. I use the bendy arm system and would never change to anything currently on the market. However I can recommend the TLC arm system and Ultralight.

My own choice

Faced with a similar decision to that of many readers with close-up and macro in mind for the Nikonos V, I would choose a Sea & Sea YS 60 TTL flash gun on an S&S base tray with the bendy arm system from Photo Ocean products UK.

Macro and close-up accessories

Extension tubes

Various manufacturers produce extension tubes in 1:3, 1:2, 1:1 and 2:1 sizes *Isotecnic, Helix, Ikelite, Aquacraft* and *Dacor*, for example, are all strong and robust in a typical 'fixed-post' frame style. Sea and Sea manufacture a set of tubes with posts which unscrew to aid lighting technique and prevent shadows.

Figure 29.2
Bendy arm system from Photo
Ocean Products, UK.

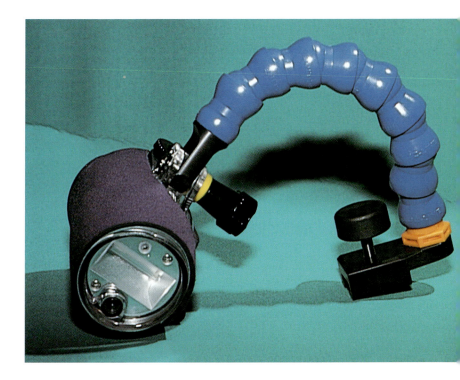

A set of tubes has also been designed and equipped with unscrewable probes as opposed to the traditional post type tube. These are produced in Britain by London-based specialists, Ocean Optics. They allow unrestricted positioning in relation to the subject. They are colour coded for simplicity: the blue 1:2 tube has blue probes, the red 1:1 tube has red probes and, by stacking the two tubes, you use the yellow probes to obtain a ratio of 1:1.5.

Which ones are best?
Fixed posts are stronger, Sea & Sea aid lighting techniques and the Ocean Optics system allows unrestricted positioning. In my opinion there's little to choose between them. But you do need a set of one or the other in your camera bag to avoid disappointment in your macro photography.

Close-up
Beyond the scope of the largest extension tubes, and offering a slightly bigger picture area ratio, are the close-up systems. I am familiar with two but there are numerous types available, particularly in the USA.

The **Ocean Optics Close-Up Lens 001** is an optical adapter designed by Ocean Optics in the UK for use in front of the 35 mm Nikonos or 28 mm Nikonos lenses. A clamping screw keeps it in place and it's supplied with two stainless steel probes to show exact focusing. The adapter can be removed from the

Figure 29.3
Extension tubes.

Figure 29.4
Ocean Optics close-up prongs.

lens under water but this is not recommended. (I've seen several lenses twisted from the Nikonos body causing a flood.)

The Ocean Optics Close-Up 001 is an excellent (and more affordable!) alternative to The Nikonos Close-Up outfit, which is optically superb, although expensive! It is a superior lens system which again fits on to the 35 mm, 28 mm and 80 mm lenses. The system is supplied with 3 sizes of frames for the different lenses, the 28 mm frame being the largest. These are held in position by a focusing rod that is also attached to the adapter. To get the most out of this system the purchase of a Nikonos 28 mm lens is also recommended. However, I would not advise you to buy the 80 mm lens. I have always found it totally impractical. It is difficult to use with virtually no advantages.

The frames of the system can be removed for accessibility or to entice those shy fish into the picture area! This truly excellent piece of equipment can also be safely fitted or removed under water.

28 mm Nikonos lens

Without the use of extension tubes, wide-angle and close-up adapters, the standard 35 mm lens on its own is, in my opinion, of little use for any type of serious underwater photography. The fact that it is hardly ever used by professionals is well documented.

Figure 29.5
The performance of the Nikonos V and Nikonos 15 mm lens cannot be surpassed.

However, the 28 mm lens is much more versatile than the 35 mm. The optical quality is better, depth of field is increased and it is capable of focusing down to 0.6 m. With its 59 degree angle of coverage it fits nicely between close-up and wide-angle photography and is ideal for subjects which are much too large for a framer system but too small or shy for a wide-angle approach. It's a favoured tool of many professional Nikonos users for fish portraiture and shots of larger marine life.

Wide-angle lenses

The benefits and applications of wide-angle photography are highlighted elsewhere (see Chapter 4). There are basically two types of wide-angle lenses – those which fit directly on to the Nikonos Camera and supplementary lenses which screw or push on to the standard 35 mm lens.

Prime 15 mm Nikonos wide-angle lens
The 15 mm Nikonos f2.8 is the 'Daddy of them all' as regards unbeatable quality. But it's also an unbelievably high price! Its virtues have been documented many times, its track record is proven and there is nothing to touch its performance.

I invested in a second-hand 15 mm lens in the mid-1980s and despite a price tag which almost caused a coronary I've never looked back. The viewfinder is a delight to use with a bright, sharp image which enhances the reality of the subject.

The Sea & Sea SWL12 fisheye is also a prime lens which fits easily on to the Nikonos. The angle of view is 167° and when it's used with the appropriate viewfinder it can achieve amazing fisheye results previously unattainable with the Nikonos system.

The Nikonos 20 mm f2.8
Less extreme than the 15 mm, its older brother, the 20 mm lens has filled a gap in the market by maintaining the expected optical quality but at a more affordable price.

Sea & Sea 15 mm prime lens
This lens has taken a large market away from the Nikonos 15 mm lens by being of comparable optical quality at a fraction of the price. The minimum focus is 0.3 m and the angle of view is slightly wider at 96 degrees. The Sea & Sea Optical Viewfinder, too, is a huge improvement over the Universal Optical Viewfinder.

Sea & Sea 20 mm F:3.5 lens
Once again designed to compete with its Nikonos 20 mm counterpart, this lens also saves on cost without any significant loss in picture quality.

A personal choice

Without doubt it would have to be the 15 mm Nikonos with viewfinder. But it is expensive so look around for second-hand possibilities. The other lenses compare and I can recommend them all. It's simply a matter of what you can afford!

Wide-angle supplementary adapters

The two mentioned here are not as good as prime wide-angle lenses but they are excellent value for money and both cover angles of 90 degrees underwater.

The Sea & Sea SWL 16 screws into the front of the Nikonos 35 mm and increases the picture angle to 90 degrees. Instructions supplied indicate focus areas on the 35 mm knob for ease of use. Ensure you use an adequate viewfinder with this lens. Ask your camera stockist and check out the latest Sea & Sea viewfinder as opposed to the universal UF (which I don't personally recommend).

The Subawider range of adapters has been established for many years and are reliable, good value for money and optically sound. The Subawider III is a screw fit – as opposed to a push fit – on to the 35 mm lens. The Subawider Viewfinder is also an excellent choice. I used the system for many years and have nothing but praise and respect for it.

Flash arms for wide-angle

The major criteria for choosing a flash arm should be:

- that the arm can easily be removed from the baseplate for hand-holding techniques;
- that it can be extended or elongated so that when hand-holding at arm's length the flash is well away from the lens.

The TLC – technical lighting control – flash arms are recommended for wide angle, while the Sea & Sea Flexy works well together with the Ikelite 'Quick Handle' which can be removed with ease. However, the 'Quick Handle' is not recommended for close-up work.

Other flexible arms like the one manufactured by Sea & Sea are as good and can be bent into any position. With a ball joint or flexy arm of reasonable length you can keep it attached to the base plate and manoeuvre it into a position which simulates hand-held positions for both top and side lighting of macro and close-up subjects.

Longer ball joint arms of 60 cm are available for wide-angle lighting. By extending your own arm with another 60 cm of flash arm you can position your light some 1.2 m away from the lens. This creates good lighting effects and minimises backscatter.

There are several underwater photographers who have mastered hand-holding techniques when using SLR cameras in housings with close-up subjects. They should be congratulated because many others, including myself, find it difficult. When using the Nikonos system for close-up or wide-angle, I always hand-hold the flash; I also hand-hold when using my SLR in a housing for wide-angle.

It cannot be emphasised enough that, whenever possible, you should use hand-held techniques for underwater flash photography. The difference is noticeable and can often turn a good shot into an outstanding one.

Wide-angle flash guns for the Nikonos system

I recommend first and foremost the Sea & Sea YS 120 TTL duo. This flash will easily cover a Nikonos 15 mm wide-angle lens and with the addition of a diffuser it will do a pretty good job covering a fisheye lens. The quality of its light and general reliability is now tried and tested. In addition to TTL flash control, the YS 120 can be set to manual full and half power. There is also a slave facility. Lights and an audible alarm confirm correct exposure and one little gem is an audible 'bleep' to indicate that the flash has recharged. This is a tremendous tool and one which I use constantly. The flash uses eight AA size batteries and provides 250 flashes. The flash sync cord is interchangeable with other Sea & Sea flash guns, which makes it most convenient.

Sea & Sea YS-350 Pro

The Sea & Sea YS-350 Pro is the big brother to the YS120 duo and the YS300. It features multiple power settings of full 1/2, 1/4 power manual and TTL. It has a built-in slave and a built-in independently powered aiming/modelling target light. It boasts a 105 degree beam angle with a detachable flash sync cord. I recommend it for wide-angle but from limited experience I have found it too big and over-powered for macro and close-up.

The flashgun

I have some experience of using this gun in the field. I found the SB104 well balanced and easy to handle. It has a consistent recycle time of between 1 and 3 seconds depending on the

Figure 29.6
Courtesy of Sea & Sea.

power output used. I chose to dial in minus 2/3 stop exposure compensation on the camera to cater for my taste for both balanced fill-in flash and for those occasions when the flash was the primary light source. (This decision takes account of the fact that I was using Ektachrome Elite 50 ASA and 100 ASA slide film.)

The are of flash coverage is advertised as 100 degrees. I can confirm that it easily covered the 20 mm end of my lens.

I was so taken with the SB104 flash unit that I continued to use it in conjunction with my Nikon 16 mm full-frame fisheye on the Nikon F801s in a subal housing.

The consistency of TTL flash exposure, the quality and evenness of light are second to none. The flash also has other attractions such as a rear curtain sync facility and various slave modes.

The icing on the cake, though, is the stand-by switch. In this mode the flash power is turned off after 80 seconds of use. However, it retains a full charge and by just depressing the shutter release button half way the flash is instantly turned back on. This function also ensures that battery power is never wasted.

Ikelite flash guns for wide-angle

Ikelite currently have four flash guns in the series. They are the Substrobe 50, 100A, 200 and 400. They range from small macro type guns to one of the biggest most powerful guns on the market, the 400.

The Substrobe 50 started life years ago as the MS and MV models. I still own and use both. The MS is a TTL and Manual gun ideal for macro and close-up. They are small, compact, reliable, accurate and I recommend them both without question. The MV is a slave and manual gun. The other models are for wide-angle work. Let's look at the 200.

Substrobe 200 is a very powerful performer with an ultra wide 100 degree beam angle and a 2 second recycle time. Both visual and audible ready signals and TTL operation. The 200 offers four manual power modes and a powerful built-in modelling light. It has a built in Ni-Cad battery module and an LED film gauge which shows how many rolls of film can be exposed with the remaining battery power.

Spotting torch and holder

Attached to the flash gun or a bracket at the side of the Nikonos, this is an essential tool for illuminating the subjects; more to the point, it shows the photographer the true colour of the subject and, if used to test angle of light, it can indicate the effect that you should achieve. Currently, there are so many torches to choose from and suitable brackets. Check out the options with your local underwater camera store.

The Sea & Sea Motormarine 11EX System

In recent years I have seen many of my students using the Motormarine 11 system in favour of the Nikonos. The Nikonos system is far superior in terms of accessories available and the optical performance of those accessories. However, Sea & Sea offer this system at a very competitive price which allows many budding underwater photographers to 'dip their toe in the water without getting too wet'.

The MM 11EX system is capable of producing excellent photographs under a wide range of conditions. It offers drop-in film-loading, powered film wind-on and rewind together with DX 1/30, 1/60 and 1/125 which provides the creative photographer with more options. TTL flash is available at all these shutter speeds. Apertures range from $f22$ to $f3.5$. The lens is a 35 mm which like the Nikonos focuses down to 1 metre.

A built-in close-up lens can be accessed from behind the lens at the turn of a switch which allows focusing down to 43 cm.

Figure 29.7
Courtesy of Sea & Sea.

However, I know of few people who have had success with this. I certainly haven't!

Macro lenses for the Motormarine 11
There are two. The ML2T covers a 1:2 ratio and fits onto the front of the lens. It has two uprights which fold down to avoid shadows when lighting from the side. It is ideal for small macro subjects.

The ML3/T covers a 1:3 ratio and is suitable for larger subjects. The two upright posts can be removed and clipped into a bracket beneath the lens.

Wide-angle lenses for the Motormarine 11EX
The WCL 11/20 has an angle of view of a 20 mm wide-angle (84 degrees). It has a focusing range from 0.4 m/1.3 ft at *f*22. The YS60 TTL if aimed carefully will cover this lens.

The WCL 11/16 is the widest in the motormarine system covering 91 degrees underwater. It will focus down to 0.3 m/1 ft. At *f*22 it is in focus from 0.4 m/1.3 ft to infinity, making it perfect for close-focus wide-angle shots. The YS60 TTL with a diffuser

will almost cover this lens but in a perfect world the YS120 duo may be a better option.

The benefit of all the Motormarine system lenses is that they can be fitted and removed under water, just as a land photographer would change lenses. A special holder that attaches to the Sea & Sea flash arm enables these lenses to be stored until required on a photo-dive.

The Sea & Sea system is capable of obtaining images of the highest quality, however the additional macro and wide-angle lenses are essential to this objective for the reasons documented throughout this book. In a nutshell these lenses reduce the column of water between the lens and the chosen subject, the key to producing quality underwater images and an absolute necessity whichever camera system is used.

The Motormarine is an ideal first level entry system and although slightly inferior optically and in terms of versatility to Nikonos it should be seriously considered when taking up underwater photography.

A frequently asked question from experienced users of Motormarine is:

> 'Shall I move up to a Nikonos system?' My answer is always a definite 'No. If you feel the time is right to upgrade your equipment, consider housing a Nikon SLR camera.'

Author's note

I hope to have given you a flavour of what is currently available with Nikonos and Sea & Sea. Be sure to consult your local underwater photographic specialist before you make any decisions. If you have a passion for underwater photography and a desire to obtain quality images rather than the 'snapshot' approach, my advice is not to invest in anything less than a MM 11EX. The Sea & Sea Explora and accessories are not in my opinion versatile enough to produce consistent results by virtue of the flash gun which cannot be triggered unless it is attached to or very close to the camera body.

Building an Auto Focus System

There is no doubt that the latest Nikon range of cameras are head and shoulders in front of their competitors when it comes to installing an auto focus SLR camera in an underwater housing. I refer specifically to the Nikon F801s, a popular camera although even this model has been superseded by the Nikon F90x, F4 and F5. At the time of writing, Nikon have just launched the F100 model. However, I have little knowledge and I am unable to discuss the implications of housing this model.

The Nikon F90x has gained a cult following with underwater photographers throughout the world. It has numerous features, some of which have a serious underwater application.

Figure 30.1
The excellent Aquatica underwater camera housing. (Photo by Benny Sutton.)

I upgraded to the F90x in view of its speed of auto focus which is 25% faster than previous models (including the Nikon F4). I wasn't disappointed. The AF system is so much faster and efficient that I have not used manual focus of any kind of macro or close-up work for several years. The metering system is a choice of matrix, centre weighted, or spot. The fastest flash sync speed is 1/250. A large high point viewfinder has an LED display which provides all the information required.

I recommend the F90x over the F4 system by virtue of its auto focus speed, although the F4 does have an oversized pentaprism which makes viewfinding a dream.

Which housing to put it in

Aquatica housings
Aqua Vision of Montreal, Canada have the reputation for producing the best underwater housing in the world in the Aquatica range. They are made of precision-cast aluminium with numerous controls. There is a range of ports to cater for numerous lenses from the Nikon 16 mm fisheye to the 200 mm macro lens. The Aquatica 90 housing accepts the Nikon F90x series and the Aquatica 5 the Nikon F5 with the Nikon DA 30 oversized viewfinder. The price is the only disadvantage. It's not cheap and such a purchase should be very carefully considered.

Subal
For several years Subal had the monopoly and has amassed a cult following and an excellent reputation all over the world. Austrian manufacturer and founder Arnold Stepanek has been at the forefront of housing design for more than forty years.

Figure 30.2
The Subal housing showing a flat (macro) port and a dome (wide-angle) port. 'Courtesy of Ocean Optics'.

Figure 30.3
The Nikon F5 for the Subal housing. (Courtesy of Ocean Optics.)

Figure 30.4
NX-90 for the Nikon F90x cameras. With twin Sea & Sea flash guns on bendy flash arms.

Figure 30.5
NX-5 for the Nikon F5. (Courtesy of Sea & Sea.)

The compact size and ease with which all the functions of the Nikon cameras can be operated under water is a particular feature of Subal housings and enables the photographer to take advantage of the most sophisticated camera technologies in the world.

Sea & Sea NX housings
The Sea & Sea range of housings are fast gaining popularity all over the world. In the Nikon series they produce the NX-60 for the Nikon F60 mid-priced AF SLR and the NX-90 pro and the NX-5 pro for the Nikon F4 and F5 respectively. The main features include:

- A quick release shoe which enables quick and tool free installation of the camera in the housing.
- A hand-grip which is adjustable to fit the size of your hands.
- You can switch between auto focus and manual underwater.
- Illumination button which activates the light in the camera's viewfinder.
- Numerous selection of flat and dome ports which compliment all the popular Nikon lenses.

Author's comment

So which housing is the best? Which housing do you choose?

There really is no answer to these questions. All have different merits. I have always been a Subal user and I am delighted with the system. However, some of the best underwater photographers in the world use Aquatica.

You will find more thorough and researched arguments in other books on underwater photography than any opinion contained here. Everyone should select the equipment to suit their own purpose and their own pocket. One thing is for sure. Whichever system you choose it will not make you a better photographer than the others. It is the underwater photographer not the camera who sees the potential for a stunning image in their 'mind's eye' and ultimately takes the photograph. Never forget that!

A famous land photographer once wrote:

> 'To become obsessed with camera equipment and technique is a real error. People end up producing technically perfect rubbish.' Are you obsessed with equipment?

Using a Single Lens Reflex Camera Under Water

Making the transition from a Sea & Sea or Nikonos to an SLR camera in an underwater housing is by no means easy. Even photographers who invest in a housing from the very beginning fumble with the controls when the camera is enclosed.

For the purpose of this chapter let's assume that you are using a Nikon F90x with a 60 mm AF Nikon macro lens on the AF setting. The flash is a Nikon S&S YS60 TTL in a housing (this is the set up I use at the time of writing).

Familiarise yourself with camera and housing

1. Read and digest the users' guide for both the camera housing and flash. And familiarise yourself with the operation of every part of the rig including the lens.
2. Put the camera in the housing, remove the front port to reduce the weight and practise focusing and composing everyday subjects around your home. Put a roll of film through the camera and use all the controls on the housing – shutter, aperture, mode, exposure compensation, autofocus, lock and so on. Try operating the same controls wearing neoprene gloves.

Practise in the pool

3. Before venturing into the sea with your housing take every opportunity to practise in a swimming pool. Put film in the camera and try the same techniques as on land but this time with silk flowers attached to lead weights.

4. Experiment with the positioning of the flash at various distances. Take the flash off the housing and practise hand-holding techniques.

5. Remove long neckstraps from the housing – a small lanyard will make it perfectly secure.

6. Good diving skills and buoyancy control are absolutely essential when using an SLR under water. Poor diving practices will almost certainly damage the environment and may also cause you – and other divers – a degree of frustration you can do without.

7. A small volume mask with black silicon allows the eye to be physically closer to the viewfinder which aids better viewing.

(I used a low volume clear mask when I first made the transition to an SLR. However, I soon found out that extraneous light penetrated all sides of the mask which constantly disrupted my viewing. I suddenly realised why the person behind the camera in old films and photographs had a black cloth over their head!)

8. When you buy your next regulator second stage consider its shape and design in relation to your viewfinding needs. For instance, a mouthpiece which is too bulky might get in the way.

Now, take some pictures!

So, you feel comfortable and confident with your camera, housing and flash and, last but not least, the versatility of your flash arm. So let's go and take some pictures.

If you are entering the water from a boat go in without your camera. Have someone standing by on deck to pass you your rig. Make sure you have already fired a shot before you entered the water to check that the flash is working OK. (It's no use finding out when you're wet and the camera's wet so do it before you enter the water.)

As you start your descent set the camera to $f11$ at 1/60 s. Even though the 60 mm autofocus lens may not be suitable for every subject, you never know what you might come across. So be prepared!

You settle on to the sand at 10 m and adjust your buoyancy. Check the housing and the LED in the viewfinder. Once you're happy with this then recheck the following:

(a) Focus mode: 'S' – single servo or 'C' – continuous autofocus.

(b) Exposure compensation dial.

(c) Metering mode: i.e. matrix, centre weighted or spot.

(d) Mode – aperture, shutter or manual. (I would not advise using program mode under water.)

(e) The ISO of your film in the camera matches the DX reading. (This little dial has ruined several photo trips for photographers.)

(f) Flash arms and the position and direction of the flash gun.

(g) You have the correct mode on your flash gun (i.e. TTL).

You're ready

On a small coral outcrop close to the sand you sight a small, colourful blenny. It's ideal for 1:3 ratio but you need to get close. Remember the relevant aspects of the TC system – approach, lighting, composition and visualisation.

Autofocus is locking on to the blenny's form perfectly. Now re-compose with the shutter release depressed in order to lock focus.

With your eye to the viewfinder glance to the flash position – and shoot! Great – you made the blenny jump but it's still on the coral. So you go closer, closer . . . the 'flash ready' light is on in the LED. *f*16 at 1/60 . . . good . . . shoot! . . . great. Alter the composition of the photograph then shoot a few more. The autofocus is searching again . . . Zzz, Zzz, Zzz . . . it won't lock on . . . the noise has disturbed your subject . . . and it's gone. Never mind, it was a good opportunity.

There's the blenny again, head just popping out of a hole. Go for a 1:1 ratio on the lenswith the eyes sharp it'll look great. The noise scared it last time so back off and sort the camera out. Depress the shutter, engage autofocus and allow the 60 mm lens to travel the length of its extension to give the 1:1 ratio. Knock off the autofocus or simply lock focus to prevent it searching and making any more noise.

Move in slowly, it's still there! This should be good. Ready? Lighting OK?

Set *f*22 for a little more depth of field. Closer . . . closer . . . pop! Then bracket the aperture – *f*32 . . . pop! – *f*16 . . . closer still . . . pop! . . . "* ! !ñ +ñ+!!* (expletive deleted!) . . . you're too close and the flash is missing the subject . . . it's time to back out again and think about this one.

Author's note

This scenario shows up a common fault of photographers using an SLR in a housing – flash position. You predict that there is, for instance, 0.5 m between your housing port and the subject.

You set the position of the flash accordingly, put your eye to the viewfinder, compose and shoot. The flash illuminates the subject. You realise that the subject can be photographed closer so you move in. Perhaps it's a blenny that isn't suspicious of your intrusion so it allows you to get closer and closer. Not daring to move a muscle in case you spook it you keep your eye glued to the viewfinder, shooting every five centimetres or so as you move in closer.

The potential increases, the fish's eyes are filling the frame and you've got dynamic composition on its face.

Consider where your flash is aiming at this point. You haven't altered its direction but by reducing your distance from 50 cm to a matter of 10 it means the flash is located beyond the subject.

This is the reason that underwater photographers who are inexperienced in using housings complain that they have underexposed very close-up subjects. They are not underexposed. The flash has missed completely or the fallout has raked across the extremities giving only a faint appearance of flash exposure.

b

Figure 31.1a–c

a

c

It's not as easy keeping your eyes on the position of the flash when using a housing. A Nikonos with extension tubes is simpler but then you haven't got the benefit of reflex viewing.

Exercise on land

Try this exercise on land in your own home with your housing, flash arm and flash gun. Put an everyday household object on a table, e.g. a glass, about half a metre away from the housing. Attach the flash to the flash arm and point it at the glass. Focus and adopt a standard flash angle of 45°. Move the housing closer to the glass. Notice the direction of the flash in relation to the subject as you move closer, culminating in a 1:1 ratio. You will notice that it's missing the subject.

Be aware of this as a potential problem under water and constantly consider it throughout your dive.

Figure 31.2

An exciting subject for one photographer may be mundane to another. I had never had the opportunity to photograph this particular species of blenny before. When I found it with 8 shots in my camera I intended to take full advantage. It was situated in a small hole that provided easy access without fear of damaging the coral. It ventured from its hole every 2–3 minutes and would dart back in after a couple of seconds. I observed its behaviour and visualised the image that I wanted to obtain. The negative space of brownish coral was a further 15 cm behind the blenny. Side lighting could have eliminated the background but with the 106 mm macro lens and an aperture of f8–11, I knew that I could throw the focus out sufficiently to make the blenny 'pop' against a fuzzy background. I used an SB 25 flash gun on a flexible arm with a top left flash angle. Ektachrome Elite 50 ASA. I slowly inched my way forward adjusting the autofocus constantly without spooking the blenny. Eight times he came out. Eight times I pressed the shutter. Seven occasions he moved too quickly and I did not achieve what I wanted. He would come out upside down at a peculiar angle. I got this one shot that pleased me. Pin sharpness on a flat plane worked well with the reduced depth of field of f8. The negative space also pleases me without detracting from the subject. Visualisation – patience – peak of the action. If I had had the chance again I would have used f11–16 for a little more depth of field.

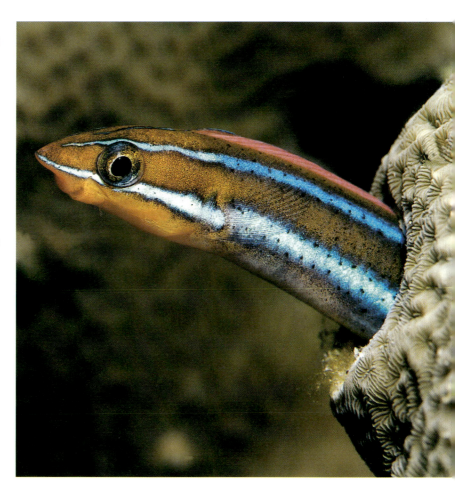

Modelling and aiming lights

The majority of underwater photographers make use of a small torch attached to either a flash or the housing. This is worth a little more explanation.

It's advisable to differentiate between torches attached to the camera and those attached to the flash gun. I use the same in both situations – a mini Q40 light from Underwater Kinetics.

An aiming light I fix above the port on the top of my camera housing. I use it:

• to assist in focusing the lens.
• to indicate the colour of subject to the photographer.
• to indicate the lighting effect if you choose to position the flash on the same axis as the torch.

A modelling light does just that: it models the quality of light falling on a subject by the flash gun and must be fixed to or enclosed within the flash unit itself. It assists in focusing and in being able to see the colour of the subject. With my flash positioned for quality light on a versatile flash arm I use my right forefinger for depressing the shutter. My left hand cups the housing and I use one finger to adjust the position/direction of the aiming light. Thus to aim and focus, the torch is on the housing, and to model the quality of light, the torch is on or within the flash gun.

Most housings designed to suit the Nikon 801s, F90 and F4 have a switch to operate the internal LED illumination. If yours does not have one try pressing the shutter to activate LED function while shading the port with your left hand. This should fool the camera into displaying the light within the viewfinder and it only takes a fraction of a second.

Using modes 'A' 'S' 'P' & 'M'

'M' – manual

When this mode is set the analogue display is constantly illuminated to indicate correct exposure or under- or overexposure in increments of 1/3 stop. The shutter speed is changed using the control dial and the aperture using the aperture dial. I use this mode about a third of the time when I wish to under- or overexpose a scenario.

A typical example would be to darken the blue mid-water background by a stop or to lighten the mid-water when photographing at depth. I find the system a little easier than using the exposure compensation facility.

Another advantage is the ability to decrease the shutter speed to 1/30 s or below (on an F90x) and still use flash.

'S' – shutter

This mode is of great advantage when shooting subjects that require a faster shutter speed than 1/60 s. For example, to stop the action of glassy sweepers and prevent them appearing fuzzy a shutter speed of 1/125 is necessary. In these circumstances I would set 1/125 or 1/250 s and allow the camera to select the correct aperture. This way you do not have to concern yourself with the shutter speed. I use this mode about 10% of the time.

'A' – aperture

This is perhaps the most popular and regularly used mode on Nikon cameras (F801s, F90, F90x and F4) under water and one which I use about two-thirds of the time. The photographer sets the aperture after considering the depth of field requirements for the shot.

It's worth noting that, in this aperture priority mode, all shutter speeds are stepless. This means that speeds of 1/59, 1/27, 1/247 s – in fact any number between 30 seconds and 1/8,000! – are all available. The camera does not display these intermediate shutter speeds, just the traditional ones with which everyone is familiar.

Avoid the 'P' – program mode under water. It controls you, the camera and your creativity. Use the other modes to assist you in your image making and not vice versa.

Macro lenses

The Nikon 60 mm AF macro

The Nikon 60 mm AF macro lens has become the most popular SLR lens for underwater photography. Its edge-to-edge-sharpness, resolution and close focusing capabilities make it the first choice in every Nikon SLR user's underwater camera bag. However, when working around the 1:2 or 1:1 ratios there are potential problem areas that you need to take account of.

Depending on the make of housing, when the 60 mm macro lens is extended to its maximum of 1:1 the shooting distance is between 10 and 15 cm from the port. When working so close, and taking into account the orientation of the subject, positioning the flash at the optimum angle to obtain an even spread of light can be awkward. The further you move back the easier positioning becomes. However, you might not want to reduce the image magnification.

The Nikon 105 mm AF macro

The Nikon 105 mm macro lens also focuses down to 1:1. At this ratio the shooting distance increases to about 24 cm. Although the column of water has increased you have still maintained your required magnification; the longer focal length has also allowed more room for positioning the flash to provide quality lighting.

With both the 60 mm AF lens or the 105 AF lens set on 1:1 magnification ratio the depth of field is identical, contrary to popular rumour. The only difference is that the shooting distance will be further away with the 105 mm lens set at macro than with the 60 mm lens.

If I enter the water knowing that I will be shooting at very close distances in the 1:1 or 1:2 ratios I will almost certainly use the 105 mm macro lens. I also use this 105 mm lens when I think a subject is going to be difficult to approach. On the other hand, for still life shots such as corals I opt for the 60 mm lens. This allows you to shoot at the minimum subject-to-camera distance, so reducing the column of water.

When using the 60 mm macro at 1:1 ratio I recommend placing the flash just above the lens port, tilting it slightly towards the subject. This is not a good technique for eliminating backscatter. However, the distance between flash and subject is usually no more than 12 cm so the particles suspended in the column of water are minimal (depending on visibility).

Wide-angle lenses

Wide-angle zoom lenses are an excellent way of covering different focal lengths with one lens. The 20 mm to 35 mm, the 24 mm to 50 mm are all excellent lenses, each with its own special place in wide-angle photography. It's more financially viable to consider these zooms; they give you a great advantage when you want the option of a variety of focal lengths.

The disadvantage of the 20 mm to 35 mm zoom lens is its size: it's a big lens and its close focusing capabilities are not that impressive. If you want to concentrate your efforts on close-focus, wide-angle photography, i.e. less than 30 cm lens-to-subject distance, you may be better off using the 20 mm Nikon Prime lens.

The 20 mm Nikon prime autofocus lens, equipped with a +2 or +3 diopter, can reduce the minimum focus distance behind a domed port to a matter of centimetres.

I use the 16 mm full frame fish-eye lens and the 20 mm prime lens. I also have a 28 mm prime lens, a 35 mm to 70 mm zoom lens, a 60 mm macro lens and a 105 mm macro lens.

But just because I mention a lens in this book is not sufficient reason for you to go out and buy it. First make yourself familiar with all the information available on the Nikon system or on any other SLR camera system you choose. Acquaint yourself with how a particular lens works and relate this to your own particular style of photography. Most importantly, make sure you use lenses that are right not for your buddy or for other photographers but for you and what you yourself wish to achieve.

Do consider the possibilities of SLR photography under water. Nikonos and Sea & Sea cameras still remain the easiest to use but, through the many technological advances in cameras and camera housings, SLRs are rapidly closing the gap.

The Underwater Photographer and Digital Imaging

I am of the opinion that digital imaging will eventually replace traditional print and slide photography. At present the quality of film is so high and the cost relatively low that the huge capital expenditure required for digital imaging equipment is unmerited, certainly for location photographers. At present it is the end user, the graphic designers and printer who are on the whole the digital pioneers. They are able to translate slides and prints into a digital format but I wonder how long it will be before they start to demand digital originals?

Whether we like it or not, this digital age is fast approaching. Many consider that it is the logical next step for photography and without doubt the biggest technological change since the discovery of the photographic process in the nineteenth century. The future for photography will see all images shot on digital cameras and manipulated on the computer, before being sent direct to the client down an ISDN (Integrated Services Digital Network) telephone line to be stored on disk or fitted straight into an awaiting desktop publishing spread. None of this denies the photographer his traditional photographic skills which will remain as important as they are today.

Already this system is working successfully for press photographers around the world and is constantly on the increase for fashion and studio based photographers. The efficiency of the system and the huge savings on film and processing costs can make this an attractive alternative despite the expensive initial set-up costs.

In my experience the publishers, editors, picture researchers, graphic designers are at present quite content to accept

Figure 32.1
Several years ago, in a mad rush to cut and mount slides for a lecture on a photo-course in Eilat, Israel, I mistakenly cut a transparency in half! Bob Wrobel has repaired the picture by scanning it into Photoshop 5.0 using the Hewlett Packard Photo Smart Slide Scanner. He selected the black frame bar situated across the middle of the frame and deleted it. The top half of the image is in fact from the next frame on the roll in which the dive light was obscuring the model's face.

transparencies and prints and scan them into a digital format for the purposes of their design work. They are not yet making demands for digital originals. However they have been working for some time within the desktop revolution and have done away with the old techniques years ago. The cost of quality digital cameras and digital camera backs together with the computer equipment necessary for manipulating, storing, and transmitting the images is so expensive that for location work it is not yet a viable option.

In my opinion, digital camera backs have yet to match the exceptional quality of conventional transparency film. However, it is certain that as quality improves in this area

Figure 32.2
This picture had all the impact,
action and movement which I had
hoped for, however, the reflection of
the inside of my fisheye dome port
was obvious in the lower half of the
frame and my buddy's exhaust
bubbles were a distracting and
unwanted addition to the left side. I
scanned it into Photoshop 5.0 as
previously described and **cloned** the
offending areas. I adjusted the **levels**
and used the crop tool to improve
the framing. I then applied a degree
of **unsharp mask**.

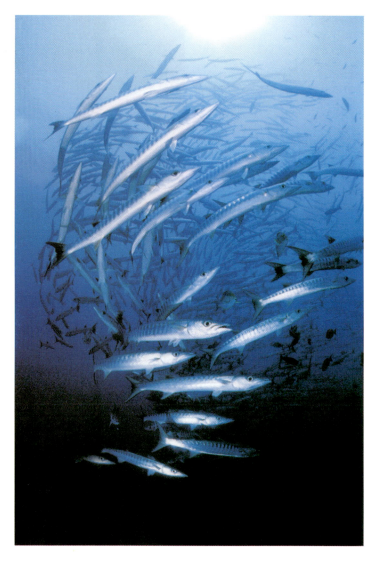

(which it surely will) the laws of supply and demand will dictate
that costs will fall as demand increases. How long this will take
depends on the speed of technological advances in this area.

For the underwater photographer, the first step to capturing an
image in a digital format is most likely to be achieved by
converting a print or slide by scanning. Once loaded into a PC
or Mac, the image can be manipulated using a software
package such as Adobe Photoshop. Just about everything can
be adjusted in Photoshop. The manipulated image can be
loaded for storage on either a hard disk, or a digital audio tape
(DAT), onto CD (compact disc) or a zip drive.

Digital manipulated images produce files which are far too
large for a conventional floppy disk, hence the alternative

Figure 32.3
Stone fish. Many years ago I was lucky enough to come across a stone fish lying on the sand near to the 'pinnacle' in Eilat. I took almost an entire roll of film and many of the frames were successful, however, one particular shot of the creature lying on the sand was flawed as a result of some seaweed floating across the bottom and drifting into the picture just before I pressed the shutter. I have **cloned** the offending areas with the **rubber stamp** tool and eliminated all the distraction. I then adjusted the exposure **levels** and printed it out on the HP photo smart printer.

methods. Entire portfolios can now be stored on compact disc. At present the fastest way of sending an image 'down the line' to a client is via an ISDN telephone line, a line dedicated to carrying data and images in digital format. The use of a conventional line via a modem in the computer is a slower and less reliable alternative. Only last month I transmitted a 20 Mb file via e-mail as an attachment to one of the UK's scuba magazines. It took two hours to transmit!

Finally, you may want to produce prints from your digital images. Excellent quality can be obtained using the latest inkjet printers. For producing a transparency from your digital image, use the services of a bureau.

For scanning slides into my PC and for producing quality digital prints I use and recommend the Hewlett Packard Photo Smart photo scanner and the Hewlett Packard Photo Smart photo printer.

I have recently invested time and money into a short university course focusing on the implications and techniques of digital manipulation using Adobe Photoshop 5, scanning and printing.

The coming of the digital age is fast approaching.

I do not intend being left behind!

Adobe Photoshop 5.0

Digital manipulation using Photoshop 5.0 can be used to alter an underwater photograph in a million different ways. Perhaps the most popular is the photo montage, where elements of various images are joined together and blended into one. Pick up any current diving magazine and you will see examples of this.

In researching this section of the book, I took the advice of many underwater photographers who use Adobe Photoshop 5.0. Their message to me was clear:

Take care to avoid deceiving the public by altering the context of the subject matter.

I am sure that many readers will remember the examples of 'double exposure' techniques of the late 1980s – one half of a composite being taken in an ocean at the opposite end of the earth as the other half. Whilst a handful of the more successful underwater photographers became particularly skilful the majority (including myself) did not. Many images were displayed to the public not as an obvious combination but as a true-to-life photograph which they expected to be taken seriously.

I am grateful to those underwater photographers who took the trouble to reply to my questions via e-mail and user-groups on the Internet: '*What does digital imaging and manipulation mean to the underwater photographer?*' I have taken their views to heart throughout this chapter. I have chosen to illustrate the power of digital imaging as an excellent tool for performing photographic repairs.

Equipment Suppliers and Useful Addresses

Alan James Photography
8–10 Kellaway Avenue
Redland
Bristol
BS6 7XR
UK
Tel 0117 944 2102
Fax 0117 924 5009

Aqua Visions Systems
Aquatica
7730 Trans Canada Highway
Montreal
Canada
Tel 514 737 9481
Fax 514 737 7685

BSOUP
British Society of Underwater Photographers
Secretary: Peter Tatton
103 Charmouth Road
St Albans
Herts
AL1 4SG
UK
Tel 01727 832895

Cameras Underwater
East Island Farmhouse
Slade Road
Ottery St Mary
Devon
EX11 1QH
UK
Tel 01404 812277
Fax 01404 812399

Divequest
Two Jays
Kemple End
Clitheroe
Lancashire
BB7 9QY
UK
Tel 01254 826322
Fax 01254 826780
E-mail: divers@birdquest.co.uk

Hewlett Packard Co
PO Box 3025
Corvallis
OR97339
USA

Ian Ratcliffe Design
49b Rowley Road
Little Weighton
Cottingham
East Yorkshire
HU20 3XJ
UK
Tel 01482 875113

Ikelite
50 west 33rd Street
PO Box 88100
Indianapolis
IN 46208
USA
Tel 317 923 4523

Kevin Cullimore (flash housings)
7 Mount Echo Drive
Chingford
Essex
UK
Tel 0181 529 5886

Photo Ocean Products
Ken Sullivan
52 Highfield
Letchworth
Hertfordshire
SG6 3PZ
UK
Tel 01462 627670
E-mail sully@mcmail.com

Kodak
PO Box 66
Station Road
Hemel Hempstead
Herts
HP1 1JU
UK

Nikon UK
308 Richmond Road
Kingston
London
KT2 5PR
UK
Tel 0181 541 4440

Ocean Optics
Ocean Leisure
Embankment Place
Northumberland Avenue
London
WC2N 5AQ
UK
Tel 0171 930 8408

Sea & Sea UK
Phillip House
Aspen Way
Paignton
Devon
TQ4 7QR
UK
Tel 01803 663012
Fax 01803 663003

Subal
PO Box 25
Leopold Werndl-Str 31
A-4406 Steyr
Austria
Tel 43 7252 46424
Fax 43 7252 52651

Subatech
1093 La Conversion
Lausanne
Switzerland
Tel 021 39 2777

Ultralight Flash Arms
3304 Ketch Avenue
Oxnard, CA 93035 USA
Tel 800 635 6611
Fax 805 984 3008

Underwater Images
216 Uxbridge Road
Shepherds Bush
London
W12 7JD
UK
Tel 0181 743 3788

Underwater Photography Centre
574 Kingston Road
Raynes Park
Surrey
SW20 8DR
UK
Tel 0181 296 8855

Videoquip
5 Foss Road South
Leicester
LE3 0LP
UK
Tel 0116 255 8818

Warren Williams
30 Windmill Road
London
N18 1PA
UK
Tel 0181 807 2596

Glossary

'A' – Auto The automatic exposure control automatically sets the shutter speed.

Absorption The blue, filtering effect of sunlight. Water absorbs the colours of the spectrum selectively until, at depths of around 20–25 m only tones of blue and green remain.

Aperture priority automatic exposure (Also referred to as 'Aperture priority' and 'Automatic exposure control'.) On many cameras this setting automatically sets the right aperture and shutter speed for proper exposure. On the Nikonos V and RS you manually adjust the aperture control which transmits light from the lens to the viewfinder.

AF – Autofocus sensor A device in 35 mm SLR autofocus – AF – cameras which tells the lens where to focus. Generally speaking the more sophisticated the camera the more autofocus sensors it has.

Ambient light (also referred to as natural light) The light from the sun which is available under water.

Angle of view (also referred to as the Angle of Acceptance, Angle of coverage, Picture angle) This refers to the angle that the camera lens 'sees', measured across the diagonal from corner to corner.

Aperture The opening in the lens which regulates the amount of light reaching the film, expressed in f-numbers or f-stops. The higher the f-stop number the smaller the aperture so the less the amount of light reaching the film. As the f-stop increases so does the depth of field, whatever the lens.

Apparent distance The distance which objects appear to be away from the eye/camera under water. Objects under water appear to be one quarter closer than they really are.

ASA Acronym for the American Standards Association. It is used universally as the standard for the rating of films according to their sensitivity to light. This is referred to as the film speed and expressed by an ASA number such as 100 ASA, 200 ASA, 400 ASA and so on. The higher the number the faster the film, i.e. the more light-sensitive it is said to be.

Autofocus A built-in system which automatically focuses the lens correctly on the subject to be photographed.

Backscatter Light reflected in the camera lens, and showing up as 'snow' on the finished photograph, from suspended particles in the water.

Baseplate Plate, usually metal, fitted underneath the camera to which flash guns, tripods or other accessories can be attached.

Beam angle The angle of a strobe light beam, expressed in degrees.

Bracket To take a series of pictures at various exposures by varying *f*-stops or shutter speeds and covering both sides of the meter reading with the object of obtaining one perfect exposure.

Centre-weighted metering pattern Describes the fact that the light reading of exposure meters is taken mostly in the centre of the picture area.

Close-focusing (macro) lens A lens that can focus from infinity down to a few centimetres with reproduction ratios of 1:2 or 1:1.

Close-up lenses (close-up attachments) Inexpensive lenses that enhance the close-up capabilities of normal (i.e. 35 mm–55 mm) focal length lenses by reducing the minimum focus distance.

Contrast The range of brightness from the darkest to the lightest areas of a picture.

Depth of field The area which is in focus behind and in front of a subject. Depth of field is controlled by three factors – the focal length of the lens, the size of the aperture and the camera-to-subject distance.

Diffuser A curved disc placed over a strobe reflector to widen the strobe's beam of light. Also decreases light intensity by about one *f*-stop.

DIN (*see also* ASA) Acronym for Deutsche Industrie Norm, the alternative, but less commonly used, term to describe the speed of film in reacting to light.

Diopter Magnification power of a supplementary lens. The focal length of such a lens can be calculated by dividing 1000 by the power of the diopter.

Dome port A semi-spherical piece of glass or plastic used to eliminate the magnifying distortion caused by reflection.

Double exposure Cocking the shutter and taking a shot without winding the film on to produce – deliberately or otherwise – a second image on the same film frame.

Effective *f*-stops The actual *f*-stop value when you place an extension tube between the lens and camera or when you focus for extreme close-ups.

Exposure The quantity of light striking the film.

Exposure compensation Adjusting the camera or metering system to give a greater or lesser exposure than that which the light meter considers to be correct. The Nikonos RS has an exposure compensation dial for this purpose; on the Nikonos V you can vary the film speed setting.

Exposure latitude (film latitude) The measure of a film's propensity to compensate for over- or underexposure. Slide films have a low latitude – plus or minus a half *f*-stop is common – so exposures have to be very accurate. Print films have a much wider latitude.

Exposure mode Camera setting, such as M – manual, A – aperture priority, etc., which determines which controls you have to adjust manually for an exposure and which ones the camera does automatically.

Exposure table (flash table) Shows the *f*-stops for strobe exposures at various distances and power settings.

Extension tubes Used exclusively for close-up and macro photography these hollow tubes are placed between the lens and the camera body. They increase the magnification and close focusing distance of the lens.

Fast (or high-speed) film A film which is very sensitive to light, indicated by a higher ASA rating number of 400, 800, 1200 or more.

Fill lighting The use of flash (or other artificial light source) to enhance colours and lighten shadows when ambient light is the primary light source.

Film speed The measure of a film's relative sensitivity to light, shown by its ASA/DIN number. The higher the number the faster the film. In contrast, the lower the number, e.g. 100 ASA, 50 ASA, the slower the film is said to be. The film speed is usually included in the film's name or shown very clearly in packaging.

Filter A piece of transparent glass, plastic or gelatin placed over the lens to adjust colour in natural light pictures or to balance the light when flash is used. Many filters may reduce the amount of light which reaches the film and aperture/shutter speed may need to be adjusted to compensate.

Fisheye lens A lens with a 180 degree field of view which produces a circular image on the rectangular picture frame. Fisheye lenses offer maximum depth of field.

Focal length The distance from the centre of the lens to the film, usually stated in millimetres. Usually used to describe the lens size in general, e.g. 35 mm lens, 50 mm lens, etc.

Format The dimensions of an image on film. For instance the 35 mm film format (35 mm wide) produces an image which is 24 mm by 36 mm.

Fractional *f*-stop Any aperture setting which is between the full *f*-numbers marked on the camera's aperture control ring.

Frame One single image on a roll of film. Also refers to the outer edges of an image.

Framer (field frame) A metal frame attached to the front of a close-up lens to indicate the limits of the picture area. Different sized frames are used on different lenses.

***f*-stops** The various settings which control the camera lens aperture. The *f*-stop or *f*-number indicates the relationship between the size of the aperture opening and the focal length of the lens. So a setting of *f*8 means that the diameter of the aperture is 1/8 of the lens's focal length.

Grain All film is made up of grains of a silver compound. The larger these grains the more sensitive, i.e. faster, the film is to light. Photographs taken on higher speed films sometimes appear 'grainy', particularly if the finished image is enlarged.

Guide number Term used to indicate the power of a flash gun. The higher the number the more powerful the unit. The lens aperture setting is determined by dividing the guide number by the flash-to-subject distance.

Hot shoe Mounting on top of the camera to which the flash is attached.

Interchangeable lens One that can be removed from a camera to be replaced by another lens.

ISO (*see also* ASA and DIN) Acronym for International Standards Organisation, another system of rating film speeds. Interchangeable with ASA numbers, i.e. 100 ASA = ISO 100.

Latitude *See* Exposure latitude.

LED Acronym for light-emitting diode. Lights and symbols usually displayed in the camera viewfinder to give exposure data.

Lens speed The widest aperture to which a lens can be opened. The wider the maximum aperture a lens has, the faster it is said to be.

Linking controls The knobs, levers and other controls which operate the camera functions from outside the underwater housing.

Low-speed film *See* Fast film; Film speed.

Macro lens A lens, usually 50 mm or 100 mm, specifically designed for macrophotography, allowing very sharp focusing at short camera-to-subject distances. The lens can be positioned very close to the subject and the resulting image is magnified.

Master flash (Master strobe) Any flash which is used to trigger a slave flash.

Matrix flash fill A feature of the Nikonos RS, the matrix flash-fill automatically balances foreground flash light with background ambient light.

Matrix metering Another feature of the Nikonos RS. The automatic exposure control takes a light reading in five different segments before calculating the correct exposure.

Modelling light (aiming light) A light, often a small underwater torch, incorporated in or attached to a flash gun which shows the direction in which the flash is pointing.

Motor drive Accessory or fitting which automatically winds the film on once the shutter has been pressed.

'M' setting The setting which indicates the camera is in manual mode.

Multimode (camera) The ability of a camera to function in a variety of modes, e.g. manual, automatic, aperture priority, shutter priority, etc.

Multiple exposure photography Taking one or more photographs on the same frame without advancing the film. *See also* Double exposures.

Negative space Everything in the photograph which is not the subject.

Neutral density filter A filter (see Filters) which reduces the amount of light entering the camera without affecting the colour of the finished photograph.

Normal lens One that has an angle of view similar to that of the human eye.

'O' ring Neoprene/synthetic rubber gaskets used to seal the joints between different parts of underwater equipment and render them watertight.

Panning Following the movement of a subject with the camera. Carried out correctly with the shutter open this should produce a sharp subject against a blurred background.

Parallax The difference between what the eye sees through the viewfinder and what the camera lens sees in non-reflex cameras. This discrepancy in the position of an object viewed from two different points is most noticeable when close up and at minimal distance. Some viewfinders have parallax correction marks.

Pentaprism Optical device in the lens of SLR cameras which transmits light from the lens to the viewfinder.

Picture angle *See* Angle of view.

Port Glass or perspex window through which the lens 'looks' underwater. May be domed to eliminate problems of refraction.

Prism Optical device which changes the direction of light.

Programme mode (Automatic mode) Mode in which the camera selects both aperture and shutter speed automatically.

Recycle time The time it takes for a flash unit to recharge between flashes.

Reflex system (RS) References to 'the RS' usually mean the Nikonos RS underwater camera. The RS actually indicates that the camera is an SLR.

Refraction The behaviour of light under water which causes objects to appear closer and larger than they actually are.

Relative *f*-stops Those marked on the camera's aperture ring as opposed to effective *f*-stops.

Reproduction ratio The size of the image on film compared to its actual 'real life' size. Most commonly used when talking about the relative magnification of macro lenses and extension tubes.

Resolution A lens's ability to record fine detail sharply.

Ring flash A ring flash does just what its name implies, encircling the camera lens with a flash tube so that the light is projected forward from the camera.

Selective metering Selecting the part of the subject for which you wish the light meter to take a reading.

Shutter priority Mode setting on automatic cameras (*see* Aperture priority). In this mode the shutter speed is set manually while the camera automatically selects the aperture setting.

Slave flash (Slave strobe) A flash which is activated by the light from a 'master' flash unit. It can be turned on or off at the touch of a switch. *See also* Master flash.

SLR Acronym for single lens reflex. Through a system of mirrors and a pentaprism (*see* above) anyone looking through the viewfinder of an SLR camera sees the precise image which will appear on film.

Snell's window The circular arc in the surface of the water caused by the effect of refraction.

Stepless shutter speeds Infinite number of shutter speeds available on (usually the more expensive) cameras.

Stop see Aperture; *f*-stop.

Stopping down Reducing the aperture of a lens by increasing the *f*-stop number. This increases the depth of field.

Strobe Another name for an underwater flash unit.

Sync cord (or connector) Electronic connection between camera and flash unit.

Synchronisation (Sync) speed The fastest shutter speed which will allow the film to be completely and correctly exposed when the flash is activated.

Slow film *See* Fast film; Film speed.

TTL Acronym of through the lens (1) A flash exposure system which measures the amount of light passing through the lens. The TTL system turns the flash on once the film has received enough light to produce the correct exposure. (2) Refers to the viewing mechanism of a camera when you look through the lens of an SLR camera – the image you see is what you get. (3) Describes a built-in light metering system, known as 'through the lens metering'.

Wide-angle lens A lens with an angle of view wider than that of the human eye. For underwater photography using the Nikonos system wide-angle lenses are those with a focal length shorter than 28 mm.

Wire framer *see* Framer.

Zoom lens A lens, such as the RS 20–35 mm zoom lens, which offers several lenses in one by allowing the focal length to be altered at will. The minimum and maximum focal lengths available are clear by the way zoom lenses are described and labelled, e.g. 35–105 mm zoom.

Index